THE UNIVERSITY OF KANSAS

FRANKLIN D. MURPHY LECTURE SERIES

Searching

FOR

Modernity

...

Western Influence and True-View Landscape

in Korean Painting of the Late Chosŏn Period

...

YI SŎNG-MI

SPENCER MUSEUM OF ART

and the

KRESS FOUNDATION DEPARTMENT OF ART HISTORY

THE UNIVERSITY OF KANSAS

in association with

UNIVERSITY OF WASHINGTON PRESS

SEATTLE AND LONDON

The Murphy Lecture Series is sponsored by the Spencer Museum of Art, the Kress Foundation Department of Art History at the University of Kansas, and the Nelson-Atkins Museum of Art. The lectureship was established in 1979 through the Kansas University Endowment Association in honor of former chancellor Dr. Franklin D. Murphy.

Printed and bound in China

17 16 15 14 5 4 3 2 1

SPENCER MUSEUM OF ART

The University of Kansas
1301 Mississippi Street
Lawrence, KS 66045-7500 USA
www.spencerart.ku.edu

UNIVERSITY OF WASHINGTON PRESS

P.O. Box 50096
Seattle, WA 98145 USA
www.washington.edu/uwpress

LIBRARY OF CONGRESS
CATALOGING-IN-PUBLICATION DATA

Yi, Song-mi, 1939– author.
Searching for modernity : Western influence and true-view landscape in Korean painting of the late Choson period / Yi Song-mi.
pages cm. — (Franklin D. Murphy lecture series)
Includes bibliographical references and index.
ISBN 978-0-295-99393-5 (hardcover : alk. paper)
1. True-view landscape painting.
2. Painting, Korean—Choson dynasty, 1392–1910—Western influences.
I. Title.
ND1366.94.Y49 2014
759.9519—dc23 2014011493

CONTENTS

PREFACE AND ACKNOWLEDGMENTS

In February 2001, I had the honor of lecturing in the twenty-first Franklin D. Murphy Lecture series at the University of Kansas, Lawrence. I was the first in the distinguished lecture series to specialize in Korean art. A few years earlier, Professor Marsha Haufler had planned to establish a Korean art lecture course and seminar in the curriculum of the Department of Art History. She believed that East Asian art could not be fully and organically understood without a proper understanding of Korean art. Her annual trips to Korea to participate in the well-established Workshop for Korean Art Curators, sponsored by the Korea Foundation, enabled her to offer a graduate seminar at the university on Korean painting in the spring of 2001. I participated in this seminar as an outside lecturer.

Professor Haufler and I designed the course to include six seminar meetings, with topics ranging from Koguryŏ tomb murals to the nineteenth-century court decorative paintings. My presentations were followed by questions and discussions by the seminar students. Late Chosŏn painting, centering on the eighteenth century, was also highlighted in two lectures open to the public. The first lecture (titled "Western Influence on Late Chosŏn Period Painting") was held at the Spencer Museum of Art at the University of Kansas, Lawrence; the second lecture (titled "True-View Landscape Painting") was delivered at the Nelson-Atkins Museum of Art in Kansas City, Missouri. The subject of this book originated in these two public lectures.

I would like to express my gratitude to the faculty of the Kress Foundation Department of Art History and the Spencer Museum of Art at the University of Kansas for granting me the honor and the opportunity to serve as the Murphy Lecturer, first in 2001 and again in 2006. I would like to thank Professors Amy McNair and Linda Stone-Ferrier for allowing me to take all this time to complete the manuscript. Finally, thanks are due to Professor Marsha Haufler, my classmate at the University of California, Berkeley, and longtime friend and colleague who made all the arrangements for my visits to the university to serve as the Murphy Lecturer.

I would also like to thank my former student, Dr. Yi Su-mi, curator of painting at the National Museum of Korea, for locating and securing many of the illustrations included here. Dr. Hong Soil kindly read the first draft and her comments made the manuscript more readable. My thanks also go to past and present research assistants: Ms. Yi Yun-hŭi, my former master's student at the Academy of Korean Studies, helped me in all stages of research; Ms. Shin Hanna, my current assistant, helped me in the final stages of manuscript preparation, putting together illustrations as well as the glossary and bibliography.

Finally, my heartfelt gratitude goes to my husband and lifelong friend, Dr. Han Sung-joo. Without his care, understanding, and thoughtful support of my work, the completion of this book might not have been possible.

Yi Sŏng-mi
Professor Emerita of Art History
The Academy of Korean Studies
Sŏngnam, Korea

Searching
FOR
Modernity

INTRODUCTION

The titles of my two lectures in 2001 for the Franklin D. Murphy Lecture series, at the Spencer Museum of Art at the University of Kansas, were "Western Influence on Late Chosŏn Period Painting" and "True-View Landscape Painting." The lectures were the products of my own explorations of Koreans' inquiry into things both foreign and domestic during the late Chosŏn period—that is, from 1700 to the end of 1910. True-view landscape painting, which has its roots in documentary painting of the early Chosŏn period, developed into a uniquely Korean tradition during the eighteenth century. However, the Western practice of depicting art objects based on one's actual observation of nature played an important role in the shaping of the true-view landscape painting tradition. These two seemingly unrelated contemporaneous trends in Korean painting are closely interrelated in their basic approach to art. Therefore, it is fitting to discuss them according to a unifying theme of "searching for modernity."

Western influence and the true-view landscape tradition have remained significant in Korean painting since the eighteenth century. Both trends, having flowered contemporaneously, share interlinked historical and intellectual backgrounds. Beginning with the fall of the Ming dynasty (1644), Koreans became much more conscious about their own country's historical, cultural, natural, and geographical heritage. At the same time, they were eager to learn about the new School of Practical Learning in Qing China. Many educated elites of the Chosŏn

felt a great sense of loss after the fall of the great Han cultural tradition, which had been upheld in the Chosŏn kingdom. In the absence of an heir to that enormous tradition in China, Koreans felt responsible for carrying it on. Ironically, this sense of responsibility prompted them to be more aware of their own past and their own land.

Scholar-officials (a uniquely Chinese and Korean social designation) and men of letters traveled to scenic and historic spots in Korea accompanied by court painters, who captured those spots in their paintings. Literati painters (amateurs as opposed to professionals) also recorded what they saw during their journeys. In order to portray the scenery, some painters had to devise their own brush idioms (such as the sharp vertical brush strokes that delineate the hard edges of the rocky peaks in Chŏng Sŏn's *Complete View of Mount Kŭmgang* [see fig. 76]), because the Chinese brush conventions alone proved inadequate for depicting particular scenery. Thus, a new genre of landscape painting, which later was termed *chin'gyŏng sansu-hwa,* or "true-view landscape painting," came into being. In short, true-view landscape paintings are those depicting the wondrous landscapes of Korea via uniquely Korean brush conventions along with traditional Chinese brush idioms. One of the best examples of *chin'gyŏng sansu-hwa* would be Chŏng Sŏn's (1676–1759) *Clearing after Rain on Mount Inwang,* dated by inscription to 1751 (fig. 1). It depicts the prominent mountain (fig. 2) on the northwestern border of the Chosŏn dynasty's capital, Hanyang, today's Seoul.

Korean scholar-officials were also deeply interested in the advanced Qing culture, including aspects of the civilization that China had received directly from the West through Jesuit missionaries in Yanjing. The Chosŏn emissaries to the Qing court were shocked when they saw the lifelike figures on the ceilings and walls of the Jesuit church in Yanjing. They described their various reactions in travelogues that serve as documentary evidence of Korea's initial contact with Western civilization. Chosŏn emissaries brought back prints and paintings of Western origin that they had purchased in Yanjing or received as gifts. It was not uncommon at the time to see Western paintings hung in the center halls of the Chosŏn scholar-officials' residences.

Western influences on Korean painting, which came to Korea indirectly by way of China, brought about changes not only in true-view landscape paintings but also in portrait and figure paintings, bird and animal paintings, documentary paintings, and others. The *Bust Portrait of Sin Im* (fig. 3) and the *Ferocious Dog* (fig. 4) exemplify paintings that reflect Western influence in eighteenth-century Chosŏn. After a short setback in the second half of the nineteenth century (influential scholar painters such as Kim Chŏng-hŭi sided with the traditional literati painting), a second wave of Western influence came to Chosŏn—this time through Japan. It was not until the early twentieth century that Korean artists themselves began to study in Europe, importing Western styles of painting directly to Korea.

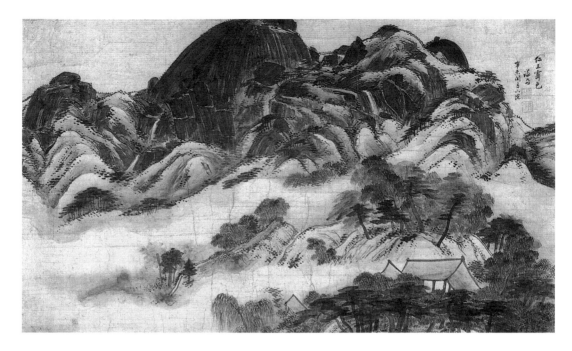

1 Chŏng Sŏn, *Clearing after Rain on Mount Inwang*, dated to 1751. Hanging scroll, ink on paper, 79.2 × 138.2 cm. Collection of Leeum, Samsung Museum of Art, Seoul.

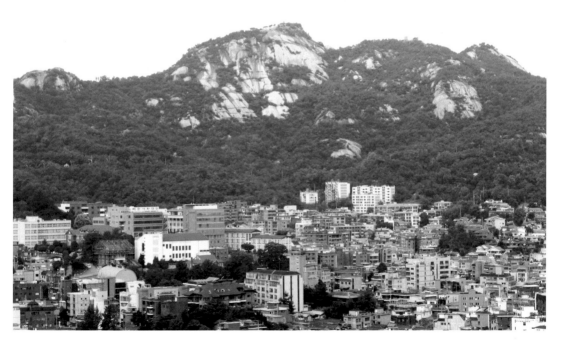

2 Mount Inwang, Seoul, 2010. Photograph by Yi Sŏng-mi.

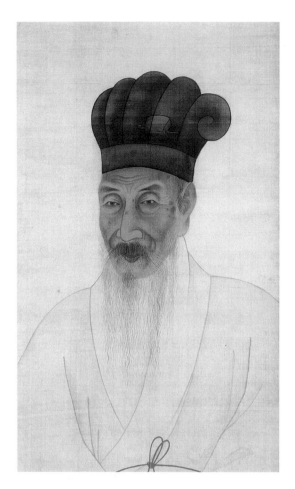

3 Unidentified artist, *Bust Portrait of Sin Im,* date unknown. Ink and color on silk, 73.1 × 44.8 cm. National Museum of Korea, Seoul.

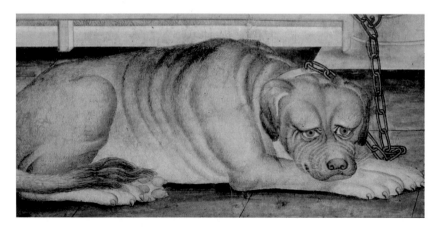

4 Unidentified artist, *Ferocious Dog,* date unknown. Ink and color on paper, 44.2 × 98.5 cm. National Museum of Korea, Seoul.

This book traces the development of the two trends of Korean painting through existing works of art as well as through documentary evidence in the form of historical records and travel diaries of Chosŏn emissaries to Yanjing (collectively known as *yŏnhaeng-rok*, records of travel to Yanjing). Travelogues of scholar-officials were written when they visited the country's scenic spots, sometimes accompanied by their favorite painters. Inscriptions on and colophons to paintings also serve as primary sources that shed light in understanding the painters' thoughts on key issues in the development of these trends. Writings of scholars of the School of Practical Learning serve as important documents in understanding the then current issues. These Chosŏn scholars, without visiting Yanjing, acquired knowledge on Western painting techniques or Western culture in general through Western books that had been translated into Chinese.

In 2000, before delivering my two lectures in the Murphy series, I published a monograph in Korean on the Western influence on Korean painting of the Chosŏn dynasty.[1] A revised and enlarged edition of the same book was published in 2008.[2] In 2006, I published a monograph on Korean landscape in which true-view landscape painting was covered in two chapters.[3] In 1998, I contributed an article in *The Arts of Korea,* published by the Metropolitan Museum of Art on the occasion of the opening of the Arts of Korea Gallery in that museum.[4] The present book draws much from these previous publications, with necessary updates to reflect the most recent scholarly findings by a younger generation of scholars.

Two scholars in particular have contributed to the advancement of scholarship on true-view landscape painting. Professor Kang Kwan-sik of Hansung University in Seoul conducted in-depth research on the official careers of Chŏng Sŏn and his important paintings; this research helped me revise much of the section on the pioneer of the true-view landscape painting. Professor Yi T'ae-ho of Myŏng-ji University has had a long-term interest in true-view landscape painting and produced many pioneering scholarly articles on individual artists and their important works. His most recent monograph is *Yet hwagadŭl ŭn uri ttang ŭl ŏttŏke kŭryŏtna* (The way past Korean artists painted their land), published after my manuscript was completed.[5] My research has also been enhanced by many master's theses and PhD dissertations of the past decade that have dealt with hitherto little-known painters or issues. The names of these scholars and their topics of study have been duly recognized in chapter notes and the selected bibliography.

The strength of this book, I believe, lies in its tying together of the two seemingly unrelated topics--the Western influence and the true-view landscape tradition--of Korean painting that developed nearly simultaneously. By linking the two themes that sprang from common historical and intellectual background, I illuminate the forward-looking attitude, the "modernity" if you will, of the Koreans in the early part of the eighteenth century. This cultural outlook continued into the nineteenth century, encouraging the Chosŏn people to seek their true identity amid changing international circumstances.

Compared with the history of Chinese or Japanese art, that of Korean art is relatively less known outside of Korea, even in the world's English-speaking areas, as the amount of English-language publications on Korean art is far smaller than those on Chinese or Japanese art. In recent years the Korea Foundation has made an effort to alleviate this problem by publishing English-language books on Korean art and culture as part of the Korean Culture Series. To date, thirteen books in the field of Korean painting, Buddhist sculpture, architecture, and crafts have been published in the series, which will continue to cover wide areas of Korean culture.[6] Adding to the growing number of books published on Korean art, *Searching for Modernity* complements the Korea Foundation's series. While most of the books in that series are surveys of one particular area of Korean art and culture, this work provides in-depth treatment of two specific themes at a more narrowly defined period in Korean history. I hope it elevates the level of interest and understanding of Korean art for readers both in and outside of Korea.

1

HISTORICAL AND INTELLECTUAL
BACKGROUND OF THE LATE
CHOSŎN PERIOD

Japanese and Chinese Invasions

In current scholarship of the history of Korean painting, the late Chosŏn period spans roughly the second half of King Sukchong's reign (1667–1720)—that is, from 1700—to the end of the dynasty in 1910. This periodization is consistent with Professor Ahn Hwi-joon's division of the Chosŏn dynasty into four periods in his *History of Korean Painting*.[1] However, it is necessary for us to track back about a century—to the end of the sixteenth century—to understand the historical and intellectual backgrounds of the late Chosŏn period. In fact, some of the events that led to the beginning of Western influence on Korean painting and some of the early examples of true-view landscape painting can be found during the seventeenth century.

In Korea the period between the end of the sixteenth century and the fall of Ming dynasty in 1644 was one of foreign invasions. Within fifty years, there were four invasions: two by the Japanese—the Imjin waeran (Japanese turmoil in the cyclical year *imjin*, 1592) and the Chŏng'yu chaeran (Japanese turmoil in the cyclical year *chŏng'yu*, 1597)—and two by the Jurchens (Manchus). The first of these invasions took place before the establishment of the Qing Empire—the Chŏngmyo horan (Chinese barbarian turmoil in the cyclical year *chŏngmyo*, 1627)—and the second invasion happened immediately after the empire's establishment, known as the Pyŏngja horan (Chinese barbarian turmoil in the cycli-

cal year *pyŏngja*, 1636).[2] The first Japanese invasion, launched in April 1592 by the Regent Toyotomi Hideyoshi (1536–1598), happened when the Chosŏn court was totally unprepared and thus was the most devastating of the four invasions. Hideyoshi's forces landed in Pusan and marched to Hanyang, then the capital of Chosŏn, in fewer than three weeks' time. King Sŏnjo's court fled to P'yŏngyang and then on to Ŭiju only to return nineteen months later. While on the southern sea, Admiral Yi Sun-sin (1545–1598) and his famed turtle ship successfully blocked the sea routes of the Japanese navy; on the land, the combined forces of Chosŏn and Ming pushed the Japanese south from P'yŏngyang.

The peace negotiations between Hideyoshi and the Ming, both of whom considered themselves victors, dragged on for more than three years without any conclusion. In January 1597, Hideyoshi's forces launched another attack on the Korean peninsula, and an inconclusive war waged until Yi Sun-sin's death in August 1598, ending the six years of invasion and war. During these two invasions, the Japanese inflicted irreparable damage on the entire Korean peninsula. Many royal palaces, including Kyŏngbok-gung, the dynasty's main palace, as well as such Buddhist monasteries and temples as Pulguk-sa, three of the four history archives (*sago*), and fortifications were burned down, along with precious books, historical documents, and paintings and sculptures. Many transportable cultural assets were taken by the retreating army to Japan, where they still remain. Notable among these are many Koryŏ Buddhist paintings, only a handful of which remain in Korea today. Many Korean potters during these years were forcibly taken to Japan, where they subsequently revolutionized the art of pottery making, which in Japan had been lagging far behind that in Korea and China. Descendants of some of those transplanted Korean potters are still actively engaged in Japan in the production of high-quality pottery. The Ming court, which had come to Chosŏn's aid, also suffered in the end, having been drained of its military, financial, and personnel resources. As a result, the court was unable to pay due attention to the defense of the country's northern border regions. This allowed Nurhachi (1555–1627, later Qing Taizu) of the Jurchens to expand his power and establish the Later Jin dynasty (1616–1636), which subsequently changed its name to the Qing dynasty (1636–1912).

The monarch Kwanghae-gun (r. 1608–1623), who succeeded King Sŏnjo, was a shrewd and able ruler, although he was not given the title of kingship because of factional strife at court. He had the history archives rebuilt and published many books. He kept a watchful eye on the ailing Ming empire and the newly rising Jurchen Manchus. As a result, Korea was saved from the Later Jin's expanding forces during the early days of the Manchu dynasty. However, after Kwanghae-gun was ousted by the "Westerners" (*sŏ'in*) faction, and King Injo (r. 1623–1649) was installed, the Chosŏn court was led by scholar-officials who identified themselves with the Ming's great Neo-Confucian tradition. In foreign policy the court no longer maintained the delicate diplomatic balance between the Ming and the Manchus. Korea's abrupt policy change to pro-Ming and anti-Manchu irri-

tated the Later Jin's second ruler, Abahai (1592–1643, later Qing Taizong). In 1627 he waged a war against Chosŏn (the Chŏngmyo horan) primarily to block the Korean kingdom from aiding Ming forces. The Later Jin's victory over Chosŏn resulted in King Injo's humiliating surrender under conditions that included the establishment of the brother relationship between the two countries and the Chosŏn court's abandonment of the Ming reign title, Tianqi.

In April 1636 the Later Jin ruler formally established the Qing empire (1636–1912), proclaiming himself an emperor. Since the 1627 invasion, however, the Chosŏn court had not complied with Jin demands, and when the Qing sent its emissary to Injo's court after the Qing's establishment, the king refused to receive him. In December 1636, Qing Taizong himself launched the second attack on Chosŏn (the Pyŏngja horan). It was much worse than the 1627 attack, and King Injo's surrender ceremony at Samjŏndo, a ford on the southern bank of the Han River (now Songp'a district, Seoul), was the most humiliating in Korean history. Crown Prince Sohyŏn (1612–1645) and his younger brother, Prince Pongrim (1619–1659), were taken as hostages to Shenyang along with many other scholar-officials. Chosŏn was forced to sever its ties with the Ming. Chosŏn had to acknowledge the suzerainty of the Qing, and eight years later, in 1644, would witness the fall of the Ming. Crown Prince Sohyŏn's return after a nine-year sojourn in the Qing capital marks the beginning of the influence of Western culture through China because he brought to Chosŏn books and images related to Christianity.

King Hyojong (r. 1649–1659), who succeeded King Injo, spent ten years in Shenyang and other places in China as Prince Pongrim. Even though he aided his brother, Crown Prince Sohyŏn, as a diplomatic link between Chosŏn and Qing, he himself had to endure greater suffering. He had been taken to Qing military expeditions in many difficult places. These harsh experiences in China apparently shaped Prince Pongrim's strong anti-Qing attitude in contrast with Crown Prince Sohyŏn, who was known to have a pro-Qing slant. Prince Pongrim succeeded Crown Prince Sohyŏn as the crown prince after his brother's premature death following his return from China.

The Fall of the Ming and Chosŏn Intellectuals' Response

Officially, the Chosŏn court paid tribute to the Qing, and adopted the Qing reign title, but most scholars and scholar-officials felt enmity toward the Qing, who imposed punitive conditions of surrender in 1636. However, the more fundamental issue was that such Korean scholars as Song Si-yŏl (*ho* U'am; 1607–1689) and Song Chun-gil (*ho* Tongch'undang; 1606–1672) of the "Westerners" faction (*sŏ'in*) considered their national identity in two separate entities: cultural and political.[3] In their view, "as a cultural entity, Korea was inextricably linked to a civilization that was defunct in its place of origin," and "Korea was perhaps the

sole surviving embodiment of that civilization."[4] The Koreans viewed the fall of the Ming as not just a dynastic change in China but more as a barbarian conquest of the center of the civilized world (Chunghwa). The Chosŏn intellectuals and the ruling class, who culturally felt far superior to the Manchus, whom they despised as lacking in culture, considered themselves as the heirs to the great Han cultural tradition that had been upheld by the Ming. The intellectuals and the ruling class felt loyal to the dynasty that had helped them during the Japanese invasions of 1592 and 1597.[5]

Although the Qing reign title was used in official documents, Korean scholars' political loyalty to the Ming was such that privately they continued to use the last Ming reign title, Chongzhen, for more than a hundred years after the fall of the Ming. Song Si-yŏl (1607–1689), one of the greatest Neo-Confucian scholars, had been performing rites in deference to the Wanli emperor (Shenzong, r. 1572–1619), who had aided Korea during the Japanese invasion, and the last emperor, Chongzhen (Yizong, r. 1628–1744). These rites took place under the cliff in Hwayang-dong, Kwesan, North Ch'ungch'ŏng province, on which Chongzhen Emperor's handwriting, *fei-li-bu-dong* ("do not act without observing propriety," from *Zhongyong*), was carved.[6] After Song's death, in accordance with his will, his chief disciple, Kwon Sang-ha (1641–1721), and other Neo-Confucian scholars had a shrine built in 1703 and named it Mandong-myo. There they continued to perform rites for the two Ming emperors.[7]

These gestures gained wide approval among court officials who suggested to the throne that it was time to make such rites official. On the nineteenth day of the third month in 1704, on the occasion of the sixtieth memorial of the Chongzhen emperor, King Sukchong (r. 1674–1720) had the Taebo-dan (the Altar of Requital) built in a corner of the Secret Garden (Piwon) in the Ch'angdŏk Palace for performing rites to the Wanli and the Chongzhen emperors.[8] In 1776, as soon as King Chŏngjo (r. 1776–1800) ascended to the throne, he bestowed a signboard to the Mandong-myo shrine, thus elevating the status to a "royally bestowed" (*sa'aek*) shrine. In 1865 the Regent Taewon-gun (1820–1898), then ruling as the regent to King Kojong (1852–1919), who had succeeded the throne in 1864 at age twelve, had the shrine forcibly closed. The shrine had become the gathering place of the Confucian scholars, who were mostly critical of the regent's policies. The pretext of the closing, however, was that there was no need to maintain the shrine as the rites had been performed officially at the Altar of Requital in the Ch'angdŏk Palace.

This series of events reflects not only the general policy of moral justification and loyalty (*myŏngbun ŭiri-ron*) to the Ming since King Hyojong's reign, but also Korean intellectuals' pride for their country as the sole heir to the Confucian tradition of scholarship, learning, and propriety. Since the early Chosŏn period, the Chosŏn ruling class had referred to their nation as "minor China" (so-Chunghwa).[9] They believed that when the legendary ruler Kija (active around 1100 BCE) was enfeoffed as king of Old Chosŏn, he brought with him the great Zhon-

ghua ("Chunghwa" in Korean) culture to Chosŏn that continued to dominate the nation's culture throughout history.[10] It is recorded that in 1487 the Ming emissary to King Sŏngjong's (r. 1469–1494) court, Qishun, remarked that the nation's understanding of propriety is such that the appellation of Chosŏn as so-Chunghwa is not an empty word.[11] Therefore not only the Koreans but also the Ming Chinese considered it appropriate to refer to Chosŏn as so-Chunghwa.

After the advent of the Jurchen Jin dynasty and its first invasion of Korea, Chosŏn officials' detest for the "barbarians" was such that the high official Hong Ik-han (*ho* Hwap'o; 1586–1637) presented a memorial to the throne in which he asked the king to kill the emissary from Jin. Chosŏn was the so-Chunghwa under heaven, Hong Ik-han cited, and receiving a barbarian emissary was not proper for Chosŏn.[12] There were numerous incidents in the late Chosŏn period in which Chosŏn as so-Chunghwa was cited in carrying out royal decrees. For example, in 1684, King Sukchong ordered proper rites be performed at the tomb of Kija.[13] In 1729, Kwon Hyŏk (1694–1759) in his memorial to the throne deplored the act of Yun Sun (1680–1741), the famous calligrapher who had been sent to the Qing court as an emissary. Yun had been accused of showing off his calligraphic skills in front of the "barbarian officials" and, in return, receiving generous gifts from them. By doing so, Kwon wrote, Yun had disgraced the pride of Chosŏn, the so-Chunghwa.

What was the effect of this attitude on art and culture? Some Korean art historians try to discount the impact of the so-Chunghwa concept in the development of true-view landscape painting throughout the eighteenth and early nineteenth centuries.[14] However, it seems certain that an attitude of pride and superiority over the Manchus ran especially deep in the minds of the Chosŏn intellectuals during the period that led them to investigate things Korean more seriously than ever before.[15] Beginning in the early seventeenth century, with the rise of the School of Practical Learning (Korean *sirhak,* Chinese *shixue*), a subject that is discussed in the next section, Korea redefined itself and its intellectual leaders became aware of their role relative to the outside world. This awareness contributed to the development of the new art and culture in the form of true-view landscape and acceptance of a new artistic form—the Western painting style, from China. These two new trends formed the core of late Chosŏn culture, when Korean arts reached an unprecedentedly high point.

The Rise of Studies on Korea and the School of Practical Learning

The Chosŏn intellectuals' respect for the grand tradition of Chinese culture and their sense of pride and responsibility for being the custodians and conveyors of this tradition gave them a new sense of self-respect and self-confidence regarding their own culture. It provided them with an incentive to pay greater attention to their own history. This led, during the reigns of Kings Sukchong and

Yŏngjo (r. 1724–1776), to the refurbishing of the royal tombs of the founders of the Paekche, Silla, Koguryŏ, and the Koryŏ kingdoms as well as that of the legendary founder of Old Chosŏn, King Tan'gun (2333 BCE–?).[16] King Sukchong's order to the court to perform rites at Kija's tomb can be understood in this light. King Yŏngjo also ordered additional guards be provided to keep watches over the Silla royal tombs.[17]

The interest in Korea's history and culture was also prompted by a new scholarly trend—the School of Practical Learning (Korean *sirhak*, Chinese *shixue*). The *sirhak* scholars advocated political, economic, social, and educational reforms, and they took practical affairs as their point of departure. They emphasized not only the humanistic disciplines derived from China but also social science, natural science, and technology. Their interest in promoting a new understanding of the country's history and culture led to a surge of publications on various aspects of Korean history, literature, language, and geography.[18] The beginning of the *sirhak* movement can be traced to the early seventeenth century, when Yi Su-gwang (*ho*, or style name, Chibong; 1563–1628) published in 1614 an important treatise, *Topical Discourses of Chibong* (Chibong yusŏl). The work dealt with a variety of subjects, including astronomy, geography, botany, and Confucianism as well as early Korea's society and government.[19] Yi Su-gwang, who visited Yanjing in 1590, 1597, and 1611 as an emissary to the Ming court, was strongly influenced by the philosophy of the eminent thinker Wang Shouren (*ho* Yangming; 1472–1529), the leader of the School of the Mind, who had developed the theory that knowledge and action are one.[20]

Yi Su-gwang's work was followed by Yu Hyŏng-won's (*ho* Pan'gye; 1622–1673) *Treatise by Pan'gye* (Pan'gye surok), an assessment and critique of such Chosŏn institutions as the land system, education, government structure, and military service. He also wrote extensively on history, geography, linguistics, and literature.[21] Writings on historical geography, which can be more directly associated with the development of true-view landscape painting, also appeared. Han Paek-gyŏm (*ho* Kuam; 1552–1615) published a pioneering work in this area, his *Treatise on Korean Geography* (Tongguk jiri-ji), followed by Yi Chung-hwan's (*ho* Chŏngdam; 1690–1752) *Ecological Guide to Korea* (T'aengni-ji), which is characterized as cultural geography because it includes local customs and community values.

An important figure in the dissemination of *sirhak* thought during King Yŏngjo's reign was Yi Ik (*ho* Sŏngho; 1681–1763), a scholar in retirement who wrote the modestly titled *Insignificant Explanation by Sŏngho* (Sŏngho sasŏl), an encyclopedic compilation of a thirty-volume work. Organized under five broad headings ("Heaven and Earth," "Myriad of Things," "Human Affairs," "Classics and History," and "Belle Lettres"), the compilation encompasses a wide range of topics.[22] Yi Ik's scholarly contribution is further discussed in the next section, in relation to Western learning.

The pioneering studies on Korea in the seventeenth century advanced and flow-

ered in the eighteenth century. Under the sponsorship of King Yŏngjo, the *Reference Compilation of Documents on Korea* (Tongguk munhŏn pigo)—a chronological overview of the country's geography, government, economy, and culture—was published in 1770. In 1778, during King Chŏngjo's reign (r. 1776–1800), an equally important historical survey was published by An Chŏng-bok (*ho* Sunam; 1712–1791): the *Annotated Account of Korean History* (Tongsa kangmok). The account spans Korea's legendary founding by King Tan'gun to the end of the Koryŏ dynasty. Han Ch'i-yun's (*ho* Okyudang; 1765–1814) *History of Korea* (Haedong yŏksa) was published, along with several other works. Among them, Sin Kyŏng-jun's (*ho* Yŏam; 1712–1782) *On Routes and Roads* (Toro-go) and *On Mountains and Rivers* (Sansu-go) were much welcomed by travelers to the country's scenic spots as their number increased significantly. This increase in travelers was directly related to the development of true-view landscape painting.

The map of Korea, *Tongguk chido*, was also produced during these years, by Chŏng Sang-gi (*ho* Nongp'oja; 1678–1752), at the command of King Yŏngjo. Drawn in nine sheets (one sheet showing the entire peninsula, and the remaining eight showing the eight provinces), the maps could be folded into an album—a pioneering work in that it precisely marked the distances from one place to another. When the eight sheets were spread out and put together, they formed a large map of the peninsula the size of a carpet. The map was made on a scale of 1 to 420,000. The original map no longer exists but copies under the name "Tongguk chido" (Map of the Eastern Nation, i.e., Korea) or "P'aldo chido" (Map of the eight provinces) are preserved in Korean collections today. The rise of interest in Korea's land and history led to an increase of travel to historical and scenic places throughout the peninsula; accordingly, there was an increase in travelogues written by scholars and scholar-officials, who sometimes were accompanied by their favorite painters. This point is elaborated in chapter 3.

Western Learning and Its Impact on Chosŏn Culture

Interest in Western learning by Chosŏn intellectuals arose within the political and cultural framework of Korea's relations with China. Many scholars who were considered the champions of *sirhak* were also deeply into Western learning, especially science, whether or not they were converts to Christianity, which brought Western learning to Korea via China. The term "Western learning" (Korean *sŏhak*; Chinese *xixue*) as applied to Chosŏn culture from the mid-seventeenth century on is accepted today in Korean historiography as designating a cultural structure or system that has its roots in Christianity. It is fundamentally different from either the Confucian- or the Buddhist-based culture that had dominated Korean culture before the introduction of Western culture through China. The term itself was an import from China, where Jesuit missionaries had settled since the mid-sixteenth century and published books in Chinese. Their titles often con-

tained "Western learning": for example, *Xixue zhiping* (Korean *Sŏhak ch'ip'yŏng*, Peaceful reign through Western learning), *Xiushen xixue* (Korean *Susin sŏkhak*, Western learning for self-cultivation) by Alphonsus Vagnoni (1536–1606), and *Xixue fan* (Korean *Sŏhak bŏm*, General account of Western learning) by Julius Aleni (1582–1630).[23]

In China, the Portuguese established their colony in Macao by 1557, soon to be followed by Dominican and Franciscan missionaries to Canton and elsewhere. The true breakthrough of high-level cultural contact with China began in 1595, when Matteo Ricci (Li Madu, 1552–1610) was invited to Yanjing to work on correcting the Chinese official calendar. It was not until 1601, however, that Ricci was finally received by the Wanli emperor. The art historian Michael Sullivan has written of Ricci: "This priest of formidable learning, energy and presence was destined by his scholarship and writings to engage the interest of Chinese intellectuals in European culture, and that of European scholars in Chinese culture, as did no other man in this momentous era of mutual awakening."[24] Ricci and other Jesuit priests compiled or translated into Chinese many books on Western learning either on Christian religion or Western science, especially astronomy, geometry, mathematics, and the calendar. Even though the newly invented Korean phonetic writing system, *han'gŭl*, was promulgated in 1446, Korea maintained the use of literary Chinese in its official, scholarly, and literary writings.[25] Therefore Korean scholars were able to absorb Western learning through these materials. Many of these books eventually made their way to Korea through Chosŏn emissaries who traveled to Yanjing. The route to Yanjing during the late Ming and the Qing period thus served as a conveyor belt from China to Korea of advanced learning and Western culture.

Before the Yanjing-Hanyang diplomatic route was actively used for the importation of Christianity and Western civilization, it was through Crown Prince Sohyŏn, who after returning to Hanyang in 1644 from his captivity in Shenyang, that the Chosŏn court was first introduced to the new civilization. Shortly before his return, the crown prince had a chance to visit Yanjing for some seventy days. There, German Jesuit missionary Adam Schall showed the crown prince the astronomical observatory he had created and introduced the crown prince to the Western calendar and mathematics.[26] Thus Crown Prince Sohyŏn brought back Western books on astronomy, mathematics, and Catholicism along with an image of Jesus and a globe. However, King Injo's cold reception of the Crown Prince upon his return and the prince's sudden death brought an end to Korea's contact with Western civilization via China at this point.

The Chosŏn court's interest in the Western calendar, then called the Current Standard Calendar (Chinese, the Shixienli; Korean, the Sihŏllyŏk), was persistently pursued by Han Hŭng-il (*ho* Yusi; 1587–1651), who stayed in Shenyang as an official protector for Prince Pongrim (he was also in captivity with his brother). When Prince Pongrim later became King Hyojong (r. 1649–1659), he and another high official, Kim Yuk (*ho* Chamgok; 1580–1658), who went to Yan-

jing as the winter solstice emissary in 1646, pursued the matter further. Kim presented a memorial to the throne expounding the need to adopt the new calendar. Officially, China prohibited exporting the new Western calendar Schall had produced; but Kim had arranged his interpreter as well as an official from the Bureau of Meteorology so that he could secretly learn the calendar from Schall. After a great deal of bribery, Kim was finally able to import the *New Western Calendar Book* in 1651 (the second year of Hyojong's reign).[27] It is not a coincidence that Kim Yuk was one of the first emissaries who had his portrait painted in China in the style of heavy shading that reflects Western influence. This shows another aspect of his interest in Western art and culture (chapter 2 discusses this further). The exact figure is unknown about how many books on Western learning were introduced to Korea from the mid-seventeenth century to 1801, the year the Chosŏn court launched the first major persecution of the Catholics, when books on Western learning were seized and burned.[28] Before this incident, in 1791, King Chŏngjo (r. 1776–1800), considered one of the most enlightened monarchs of the Chosŏn period, ordered the burning of twenty-seven books on Western learning that had been in the royal library, Kyujang-gak. It is certain that there was a steady flow of books from China through emissaries to Yanjing, and some scholars had these materials hand-copied in Korea for wider circulation.[29]

The *sirhak* scholar Yi Ik had never visited China, but he possessed a vast knowledge of Western learning through Chinese-translated books. He came from an illustrious family of scholar-officials. His grandfather, whose official title reached to the minister of the Board of Personnel, Sang-ŭi (*ho* Sorŭng; 1560–1624), traveled to Yanjing in 1597 and again in 1611. Yi Ik's father, Ha-jin (*ho* Maesan; 1628–1682), was also a high-ranking official who had traveled to China in 1678, bringing back many books of Western learning that had been translated into Chinese. Yi Ik and his two brothers, Yi Cham (*ho* Sŏmgye; 1660–1706) and Yi Sŏ (*ho* Oktong; 1662–1723), benefited from this vast collection. When he was forty, Yi Ik began to jot down what was to become the *Insignificant Explanation by Sŏngho* in thirty volumes. His interest in astronomy, science, and geography was prompted by his readings of books on Western learning that had been translated into, or compiled in, Chinese by such Western missionaries as Adam Schall, Manoel Diaz, Guido Aleni, Matteo Ricci, and Ferdinand Verbiest. Yi Ik's knowledge on the Western calendar as well as Western science and technology, including Ricci's *Map of the World,* made him newly aware of the existence of a civilization that was impossible for the Chinese to catch up with at this point. This revelation encouraged Yi Ik to change his attitude toward the grand tradition of Chinese culture. He thought, rather than maintaining the status of the so-Chunghwa, Korea should turn its attention to the outside world as well as to itself.[30]

Another *shirhak* scholar, Chŏng Yak-yong (*ho* Tasan; 1762–1836), who came about a generation later than Yi Ik, was very much influenced by Yi. Chŏng had not visited China, but his family was deeply into Christianity: his brother-in-law

was none other than Yi Sŭng-hun (Christian name Peter; 1756–1801), the first Korean to be baptized in Yanjing in 1783, along with his brothers Yak-jong and Yak-jŏn, who were baptized by Yi Sŭng-hun.[31] Although he was not baptized at that time, Chŏng Yak-yong was greatly sympathetic to Christian religion and Western science and technology.[32] Parts of his writings that concern the Western painting methods are examined in chapter 2. Among the books brought by traveling emissaries to Korea were Christian books with illustrations of realistic depictions of human figures and the convincing rendering of the pictorial space created by means of geometric perspective. For example, the list of twenty-seven books burned in 1791 included the *Chinjŏng sŏsang* (Presented book of the images of the savior), published in China in 1640, and *Chŏnju kangsaeng ŏnhang kiryak* (Life of the savior) by Father Giulio Aleni.[33] The former included three images of Christ—namely, Triumphant Entry of Christ into Jerusalem, Crucifixion of Christ, and Jesus on the Cross. *The Life of the Savior* is a Chinese version printed in 1635 with fifty-six plates of woodcut illustrations taken from Nadal's *Evangelicae Historiae Imagines,* with 153 engravings published by Plantin in Antwerp in 1593; this edition arrived in Nanjing in 1605.[34]

When Yi Sŭng-hun came back from Yanjing in 1784, he was recorded to have brought what is called *sangbon,* a model book of images. Most probably the book was some kind of a collection of Christian iconography. How widely these books had been circulated before the burning, and whether any of the copies survived the destruction, is not known. However, even in the form of the Chinese woodcut versions, the Chosŏn people were exposed to Western painting style to some extent. In chapter 2, we examine the gradual process of Western influence on the paintings of the late Chosŏn period within this historical and intellectual milieu.

2

WESTERN INFLUENCE ON KOREAN PAINTING

Literary Evidence of Western Painting
in Eighteenth-Century Chosŏn

In February 1645, Crown Prince Sohyŏn (1612–1645) came back to Korea after nine years of captivity in Shenyang and the Qing capital of Yanjing. His activities in Yanjing are known only through the report of Jesuit priest Adam Schall as the Crown Prince's own *Diary of Shenyang* (Simyang ilgi), which ends on August 18, 1644. According to the report, the Crown Prince visited the observatory in Yanjing several times and met with Schall. He showed great interest in the Western calendar and other Western science.[1] Their letters reveal that the Jesuit priest gave the Crown Prince books on the Western calendar and Western science as well as a globe and an image of Christ. The following is a part of the Crown Prince's letter of thanks to Schall: "You may not imagine how much I am grateful to you and happy about your gifts of the books on astronomy, and other Western sciences as well as the globe and the image of Christ. . . . Whenever we look at the image of Christ hung on the wall, our mind is filled with peace, and we feel cleansed of the dust of [the] mundane world."[2]

In the letter, the image of Christ was simply called *chŏnju-sang,* "an image of the lord." Most probably it was a painting because it was hung on the wall, although a small sculptural image could also have been hung on a wall. Whatever it was, this "image" was the earliest literary evidence of any Western artwork brought to

Korea before the eighteenth century. Because of King Injo's (r. 1623–1649) abhorrence of Christianity, as well as his hatred toward his son, Crown Prince Sohyŏn, Western learning was not pursued after the prince's sudden death in April 1645.[3] Interest in the Western calendar continued, however. From the early eighteenth century, successive Korean emissaries to the Qing court brought back with them books, engravings, and paintings of Western origin. They expressed their "shock" and "wonder" about things Western, be it painting, architecture, or astronomy that they had witnessed in Yanjing. Many of these emissaries left travel diaries in which their experiences were recorded in vivid detail. There are about fifty such "records of travel to Yanjing," or *yŏnhaeng-rok,* remaining today that serve as excellent sources of information on a broad range of cultural exchanges between Korea and China on the one hand and between Korea and the West via China on the other.[4] Some of these are one-of-a-kind literary pieces of eighteenth-century Korea, since the writers were all first-rate men of letters.

Chosŏn emissaries to Yanjing brought back Western paintings from China and hung them on the walls of the center hall, or *taechŏng,* of their homes. In his *Miscellaneous Writings of Sŏngho,* Yi Ik (*ho* Sŏngho; 1681–1763) describes this new cultural fad among scholar-officials:

> Recently, most emissaries to Yanjing brought back Western paintings and hung them in the center hall of their homes. When looking at these paintings, one should close one eye and, with the other eye, stare at them for a long time so that the buildings and the walls reveal their true shapes. Those who study these paintings in silence say, "This is due to the wonderful techniques of the painter. Because the distance between the objects is clearly described, one should look at the painting with only one eye." Even in China, this kind of painting never existed before.[5]

Despite these distinctive descriptions and thoughts upon seeing a Western painting, none of the Western paintings brought to Korea in the eighteenth century survive today. However, based on Yi Ik's remarks, one can imagine what sort of paintings the travelers saw and brought home at this time. These "new kinds of art" changed the way Chosŏn artists saw and represented nature, human figures, animals, and other objects. Yi Ik is also acknowledging the superiority of the Western painter's technique by saying that even in China this kind of painting "never existed before."

Besides this quotation, there is only scattered literary evidence of objects of Western origin that actually made their way into Korea. Chief emissary Yi Ŭi-hyŏn (*ho* Togok; 1669–1745), who visited Yanjing in 1720 on the occasion of the Qianlong emperor's birthday, later wrote his travel diary, *Kyŏngja Yŏnhaeng chapchi* (Miscellaneous records of travel to Yanjing in the cyclical year *kyŏngja,* i.e., 1720). The diary lists artworks he brought from the Qing capital, including among other Chinese paintings a scroll of Western painting.[6] Here, the numeral

word for the Western painting is *chok,* or that of a hanging scroll in China and Korea; it seems the piece was a vertically long painting to be hung on the wall.[7] Yi revisited Yanjing twelve years later and left another travel record, *Imja Yŏnhaeng chapchi* (Miscellaneous records of travel to Yanjing in the cyclical year *imja,* i.e., 1732). Here he mentions an encounter with Mr. Fei, a Western missionary, who gave him fifteen pieces (*p'ok*) of small and large paintings (perhaps engravings). No further detail is known about the contents of this group of paintings.[8] This time, the numeral word for counting the pieces is *p'ok,* or the unit for counting thin, flat material such as cloth or paper, a general term for counting paintings. Therefore, the art was most probably an assortment of engravings of landscapes or Christian themes, many of which were available in China at that time.[9]

Hong Tae-yong (*ho* Tamhŏn; 1731–1783), who went to Yanjing in 1765, visited the famous observatory that had been built by the Flemish Jesuit missionary Ferdinand Verbiest (Nan Huiren; 1623–1688). Hong recorded his conversation with the official Augustinus von Hallerstein (Liu Songling), writing: "At the end of our meeting, Liu said, 'Lately, there are no ships coming in [from Europe], so we are short of Western products to present to you in return.' And he gave me two pieces of small prints, woodblock printed book cover patterns, dried fruits, and two pieces of poison-sucking rocks. My companion Yi Tŏk-sŏng, the court meteorologist, also got the same gifts."[10]

Here the word for print is *inhwa,* or printed picture, which definitely refers to either engravings or woodblock prints. Given the dearth of existing specimens of Western prints that might have come to Chosŏn in the eighteenth century, an engraving by Adrien Collaert, "Healing the Leper," a page from Nadal's *Evangelicae Historiae Imagines* (1593) (fig. 5), mentioned in chapter 1, is cited here as a possible example of Western engravings available in China. Chinese painters of the late Ming and early Qing periods were impressed by the perspective, chiaroscuro, and lifelikeness of such Western engravings.[11] Under these circumstances, it is possible for Korean painters to have had access to such prints and perhaps tried some of the "marvelous" new techniques these prints or paintings displayed.

The final bit of literary evidence comes from a section of an official record from 1781, the *Diary of Royal Secretariat* (Sŭngjŏng'won Ilgi), during the reign of King Chŏngjo (r. 1776–1800). The king wanted his portrait painted, and as a reference for royal portrait painters, he asked Kim U-jin (his *cha,* or childhood name, is Sŏngrae; 1754–?) and Sŏ Ho-su (*cha* Yangjik; 1736–1799) to bring in the portrait of Kim's father. As recorded in the diary: "The King said, 'I heard that the portrait of Prime Minister [Kim Sang-chŏl] was painted by a Western painter. Is it true?' Kim U-jin answered, 'Yes, it is the one my father commissioned to a Western painter whom he met at the time of his visit to Yanjing as an emissary.' The King said, 'Prime Minister [Kim]'s portrait resembles the person, but the general shape [and size] looks too small.'"[12] According to this passage, in the Kim family a portrait of Kim Sang-chŏl (*ho* Hwasŏ; 1712–1791) by a Western painter

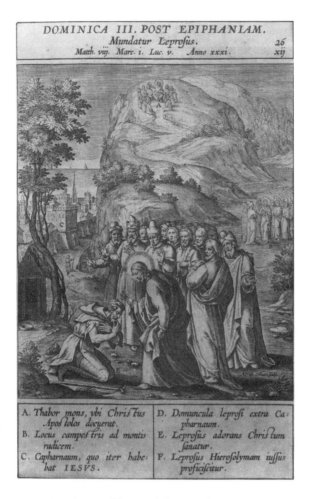

DOMINICA III. POST EPIPHANIAM.
Mundatur Leprosus.
Matth. viij. Marc. i. Luc. v. Anno xxxi.
26
xij

A. *Thabor mons, vbi Christus Apostolos docuerat.*
B. *Locus campestris ad montis radicem.*
C. *Capharnaum, quo iter habebat IESVS.*
D. *Domuncula leprosi extra Capharnaum.*
E. *Leprosus adorans Christum sanatur.*
F. *Leprosus Hierosolymam iussus proficiscitur.*

5 "Healing the Leper" from Nadal's *Evangelicae Historiae Imagines*, 1593. Engraving by Adrien Collaert.

had been kept that had been painted during Kim's visit as chief emissary to Yanjing in 1771. Kim had been sent to request the correction of the wrong entry on the Chosŏn royal line in the *History of Ming* (Mingshi). In 1781 he was admitted to the Club of Elders (*kiroso*), a highest honor for an official. Kim Sang-chŏl's portrait, now in the collection of the National Museum of Korea, seems to have been painted somewhat earlier than this date, however, as the sitter does not look like a man in his sixties.[13] Nor does this portrait reflect any of the new Western painting techniques as might have been evident had it been painted by a Western painter.

We now turn to the reactions of Chosŏn scholar-officials to the Western paintings they saw in Yanjing when they visited as emissaries. We also look at the responses of other Chosŏn scholars who never visited China but learned of Western astronomy, mathematics, the system of perspective, and painting through Chinese books on those subjects.

Yi Ki-ji (*ho* Iram; 1690–1722), the son of Prime Minister Yi I-myŏng (*ho* Sojae; 1658–1722) under King Sukchong (r. 1674–1720), accompanied his father when I-myŏng went to Yanjing in 1720. Yi Ki-ji left the "Record of Western Painting" (Sŏyanghwa-gi) in which he vividly described the wall painting in the Jesuit church in Yanjing.[14]

On the wall of the church, there is an image of the Christ. One person is standing amid the clouds wearing a red garment; several other persons seem to emerge or vanish into the clouds. Some of them are all naked, some exposing only the upper parts of their body, and still others stick only their faces out of the clouds. Also there are winged figures. Their eyebrows, eyes, mustaches, and hair all looked like those of living persons, their noses are high, their mouths, sunken, hands and feet, plump, and their garments hang loosely as if one can pull and bend. . . . At first, upon entering the hall and looking at the wall, it appeared as if there was a big niche on the wall that was filled with clouds and people, and I felt dizzy by illusions of ghosts and spirits that turned into phantoms. But upon closer examination, I realized that it was a painting on the wall. It is hard to say that human techniques reached up to such a high level. Also, the wooden members of the painted architecture cross one another, creating shadows, corners, sharp edges, and spaces so that one can turn around the corner and hide in the space behind. . . . There are myriads of birds, animals, fish, and insects, all drawn so precisely as if alive. Even down to the small creatures, such as butterflies and bees were depicted in their own distinctive shapes and colors, down to minute details that without the identifying labels next to them, one can easily tell what they were.[15]

Sadly, these wall paintings are all but gone now, so we cannot determine the accuracy of Yi Ki-ji's observations and descriptions. However, in a building called Zhuanjin-zhai, in the northeastern corner of the Forbidden Palace, are wall paintings (fig. 6) and ceiling paintings that apparently date from the first half of the eighteenth century, presumed to be the artworks by Jesuit missionaries with Chinese assistants.[16] These paintings show distinctive realistic rendering of flowers, birds, and architectural structures by means of chiaroscuro and geometric perspective. Yi Ki-ji's description of the north wall of the church is also quite vivid: "On the north wall, there was a door opened ajar through which a dog shoved its head, looking out. Upon closer examination, I realized that there was no actual door on the wall; it was just a painting of a dog looking out the door. The brush strokes and the coloring were not precise or minute, but it nevertheless was a painting. When I stepped back about ten feet from the painting, however, it appeared to be a live dog again. The space behind the door seemed so deep and far; a wondrous view as if the wall reflects [the images]."[17]

6 Wall painting, eighteenth century. Zhuanjin-zhai, Forbidden Palace (detail).

Upon seeing the wall painting that appeared so real, Yi wanted to make sure if it were a painting on the flat wall or an opened door with a dog. Apparently, he moved back and forth from the painting in amazement. Three-dimensionality, lifelikeness, and a sense of space are the typical traits of Western painting by which it earned the French label *trompe l'oeil*, or deceiving one's eye.[18]

A similar description of paintings in a church that had been rebuilt after a fire can be found in the travelogue of Yi Tŏk-mu (*ho* Chŏngjanggwan; 1741–1793), called "Ibyŏn-gi" or the "Record of Entry into Yanjing." Yi Tŏk-mu had visited Yanjing in 1778 to accompany Sim Yŏm-jo (*ho* Hamjae; 1734–1783), who had been sent to the Qing capital as an official in charge of diplomatic documents (*sŏjanggwan*). "On the right wall of the hall," Yi Tŏk-mu stated in the travelogue, "there was a small door that led to a narrow street. From the small door, I could see a picture of a big dog chained on the north wall. The dog looked frightening as though ready to attack and bite me. Under the picture, there were several live dogs lying in the shade. It was hard for me to distinguish a painted dog from a live one."[19]

Going back to Yi Ki-ji's writing, he describes a painting of a walled town with many houses: "This painting that depicts a walled town with houses measures only one or two feet high, but it looks as if one is overlooking the town from a high point, so the entire walled town comes into view at once. The houses and their roof-ridges were rendered with differing tones of ink so that the light and dark parts can be distinguished, and let the viewers discern readily the relative heights of the buildings and distances from one another."[20] We can imagine that Yi Ki-ji was looking at a painting of a walled town seen almost in a bird's-eye

view, with all the appropriate linear perspective rendering of the architectural elements and the use of atmospheric perspective. A realistic view of the city was created through these means.

Hong Tae-yong, who visited Yanjing in 1765, saw a wall painting in the northern hall of the observatory and recorded this description:

> While waiting for Mr. Liu and Mr. Bao, I looked around the paintings on the walls on both sides. Figures and a pavilion were all constructed of colors masterfully; the center of the pavilion was empty and concave, and pointed parts blend [into] one another nicely. Figures were moving and floating in the air as if alive. Above all, this painting excels in perspective; streams and valleys at times emerge or fade away; vapors and clouds at times shine or darken; even to the faraway limits of the sky, right colors were applied. Browsing through the painting, it reminded me of real scenery, while not realizing that I am looking at a painting.
>
> They say that the principles behind the Western painting are not only outstanding thoughts but also the laws of planning and dividing, which all come from mathematics.[21]

Particularly interested in Western math and geometry, Hong Tae-yong allocated a considerable portion of his writing to these subjects. He even tried computing the distance between the shoreline and a small rock off the shore by applying the principle of perspective.[22]

Hong was not the only one who showed keen interest in Western math and geometry. Scholars of the School of Practical Learning seemed to have been well acquainted with Euclidian geometry through its Chinese translation. It was possible for scholars who had never visited Yanjing to have had access to the novelty of Western learning. Yi Ik's interest in Western geometry and its relation to perspective drawings, as well as the painting of objects based on actual observation, is expressed here:

> These days, I am reading Euclid's *Geometry*, translated into Chinese by Li Madu [Matteo Ricci, 1552–1610]. There it says, "the function of geometry is to help represent on flat surface three-dimensional objects such as cylinder and cubic columns by correctly observing with one's own eyes and determining the distance, level, or the grade by applying light and shade. Geometry also helps one to be precise about measurements of distances and things in order to represent true shapes. It enables one to see big objects from the small representation, to see distant objects from the near representation, and to see a ball from a circle because the convexity and concavity are indicated. In depicting a building, some parts were painted light while others were shaded." Therefore, such paintings are nothing but the applying of techniques of concavity and convexity. But I have no idea what sort of methods were used to enable one to see large and far.[23]

It seems here that Yi Ik is trying to comprehend passages of Euclid's *Geometry* and understand the effect of the linear perspective system in which distances between objects in a painting are depicted as precisely measurable and the size of objects as gradually diminishing, due to the same principle. The Western technique of chiaroscuro was understood as the depiction of convexity and concavity.

Emphasis on actual observation seems to have been shared by the circle of scholars around Yi Ik. Yun Tu-sŏ (*ho* Kongjae; 1668–1715), the famous scholar painter and a younger contemporary of Yi Ik, left a *Self-portrait* (fig. 7) that shows an unusual degree of realism for that period, a clear testimony to the emphasis on actual observation as a result of Western influence. This portrait is fully dealt with in the next section.

By far the most well-known travel diary to Yanjing is *Yŏrha Ilgi* (Yehol diary), written by Pak Chi-won (*ho* Yŏnam; 1737–1805) during his trip to China in 1780. He was included in the retinue of his second cousin, Pak Myŏng-won (*ho* Manbojŏng; 1725–1790), who was sent to China to deliver King Chŏngjo's congratulatory message for the Qianlong emperor's seventieth birthday. Pak Chi-won's travel route included Shengjing (present-day Shenyang), Yanjing, and Rehe (present-day Chengde, Hebei), location of the Qing empire's famous Summer Palace.[24] His description of the wall and ceiling paintings of the Jesuit church in Yanjing was quite vivid, even to the point of being emotional. Such seems to have been the reaction of a sensitive belletrist.

> The figures and clouds on the walls and ceiling of the church seem hard to describe with usual written or spoken languages, also hard to figure out with ordinary mentality. There was some unknown force stemming from the eyes of the figure that tried to pull out my eyes when I was about to look at it. I abhorred the way the figures pry into my thoughts. When I tried to listen to something, they seemed to look at me from all directions and whisper something into my ear. I was afraid that they might find what I want to hide. When I was about to say something, suddenly they broke their silence and roared aloud like a thunder. Upon closer examination, rather rough strokes of ink were applied sparsely, and only the areas of their ears, eyes, noses, and mouths, and the body hairs, mustache, skin, and sinews were marked with thin brush lines. The features were represented with hair-splitting exactitude, and they look as if [they are] moving and breathing; their light and dark sides were well represented with the proper application of light and shade. In the painting, there was a woman holding a child of about five or six years old; the child squints at the woman with his sick face, and the woman turns away her head as if to avoid the child's eyes. On either side of the sick child there were five or six men looking down [on] the child, also turning their heads away from the pitiful scene. The chariot of the ghost, bombarded by flocks of birds, appears as if a bat was tumbling down. A guardian figure was stepping on the belly of a bird, and, with his iron bolt, was crushing down the bird's

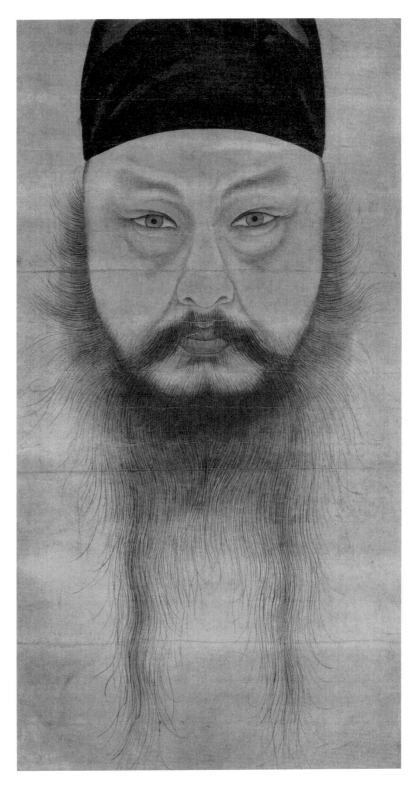

7 Yun Tu-sǒ, *Self-portrait,* early eighteenth century. Ink and light color on paper, 38.5 × 20.5 cm. Yun Hyǒng-sik collection, Haenam, South Chǒlla-do.

head. Some humans have wings coming out of their bodies, while others out of their heads. Such was the strangeness of the whole scene full of creatures I could not distinguish at all.

On the left and right side of the wall there were scenes of a summer day with lumps of clouds floating on the sky as if the sun was rising amid the valleys along with the rainbows. In the depth of the immeasurable space, ghosts and goblins of all sorts seem to fight each other; some of them look quite far away while others emerge closer from the depth of space. All of them appear to be floating with their backs against the sky, and creating winds. This spatial effect seems to have been created by the way the clouds were disposed at a certain interval.

When I looked up the high ceiling, numerous babies [*putti*] were playing amid the clouds of five colors as if suspended in midair. Their wrists and shins looked plump, their skin, warm if touched. Suddenly the viewers were struck with the sight of the falling babies, and stretched out their arms and pulled their heads back to receive them.[25]

Pak Chi-won's description of and reaction to the Western paintings he saw went beyond those of others. He thought those figures in the paintings not only looked alive but that they also interacted with the viewers physically and psychologically. Certain phrases—"they seemed to look at me from all directions, and whisper something into my ear," or "I was afraid that they might find what I want to hide"—show his extraordinary sensitivity. Pak Chi-won's observations also caught the painting style, which reminds one of any baroque oil painting where the rough brushstrokes can be seen upon closer look, but as one steps back, realistic rendering of the figure and costumes can be discerned with proper differentiations of light and dark areas (e.g., Franz Hals, *Portrait of an Officer,* 1640).

Pak's description of the ceiling painting with numerous *putti* floating in the air surely recalls typical baroque illusionistic ceiling frescoes such as the one in Saint Ignatius in Rome painted by Andrea Pozzo (1642–1709) between 1691 and 1694 (fig. 8). His vivid account of the immediate and instinctive reactions of his co-viewers who "stretched out their arms to receive the falling babies" is surpassed by no other. There seems to be no better way to describe the images. Pak's reaction, however, does not mean that he is acknowledging the superiority of Western painting technique. He also expresses his displeasure and confusion upon seeing things like the winged figures that do not exist in reality. This shows Pak's strong conviction as a scholar of the School of Practical Learning. His general negative attitude toward some aspects of Western painting notwithstanding, his "Record of Western Painting" remains one of the best pieces in the history of Chosŏn dynasty's literature.

Yi Ki-ji, Hong Tae-yong, and Pak Chi-won's accounts of the Western paintings they saw were mainly about those paintings' visual, technical, and artistic aspects. Early nineteenth-century Chosŏn scholars, however, were more inter-

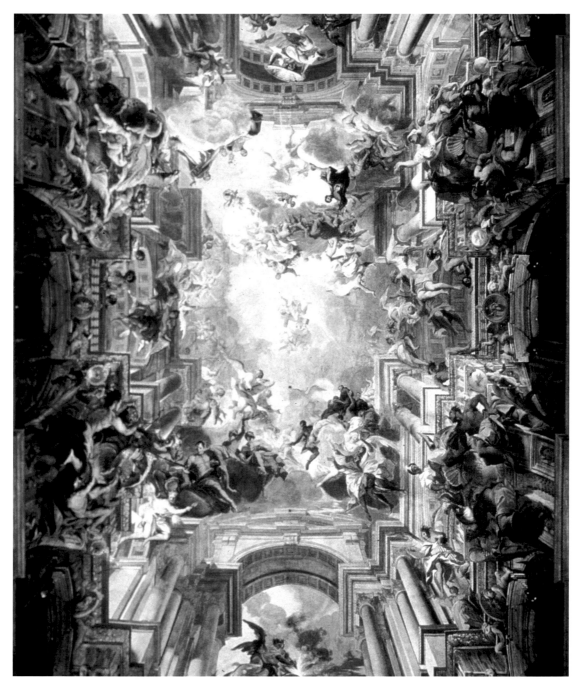

8 Andrea Pozzo, *The Glorification of Saint Ignatius*, 1691–94. Ceiling fresco. Saint Ignatius, Rome

ested in the scientific, optical, and material aspects of Western painting. Writings of scholars who belong to this category—namely, Chŏng Yak-yong (*ho* Tasan; 1762–1836) and Yi Kyu-gyŏng (*ho* Oju; 1788–1856)—are especially worth quoting. Chŏng Yak-yong, a scholar of the School of Practical Learning, was also representative as a scholar of Western learning. His interest in Western civilization was aptly shown in his planning and building of the fortified town of Hwasŏng in 1795 on the order of King Chŏngjo. Chŏng, for this task, consulted a Chinese book, *Yuansi jiqi tushuo luzui* (Illustrated explanation of far Western mechanical instruments: The most important items), published in 1627 in Chinese by the Swiss missionary scientist Joannes Terrenz (Deng Yuhan, 1576–1630) and a Chinese official, Wang Zheng (1571–1644). Based on his study of weight-lifting instruments in this book (better known by the abbreviated title *Jiqi tushuo*), Chŏng invented his own version of the machine, which was used in the construction of the fortress.[26] His interest in mechanical devices is highlighted in the following passage:

> There is a house situated between the mountain and the lake: The beautiful scenery of the sandy shoal and the mountain peaks are reflected on either side; the bamboos and trees form a forest, rocks and flowers form layers, and the pavilion and fences are obliquely connected. On a clear day, make a room pitch dark by closing all the windows and doors, leaving only a small hole on the wall. Take a lens and place it close to the hole, and also place a piece of snow-white paper [in the dark room] a few feet away from the lens. Then one will be able to receive on the paper all that is in the scenery described above. Not only the variegated colors of dark blue or light green, but also the dense or sparse look of branches and leaves, exact construction of forms, and the light and shade in the scenery will be exactly reflected on the paper. This way, a beautiful painting of the scenery was created. The minute details in this painting compare only to the thinnest of threads or hair, and far surpass those in paintings by Gu [Kaizhi] or Lu [Tanwei]; a wondrous sight under heaven! The only regret is that the painting cannot record the movement of branches by the wind, and also it is inconvenient as the image appears upside down.[27]

Judging from Chŏng's remark "the images appear upside down," we can conclude that the lens he placed on the hole was a concave lens. Here Chŏng is quoting *Yuanjing-ji* (On telescope), written in Chinese by Ferdinand Verbiest, originally written by Adam Schall and reworked by Verbiest. *Yuanjing-ji* was on the list of books brought to Chosŏn by Crown Price Sohyŏn in 1645. This experiment was visually spelled out in "On Optics" (*kwanglun*) in *Bowu xinpien* (The new edition of extensive knowledge) compiled by the British medical doctor Benjamin Hobson (Hesin, 1816–1873) and published in Chinese in 1855.[28] Figures 9 and 10 are from the "On Optics" section of the book. *Outside Scenery Projected*

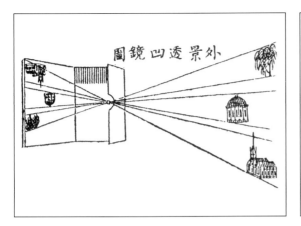

9 *Outside Scenery Projected through a Concave Lens* (Waijing tou yaoching tu). A page from He Xin's *Bowu xinbien*, 1855. Seoul National University Library.

10 *Small Insect Projected through a Convex Lens* (Chungxiang tou tieching tu). A page from He Xin's *Bowu xinbien*, 1855. Seoul National University Library.

through a Concave Lens (Waijing tou yaoching tu) (fig. 9) is a diagrammatic illustration of what Chŏng Yak-yong described, while *A Small Insect Projected through a Convex Lens* (Chungxiang tou tieching tu) (fig.10) shows an image of an insect enlarged when seen through a convex lens.

Interestingly, the author included "painting method" (*huafa*) among items that can be aided by all kinds of mechanical devices using lenses. From the relevant section of Hesin's compilation: "Western scholars conducted an in-depth research on the principles of light, and pursued its application [to other studies]. They considered light as a physical substance in the universe and analyzed its nature including colors. Magnifying glass, telescope, sun-reflecting glass, eyeglasses, and cameras were created by principles of light. These instruments bring minute exactitude in works of astronomy, painting method, and other material phenomena."[29] Chŏng Yak-yong considered it impossible to apply this method in the painting of a portrait, however, as the sitter could not sit as still as a clay figurine.[30]

Yi Kyu-gyŏng (*ho* Oju; 1788–?), a grandson of Yi Tŏk-mu, was also a well-known scholar of the School of Practical Learning. Yi Kyu-gyŏng, who was as much interested in Western science as Chŏng Yak-yong, was fascinated with the transparent and shiny surface of Western oil paintings. He wrote:

The so-called "Western paintings" that came from Yanjing are like the reflection in the mirror in their exactitudes. Therefore, the images look exactly the same as they are in reality and appear to be alive and moving. On the surface certain liquid was applied to make it as if a glass pane was placed, creating an effect of being iridescent; it also makes the colors and three-dimensional

forms in the painting break out from the surface. The viewers wonder if the images are real or painted. I have no idea what kind of liquid it is; perhaps a potion made by boiling herbs and Indian pink flowers. The transparent and glossy effect must have come from the repeated application of the liquid.[31]

Yi Kyu-gyŏng apparently noticed the glossy effect of varnish applied on the surface of an oil painting. There are several kinds of varnish in use, but the most popular used for oil painting since the Renaissance in the West is made from resin and linseed oil.[32] Yi's conjecture that this liquid might have been made by boiling Indian pink flowers and herbs stems from the fact that most of the materials and pigments used in East Asian painting at the time was made from the flora.

Sŏ Yu-gu (*ho* P'ungsŏk; 1764–1845), another mid-nineteenth-century scholar of practical learning, included a number of Western painting–related writings in the "Hwajŏn" (Painting basket) section of his encyclopedic compilation, *Imwon kyŏngje-ji* (Essays on rural life and economy), published around 1840.[33] Sŏ's "Painting Basket" contains several Chinese and Korean writers' passages on Western painting. In the "Boundary Painting" (*jiehua*) section, for example, there is a paragraph with a heading "On Western Painting Method" (*Non t'aesŏ-pŏp*), in which he discusses the methods of depicting a building precisely by exact measurement of the parts and the distance from the viewer, and by the application of light and shade. Sŏ was able to compose this paragraph by consulting several Chinese writers of the late Ming and early Qing periods.[34] From Korean works, Sŏ included Pak Chi-won's "Yanghwa" (Western painting), quoted earlier in the chapter.[35]

The impressions of Western paintings directly or indirectly experienced by Chosŏn scholars can be summarized thusly: figures looked as if alive, with their emotions and inner thoughts fully expressed; animals were depicted precisely, down to the single strand of hair; the three-dimensionality of depicted objects was achieved by means of applying light and shade; houses and buildings were rendered in perspective; a sense of space and distance was created by geometric as well as atmospheric perspective, resulting in differentiation of the size of objects according to the distance from the viewer; the sky was depicted in the right color (i.e., blue); and the varnish applied on the surface of oil paintings was scientifically analyzed.

Judging from Sŏ Yu-gu's compilation, by the mid-nineteenth century, Koreans had a great deal of knowledge about the characteristics of Western painting. By this time, Western painting methods and techniques were one of the options from which Korean painters could choose from. Some Chosŏn emissaries took court painters among their retinue for a number of reasons, such as having them copy paintings they saw or buy Chinese painting pigments. Along with the scholar-officials' observations and records on Western painting, it is not difficult to imagine that Chosŏn painters absorbed the new features of Western painting techniques and applied them in their own paintings.

Next, we examine Korean paintings of the late Chosŏn period that reflected Western influence. I examine portraiture, figure and genre paintings, animals, birds-and-flowers, *munbang-do* (or scholars' paraphernalia), popularly known as *ch'aekka-do* or *ch'aekkeri*, figures in landscape and architectural settings, and documentary painting.

Portraiture and Figure Painting

It is recorded that several Korean emissaries to the Qing court had their portraits painted by Chinese portrait painters. In 1636, as soon as the Qing empire was established, emissary Kim Yuk (*ho* Chamgok; 1580–1658) was sent to Yanjing for the occasion of the winter solstice. There he called on the painter Hu Bing (dates unknown) to paint his portrait, and he also had another painter, Meng Yung-guang (active in the first half of the seventeenth century), paint a small portrait.[36]

In 1712 emissary Kim Ch'ang-jip (*ho* Mong'wa; 1648–1722), who was sent to China on the same occasion as Kim Yuk, had his portrait painted by a certain Wang Xun (dates unknown). However, Kim's brother, Ch'ang-ŏp (*ho* Kajae; 1658–1721), who accompanied Ch'ang-jip, recorded in his travel diary that Kim Ch'ang-jip was not satisfied with his portrait because it did not resemble him.[37] In 1778, Sim Yŏm-jo (*ho* Hamjae; 1734–1783), who visited Yanjing as an official in charge of documents, had a portrait rendered of him sitting and reading under a blossoming plum tree by a professional painter, Zhu Shuzeng (dates unknown), at Yutiendian, where he stayed for a while. Sim Yŏm-jo was also unsatisfied because the painting did not resemble him.[38]

Kim Sang-ch'ŏl, cited earlier as an example of the literary evidence of Western painting, had his portrait painted by an unidentified Western painter in 1771. These Korean officials and those in their company seemed to have had high expectations of portraits that not only resembled the sitters but also reflected the new trend of painting in China with a touch of Western realism, which they had seen in the Qing capital. However, they were quite unsatisfied with the final product. Their dissatisfaction seems to stem from the basic quality of the portraits; the painters employed in these instances are quite obscure in Chinese history. Hu Bing is not particularly known for figure or portrait painting, and Wang Xun is not even recorded in any painting-related documents.[39] Among the three, Zhu Shuzeng was the only painter whose figure painting was reputed to be "elegant with no hint of vulgarity."[40] Nonetheless, there appear to be no surviving works by him today.

Of the two portraits of Kim Yuk, the one by Hu Bing portrayed Kim standing under a tall pine tree.[41] The painting measures 116 × 49.8 centimeters, but the composition was such that the face of the figure, including the bust, was about 7 centimeters high—too small to discuss the quality of the portrait. Therefore, it is better to examine the bust portrait by Meng Yungguang, which measures

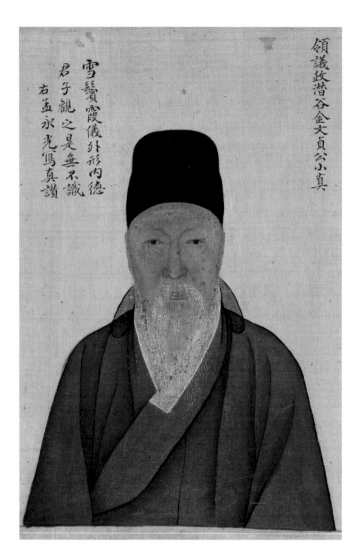

領議政潛谷金文貞公小真

雪鬢霞儀外形內德
君子觀之是無不識
右孟永光寫真讚

11 Meng Yongguang, *Portrait of Kim Yuk,* 1643 or 1644. Album leaf, ink and color on silk, 26.3 × 17.4 cm. Museum of Silhak, Namyangju, Kyŏnggi-do.

26.3 × 17.4 centimeters. Meng is relatively well-known in Korean art history, as he accompanied Crown Prince Sohyŏn in 1645 when the prince came back to Korea after nine years of captivity and stayed in Korea for about three years. In the National Museum of Korea there are several works by him, including landscapes and figure paintings.[42]

The *Portrait of Kim Yuk* by Meng Yungguang (fig. 11) is mounted as one of a leaf in an album along with other documents. Kim is portrayed as wearing a black hat with two drooping translucent flaps through which his shoulder lines can be seen; he is wearing a dark blue coat with a white-trimmed collar.[43] The

12 Meng Yongguang, *Portrait of Kim Yuk* (detail).

portrait is relatively in good condition, although there are some gray dots on Kim's face and beard; the portrait shows the artist's sensitive brushworks, especially in the depiction of Kim's eyes. The detail of this section (fig. 12) shows the eyes with thin double eyelids, the light red tear ducts, and the concentric lines on the eyeballs—all of which create an impression of a man deep in thought. Also noticeable in this portrait are the deep folds of the garment, created by the gradated shadings and occasional highlights that bring out the three-dimensional feeling of the sitter's upper body, which had seldom been seen in earlier portraits.

Moving into the early eighteenth century, let us examine several existing portrait paintings from the latter half of King Sukchong's reign. Some of them show definite features of Western influence in the way the faces show traces of shading and highlights on their protruding parts. A good example of this is the *Bust Portrait of Sin Im* (*ho* Hanjuktang; 1642–1725) in the National Museum of Korea (see fig. 3) by an unidentified artist. Although this particular portrait is undated, there is another *Portrait of Sin Im,* also in the National Museum of Korea (fig. 13), dated to 1719. A figure sits on a mottled bamboo chair, with an inscription identifying the sitter and his age (eighty-one). Sin's last official title was the minister of the board of public works, and before that, in 1718, he was admitted to the Kiroso (the Club of the Elders), an honor given to elderly high officials.[44]

The two portraits of Sin Im are very similar in the sitter's attire, facial features showing Sin's age, and above all the painting style. The bust portrait could be the preliminary stage work before the artist executed the seated full-length portrait,

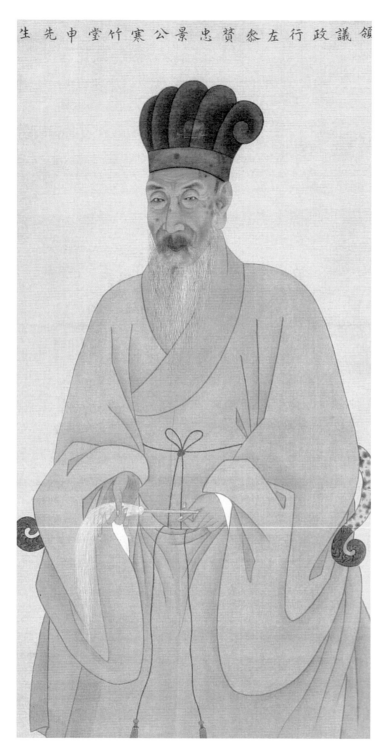

領議政行左贊忠景公寒竹堂申先生

13 Unidentified artist, *Portrait of Sin Im*, 1719. Hanging scroll, ink and color on silk, 151.3 × 78.1 cm. National Museum of Korea, Seoul.

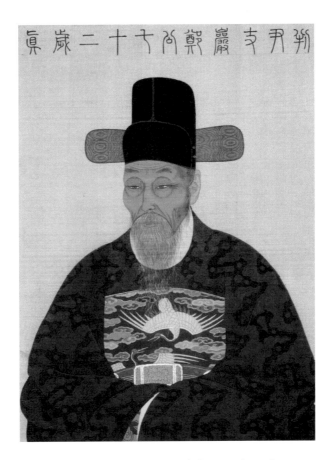

14 Unidentified artist, *Bust Portrait of Chŏng Ho*, date unknown. Ink and color on silk, 37 × 29 cm. National Museum of Korea, Seoul.

as only the face was given detailed shading and final line drawing while the garment was drawn simply with light brush lines. In both portraits the artist did not quite show his knowledge of shading according to a single light source, but he managed to emphasize the nose, eyelids, and the parts just above the eyebrows that protrude prominently by leaving those parts in light color. Sin's left ear was likewise given highlights to show its distinctive shape. Although the lower part of Sin's seated body was given more shading than the upper part, there is not much sense of the volume of his supposedly protruding knees. We can sense the presence of the knees by Sin's arms resting on them. Unlike most seated portraits prior to this, in which the sitter's hands are hidden inside the sleeves, this one shows Sin's hands holding a whip, signifying that he is a lay Buddhist. Inclusion of this detail tells more about the sitter and can be understood as a new phenomenon that could have come from the West.

The unusually dark treatment of Sin Im's face finds its echo in the *Bust Portrait of Chŏng Ho* (*ho* Chang'am; 1648–1736) (fig. 14). The inscription above the

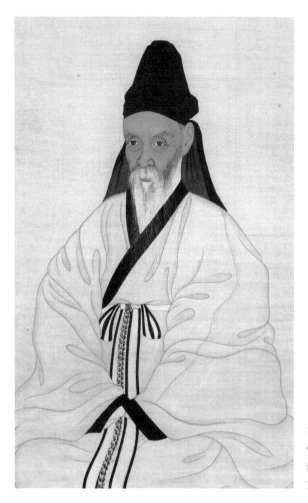

15 Unidentified artist, *Portrait of Yi Chae* (1680–1746). Hanging scroll, ink and color on silk, 97.0 × 56.5 cm. National Museum of Korea, Seoul.

portrait reads: "Portrait of Minister Chŏng Chang'am at the age of seventy-two" (Pansŏ Chang'am Chŏng gong chilsip ise jin). Thus it can be dated to 1720, around the same time as Sin's dated portrait. Chŏng, a scholar-official under King Sukchong, had a turbulent political career before he finally rose to the post of prime minister in 1725 under King Yŏngjo (r. 1724–1776) and was admitted to the Club of the Elders in 1729.[45] These three portraits all show, with differing degrees, dark shading and highlights, a definite change from Korean portraits of previous periods.

The technique of shading in these portraits reminds one of the contents of the "Letter to the Yanjing Painter Jiao Bingzhen" written by Kim Sŏk-ju (*ho* Sigam; 1634–1684) when the emissary saw his portrait that he had commissioned to Jiao Bingzhen (active in the seventeenth century) in 1682 during his visit to Yanjing. He wrote:

> My portrait you painted yesterday bears certain resemblance to me. However, please keep in mind the following when you paint my portrait next time. The

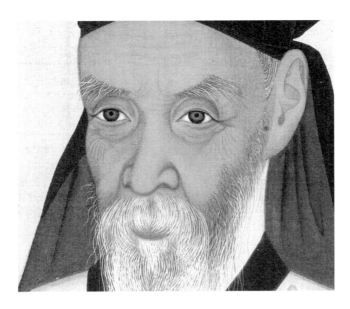

16 Unidentified artist, *Portrait of Yi Chae* (1680–1746) (detail).

way I look—eyes are thin slits, but not so thin as to hide the [eyeballs], and are rather shiny because they are where one's spirit appears concentrated. It looks like your technique is a bit short here. Please be careful not to make the face too dark to the degree not to be recognized as the same person. Yesterday, when you painted the portrait, all the doors and windows were closed so the room was rather dark. This situation resulted in the general darkness of the portrait. . . . Yesterday, you moved your brush repeatedly when you did the cheek, making it look darker. My face has an earth tone originally, so making it darker will distort the color; this should be avoided for sure.[46]

Kim expresses his dissatisfaction especially with the shading of his cheek, which the artist applied apparently to create an effect of three-dimensionality. The phrase "all the doors and windows were closed" indicates that the artist chose to have a single source of light rather than diffused light or multiple light sources to create the sense of volume of the sitter's face. But the sitter, unfamiliar with the technique, simply could not accept the result. Jiao Bingzhen was none other than the Qing artist who was serving at the Imperial Observatory along with Ferdinand Verbiest, the Jesuit missionary scientist who had taught Jiao the Western perspective technique.

The *Portrait of Yi Chae* (1680–1746) painted by an unidentified artist (fig. 15) is another good example of the eighteenth-century Korean portrait showing a definite trait of Western chiaroscuro. The detail of the portrait (fig. 16) shows that the right side of the sitter's face as well as the left side of the nose ridge were subtly but definitely darkened to create a sense of facial volume. The sitter's sunken

17 Kang Se-hwang, *Self Portrait*, 1782. Hanging scroll, ink and color on silk, 88.7 × 51 cm. Private collection, Korea.

18 Yi Myŏng-gi, *Portrait of Ch'ae Che-gong*, 1792. Hanging scroll, ink and color on silk, 80.5 × 121 cm. Ch'e Ho-sŏk collection, now in Suwon Hwasŏng Museum, Suwon, Korea.

eyes are depicted by applying different grades of shading around the eyes. The eyeballs themselves are done with three layers of concentric circles to bring out the sitter's spirited look. However, the sitter's body does not particularly look three-dimensional; only the minimum of shadings without any gradations have been applied in the folds of the drapery.

If these two portraits show a strong contrast of light and dark, the next set of two portraits exemplifies a different use of shading. In *Self Portrait* (fig. 17) by Kang Se-hwang (*ho* P'yoam; 1713–1791) and the *Portrait of Ch'ae Che-gong* (*ho* Pŏnam; 1720–1799) (figs. 18 and 19) by the court painter Yi Myŏng-gi (dates unknown), both of the late eighteenth century, the shading is subtle but enough to bring out the three-dimensional quality of the faces and the bodies. Kang, whose official title culminated with the mayor of Hansŏng (Seoul), had a chance to visit Yanjing in 1784 as the deputy to the emissary Yi Hui-ji (*ho* Nop'o; 1715–1785). After the trip Kang produced his *Album of Travel to China*.[47] However, he seemed to have had definite ideas about Western painting techniques even

19 Yi Myŏng-gi, *Portrait of Ch'ae Che-gong*, 1792 (detail).

20 Kim Tŏk-sŏng, *Wind and Rain God*, eighteenth century. Album leaf, ink and light color on paper, 28.2 × 41.5 cm. Private collection, Korea.

before his trip to China. He was known to have had contacts with Yi Ik, for whom he painted the handscroll *Tosan-do* when he was thirty-nine and Yi was sixty-two. Kang's interest in Western painting techniques was revealed in the following inscription he wrote on *Wind and Rain God* (fig. 20) by Kim Tŏk-sŏng (1729–1797): "[Kim's] brush and coloring methods show that he mastered the wonders of the Western painting techniques. Kim was known to have excelled in

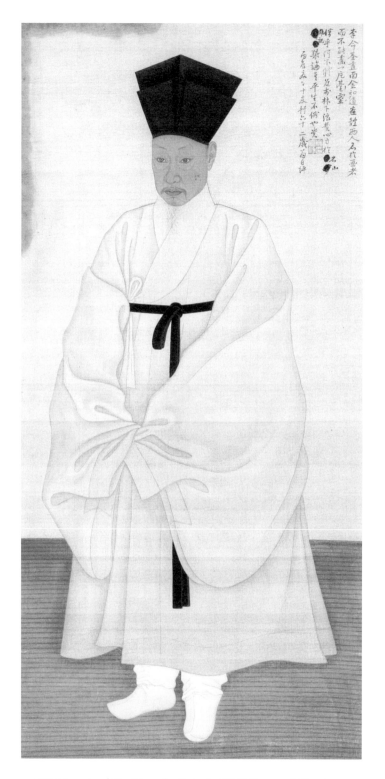

21 Yi Myŏng-gi and Kim Hong-do, *Portrait of Sŏ Chik-su*, 1796. Hanging
scroll, ink and color on silk, 148 × 73 cm. National Museum of Korea, Seoul.

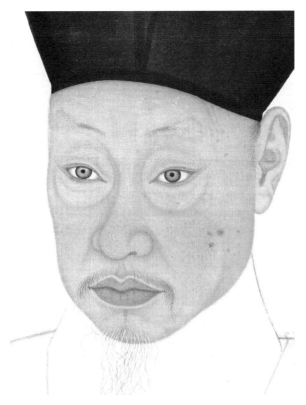

22 Yi Myŏng-gi and Kim Hong-do, *Portrait of Sŏ Chik-su*, 1796 (detail).

paintings of Buddhist deities, and the clouds in his *Wind and Rain God* display a definite sense of volume and weight due to his use of shading."[48]

According to the inscription written on the upper left of the *Portrait of Ch'ae Che-gong* by the sitter himself, King Chŏngjo gave Ch'ae the fan and the fragrance case attached to the fan by a string. In all the portraits of the scholar-officials, the sitters' hands are usually hidden under their long sleeves, but in this portrait Ch'ae's both hands are exposed to show off the two royal gifts. The rendering of the right side of his face with just a minimum of shading makes the face look three-dimensional, and the equally subtle shading on Ch'ae's light pink robe gives enough sense of bulk and displays the presence of the body underneath. Also, as can be seen in the detail of Ch'ae's portrait, the shading was applied between the fingers of the hands holding the fan, but the modeling of the hands looks somewhat awkward as the artist was not used to depicting hands in a portrait. However clumsy the shadings on fingers may look, the inclusion of hands as another means of "storytelling" for the sitter is definitely a new trend that became prevalent in Korea's late eighteenth-century portraits.[49]

In 1796, Yi Myŏng-gi collaborated with Kim Hong-do (*ho* Tanwon; 1745–1806), another court painter well known for his genre paintings, on the hanging scroll *Portrait of Sŏ Chik-su* (*ho* Sip'uhŏn; 1735–?) (fig. 21), a standing image of the scholar, for which Yi did the face (fig. 22) and Kim, the rest of the body. This time,

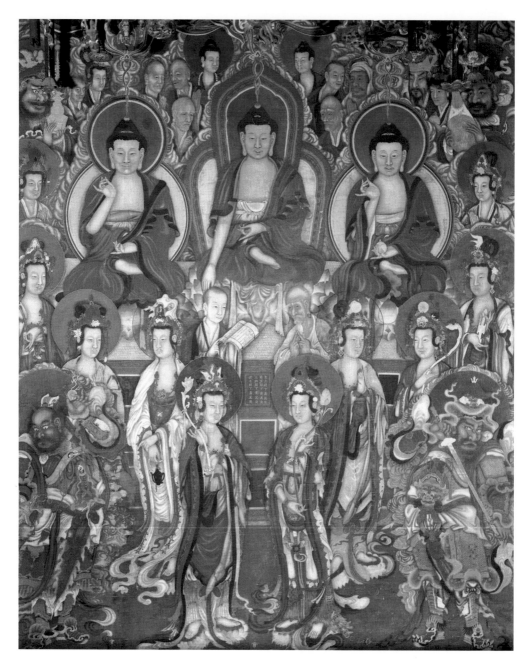

23 Attributed to Kim Hong-do and others, *Three Generations of Buddhas*, 1790. Hanging scroll, ink and color on silk, 440 × 350 cm. Yongju-sa, Hwasŏng, Kyŏnggi-do.

24 Attributed to Kim Hong-do and others, *Three Generations of Buddhas*, 1790 (detail).

Yi's use of shading is even subtler than the earlier portrait, showing no discernible transition of facial facets. Many elements come together to make this image appear alive and full of spirit: the feeling of the soft bulk of the nose, the rings around the eyes, the eyeballs with soft yellow coloring on the second rings (making them appear convex), and most of all the sensuous modeling and coloring of the lips. The rest of the body—covered by the warm ivory-colored silk coat tied with black sash that echoes the black hat—enhances the projection of Sŏ Chik-su's strong personality.

Kim Hong-do, with others, is said to have worked on the large Buddhist triad *Three Generations of Buddhas* (fig. 23)—Shyakamuni, Baishiajaguru, and Amitabha—that hangs behind the main seated Buddha image in the main hall of Yongju-sa, a temple in Suwon, Kyŏnggi. This temple was built on the order of King Chŏngjo to look after the tomb of Crown Prince Sado, the king's father.[50] Despite the fact that this painting was repaired extensively between 1912 and 1915, some scholars believe that the Western painting technique of chiaroscuro shown in this painting is evidence of Kim Hong-do's involvement in its production.[51] Kim visited Yanjing between 1789 and 1790, and most probably saw the Western-style paintings on the walls and the ceiling of the Jesuit church just before he was appointed to the supervisor position for the painting job.[52] The three seated Buddhas, standing bodhisattvas, and other figures all show quite realistic postures, proportions, and senses of volume. If we look closely at the guardian figure standing at the extreme left of the painting (fig. 24), however, we notice the bulging cheeks, nose, and eyes make him look ferocious—all achieved by the use of

chiaroscuro. No Buddhist paintings up to this time had displayed such heavy use of chiaroscuro. The monarch King Chŏngjo actively promoted the new cultural trends from China including these Western painting techniques, and Kim Hong-do was one of his favorite painters at the court painting bureau.[53]

Birds-and-Animals Painting

In Yi Ki-ji's description of the wall painting of the Jesuit church in Yanjing (quoted in chapter 1), he wrote that birds, animals, and insects were depicted in such exactitude that he could figure out all of their kinds. In eighteenth-century Korea, Pyŏn Sang-byŏk (*ho.* Hwajae; active in the eighteenth century) scored high as a painter of animals and birds. His contemporary, Yi Kyu-sang (1727–1796), wrote: "Pyŏn Sang-byŏk was a court painter. His paintings of cats look no different from live cats. People called him 'Pyŏn the Cat,' and only a few people know his real name is Sang-byŏk."[54]

In Pyŏn Sang-byŏk's *Cats and Sparrows* (fig. 25), a black and white cat turns his head around and looks up to the tabby holding onto the tree trunk; the tabby is on his way up to the tree branch where a flock of sparrows, in imminent danger, is in commotion. The scene's sense of liveliness had rarely been seen in Korean painting before. The modeling of the two cats was such that they look quite realistic: the turning motion of their necks, the fine depiction of the minute strands of fur, and the overall shading of their bodies contribute to the effect. The depiction of the old tree trunk with bold outlines and shading brings about its rugged texture and a sense of volume at the same time.

Also by Pyŏn is *Hen and Chicks* (fig. 26), in the National Museum of Korea today. The same degree of realism can be seen in the depiction of the domestic fowl. The mother hen is under a bulky *taihu* rock in a garden. From behind the rock juts out a stalk of rose above which butterflies and insects roam. The hen has found a cozy place near the rock and tips down her head to feed the chicks a fresh worm she holds with her beak. The eager chicks, six of them, have gathered around the mother's beak to try a bite of the worm. The rest of chicks are on their way, while two drink water from a shallow bowl. The contrast between the chicks' soft feathers and the mother's strong and shiny feathers is so effective; it brings out the sense of the hen's great bulk and the small soft bodies of the chicks. This painting comes close to Yi Ki-ji's description of the wall painting in the Yanjing church.

The realistic depiction of animals and birds in eighteenth-century Korean painting was gaining ground. This is evident in Kang Se-hwang's description of his own son's painting of a pheasant.[55] The painting, by Kang Sin (1767–1821), is described thusly:

> In April of the cyclical year *ŭlyu* (1789), someone presented a pheasant to the Hoeyang local administrative office. My son, Sin, painted the bird exactly the way it looked. Once there was [a painter] called Pyŏn Sang-byŏk who

25 Pyŏn Sang-byŏk, *Cats and Sparrows,* date unknown. Hanging scroll, ink and light color on silk, 93.7 × 43 cm. National Museum of Korea, Seoul.

26 Pyŏn Sang-byŏk, *Hen and Chicks*, date unknown. Hanging scroll, ink
and color on silk, 94.4 × 44.3 cm. National Museum of Korea, Seoul.

excelled in painting cats, to the extent that he earned the nick name "Pyŏn the Cat." Now it would be a shame if someone calls my son "Kang the pheasant," but that is not too far off. Therefore, one should avoid being an exceedingly good painter.[56]

Kang also left the following comment upon seeing his son Sin's copy of a painting of the moon shadow by a Western painter:

> Westerners invented a device called a telescope through which one can see objects one thousand *li* away. When one sees the heavenly bodies through this telescope, one can distinguish the shapes of the sun, moon, and all the stars, and realize that the Five Stars look all different from one another. This painting depicts the shadow on the moon, which looks as if [it is] moving. Since the olden days, the Chinese, not being able to observe correctly, said of the shadow, it looks either like the Guanghan-gung palace, or the shadow of a cassia tree, or like the shape of a bunny and a turtle milling. At first it was hard to tell what it was. Now they say it is only the shadow of the hills on the moon, but I am not sure if it is true. I would rather not talk about it. A Westerner, Tae Chin-hyŏn [Dai Jinxian, Ignatius Kogler], painted the *Heavenly Bodies* in which the moon shadow was depicted thus. My son Sin made a copy of it.[57]

Ignatius Kogler (1680–1736) was a German Jesuit missionary who served in the Qing Imperial Board of Astronomy. He was known to Korean scholar-officials as he once met with Kim Sun-hyŏp (1693–1732), a Korean emissary to Yanjing in 1729 in the Jesuit church there.[58] From these excerpts, we can surmise that Kang Sin, under his father's influence, pursued the Western manner of realistic depiction of objects based on observation. None of Kang Sin's paintings remain today to support his father's comments on them. It is interesting to note that Kang admired the Western scientific and realistic depiction of objects, but he expressed a negative and pejorative attitude toward the artisanlike precision. This is indicative of the conflicting attitude toward painting skills harbored by most of the literati painters of the late Chosŏn period.

Kang Se-hwang collaborated with Kim Hong-do on the *Ferocious Tiger under Pine Tree* (fig. 27) in the Collection of the Leeum, Samsung Museum of Art in Seoul. On the upper-right corner of the painting, there is an inscription that says "P'yoam [i.e., Kang Se-hwang] painted the pine," while on the lower-left edge there is a signature of Kim Hong-do reading "Sanŭng," one of his style names. Therefore, it is reasonable to believe that the tiger was painted by Kim Hong-do and the pine tree by Kang Se-hwang.[59] In the long and narrow format of the hanging scroll, Kim Hong-do positioned the tiger with its face frontal while the profile of the body curves around to show the animal's condensed power. Equally powerful feeling is created by the curving tail that forms a reversed "S." The tiger's

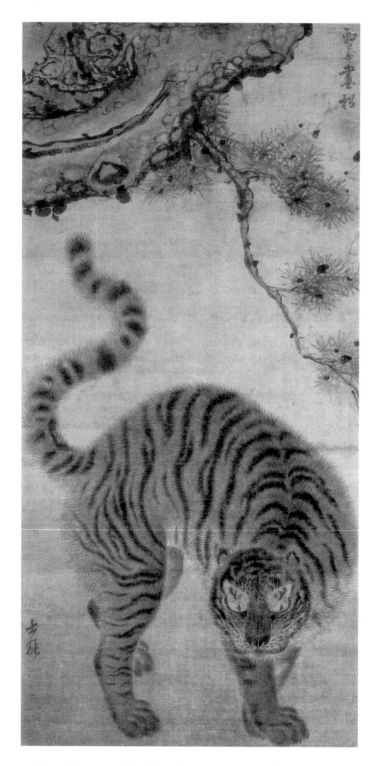

27 Kang Se-hwang and Kim Hong-do, *Ferocious Tiger under Pine Tree*, late eighteenth century. Hanging scroll, ink and color on silk, 90.4 × 43.8 cm. Leeum, Samsung Museum of Art, Seoul.

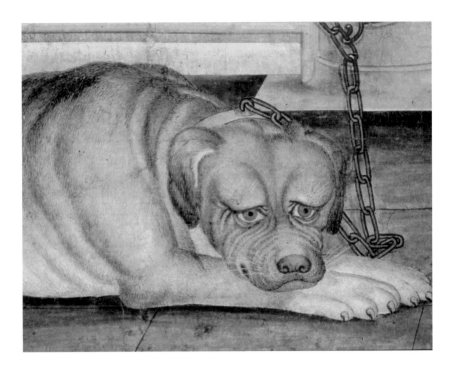

28 Unidentified artist, *Ferocious Dog* (detail).

soft and fine fur, the turning movement of the animal's spine, and its shiny, bright eyes are all realistically captured to the degree that far exceeds Pyŏn Sang-byŏk's cats. The rugged trunk of the pine tree that diagonally spans the upper part of the scroll with a drooping thin branch and a few bunches of pine needles complements the powerful presence of the tiger below.

A powerful and realistic image such as Kim Hong-do's tiger makes us understand why *Ferocious Dog* (see fig.4) in the National Museum of Korea came to bear a seal of Kim Hong-do reading "Sanŭng."[60] Here we recall Yi Ki-ji's remark in his Yanjing travel diary about the dog on the north wall of the Jesuit church in Yanjing that looked so real and alive. Yi Tŏk-mu, in his travelogue, said he could not distinguish the dog in the painting from the live dogs lying in the shade under the painting. His description of the "chained dog" is even closer to this *Ferocious Dog*. The space the animal occupies in this painting seems not so deep in actuality, but the skillful shading gives it enough depth for the dog's huge bulky body, whose effect is also achieved by proper shading and realistic depiction of the fur (this can be seen in the detail of the painting [fig. 28]). Even the dog's chain is depicted in such minute detail, creating a three-dimensional effect.

This series of animal paintings shows a gradual increase in the use of Western painting techniques imported from China. *Ferocious Dog* exemplifies the most mature stage in the employment of realism for depicting details, such as shading, to bring out the sense of space and the effect of three-dimensionality. Putting aside the problem of the authorship and the date of this painting, it is reasonable to believe

29 Yi Hyŏng-rok, *Ch'aekka-do,* date unknown. Eight-fold screen, ink and color on paper, 202 × 438.2 cm. Collection of Leeum, Samsung Museum of Art, Seoul.

that a painting such as this was possible in the Chosŏn art scene of the late eighteenth or early nineteenth century based on the documentary evidence of the presence of Western paintings as well as the knowledge of Western painting techniques.

Ch'aekka-hwa (Bookcase Painting)

Paintings of scholars' paraphernalia arranged in bookcases, called *munbang-do* or *ch'aekka-hwa* (or *ch'aekkŏri*), appeared relatively late as a genre of Korean painting. There are two types: the first displays books, brush and paper, and other scholar's paraphernalia in a vertical column without a case to hold them; the second type uses a wide bookcase to neatly arrange these materials on the shelves, such as *Ch'aekka-do* by Yi Hyŏng-rok (1808–?) (fig. 29).[61] Kim Hong-do was known to have painted the subject using the Western perspective system. Yi Kyu-sang wrote the following in his "Record of Painting Box" (*hwaju-rok*), a collection of biographical and critical comments on nineteen famous contemporary painters:

> Kim Hong-do's courtesy name is Sanŭng, his sobriquet, Tanwon. His career started at the court bureau of painting, and later, he was appointed to the position of a magistrate. He became a master of painting and was famous for his horse painting. He was also good at genre painting that depicted the contemporary customs and daily life. His genre painting is called "vulgar style" (*sokhwache*). . . . At that time court painters began to learn the Western perspective system. When one looks at a painting done in this perspective system, he should close one eye, and objects in the painting will appear to be neatly arranged [in space]. This kind of painting is commonly called *ch'aekka-hwa*, and it is always colored. Upper-class people of that time all had their walls decorated with it.[62]

30 Yi Sŏng-mi, perspective drawing of Yi Hyŏng-rok's *Ch'aekka-do.*

It is quite possible that Kim Hong-do also painted a bookcase screen for King Chŏngjo. The scholar-official Nam Kong-ch'ŏl (*ho* Kŭmrŭng; 1760–1840) stated that the king had a court painter paint a bookcase screen, which was placed behind his seat in his living quarters.[63]

Bookcase painting appeared relatively late in Korea's painting scene. One of the barometers for determining the appearance of a certain painting theme in the late Chosŏn period is the quarterly examination questions given to a group of painters called court painters-in-waiting at Kyujang-gak (*Kyujang-gak chabi taeryŏng hwawon*) as documented in *Naegak illyŏk* (Diary of Kyujang-gak). This diary, kept from 1779 to 1883, documented day-to-day affairs of the Kyujang-gak, also known as *Naegak*, or "cabinet" created by King Chŏngjo.[64] The records include the examination questions in the form of poetry as well as the examinees' names and their scores. Therefore, the entire 104 years of records show the trends of certain favored themes throughout the period as well as the names of painters associated with the themes they excelled at.

Court documents collectively known as *ŭigwe* also help us learn about the appearance of a new theme at a certain moment in Korean art history.[65] There are many categories of *ŭigwe* (royal weddings, court banquets, royal funerals, and so on), and they show what kind of screen paintings were used at which locations within the venues of the court events. According to the *Naegak illyŏk*, bookcase paintings first appeared as an examination question in 1784, and from 1864 on it appeared under the name *munbang* until the end of the dynasty. In the royal banquet–related *ŭigwe*, this kind of screen first appeared in a banquet held in 1827, to be placed around the seat of the crown prince.[66] The subject of *munbang*, or *ch'aekka,* is definitely a theme newly introduced to Chosŏn in the late eighteenth century with the introduction of Western painting techniques from China. Yi Hyŏng-rok's *Ch'aekka-do*, however, does not employ precise application of the one-point perspective system; the orthogonals do not converge on one point but at least on five points on the central axis of the screen, as seen in the diagramic

31 Attributed to Lang Shining (Giuseppe Castiglione), *Duobaogejing* ("treasure cabinet"),
date unknown. Panel, ink and color on paper, 123.4 × 237.6 cm. Private collection, Florida.

drawing I created (fig. 30). Nevertheless, Yi's *Ch'aekka-do* comes closest to making a viewer feel as if there were a bookcase filled with scholars' paraphernalia set against the wall of a room.

If we search for the origin of a Korean *chaekka-do* in China, we find a painting attributed to Lang Shining (Giuseppe Castiglione, 1688–1766), the Jesuit painter who served at the Qing court, called *Duobaogejing* ("treasure cabinet") (fig. 31). The painting depicts books and other scholars' paraphernalia neatly arranged in the shelved compartments of an open cabinet.[67] The shading and the perspective applied to this painting make it look as if the compartments that contain the objects show enough spatial depth to hold the objects. Another painting from the Qing period, *Duobaogejing-tu* (fig. 32), a folk painting, shows no three-dimensional space for the same kinds of objects: instead, the objects appear merely as a surface pattern arranged in rectangular divisions created by vertical and horizontal lines purporting to be the edges of shelves.

Lang Shining, being an Italian painter, was well versed in the Renaissance geometric perspective system, and he was also most probably aware of the *trompe l'oeil* technique seen on the wall of the Liberal Arts Studiolo at the Ducal Palace at Gubbio (fig. 33) in northern Italy, built in 1476. This Studiolo has been moved to the Renaissance Gallery at the Metropolitan Museum of Art in New York.[68] The wooden panels on the wall show open doors of the cabinet inside of which can be seen books and other items. A book stand placed on the protruding ledge of the lower part of the cabinet, and the two supporting columns of the ledge, were all done in the technique called *intarsia*—that is, inlay of darker-colored wood

32 Unidentified artist, *Duobaogejing-tu* ("treasure cabinet") folk painting, Qing dynasty, date unknown. Panel, ink and color on paper, 103.0 × 222.8 cm. Private collection, Beijing.

33 Liberal Arts Studiolo. Originally at the Ducal Palace, Gubbio, Italy, 1476. Inlaid wood, or *intarsia*. Now in the Renaissance Gallery, Metropolitan Museum of Art, New York.

pieced on the panel's lighter main part. The light and dark shading is so skillfully done that one really believes there is a wall cabinet with open doors and the cabinet has enough space to hold those items.

Yi Hyŏng-rok might have followed what Kim Hong-do had started several decades earlier. The art historian Kay Black has surmised that Yi Hyŏng-rok's grandfather, Yi Chong-hyŏn (1718–1777), was an older contemporary of Kim Hong-do, who transmitted the technique to Yi's son, Yun-min (1774–1841), who in turn, taught his own son, Hyŏng-rok.[69] About the bookcase paintings by Yi Yun-min and Yi Hyŏng-rok, nineteenth-century scholar Yu Chae-gŏn wrote the following:

> Painter Yi Yun-min's courtesy name was Chaehwa, and he was good at the painting of scholars' paraphernalia. Many of the screens and sliding doors decorated with the theme used in upper-class homes were painted by him. They say that there is no match for Yi in the high level of his paintings. His son, Hyŏng-rok, inherited the family tradition and produced wondrously precise scholars' paraphernalia paintings. I own several such screens in my home, and when people see them, they think that there are bookcases filled with books placed against the wall but soon, realizing that it is a painting, they just laugh. Such was the degree of preciseness and realism of Yi Hyŏng-rok's paintings.[70]

Like other court decorative paintings, *ch'aekka-do* became very popular in the nineteenth century even among the middle and lower classes. Simpler versions of this art form survive today that we now classify as "folk painting."

Figures in Landscape and Architectural Settings

Next we look at two paintings that are difficult to categorize under either figure painting or documentary painting. The first one, *Yŏnp'yŏng Relying on His Mother in His Childhood* (fig. 34) by Pak Che-ga (*ho* Ch'ojŏng; 1750–1805), is now in the collection of the National Museum of Korea. Pak Che-ga, a well-known scholar of Northern Learning (*pukhakp'a*, a branch of the School of Practical Learning), visited Yanjing three times (in 1778, 1790, and 1801) in his official capacity and had contacts with Western art and culture there. Therefore, it is not surprising to see the heavy influence of Western chiaroscuro in his painting.

The scene illustrated here is a story about Yŏnp'yŏng, the young son of a late Ming local ruler, Zheng Zhilong, and his Japanese mother. The setting, identified by Mount Fuji, which appears just below the inscription on the top left, is Japan, where the two lived.[71] The mountain peaks on the upper section of the painting show heavy shadings in their lower parts as well as the undersides of the strangely shaped peaks. They are placed against the blue sky with some white clouds. In the

34 Pak Che-ga, *Yŏnp'yŏng Relying on His Mother in His Childhood*, end of the eighteenth century. Hanging scroll, ink and color on paper, 214.0 × 49.5 cm. National Museum of Korea, Seoul.

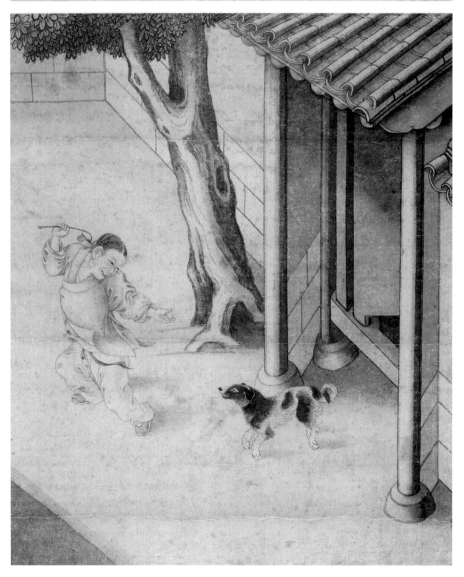

35 Sin Kwang-hyŏn, *Calling the Dog*, nineteenth century. Album leaf, ink and light color on paper, 35.3 × 29.5 cm. National Museum of Korea, Seoul.

lower part of the painting, Yŏngp'yŏng's mother is seated against a *taihu* rock, as heavily shaded as the mountain peaks. Notice the quasi-perspective system used in the drawing of the architectural setting. In this single piece, Pak sums up his knowledge of Western painting: the use of chiaroscuro, the perspective drawings, and the natural blue sky that appeared in Korean art as late as the mid-eighteenth century.

The second painting discussed here is *Calling the Dog* (fig. 35) by the nineteenth-century literati painter Sin Kwang-hyŏn (*ho* Chŏggam; 1813–?). The painting shows a boy and a dog in a shaded architectural setting, which can be understood as something similar to the shaded shelves of the *ch'aekka-do,* although the artist was seriously adhering to the single source of light for the entire painting. The columns that support the tiled-roof entrance to a house, the tree growing next to it, and the boy calling the dog were given light and shade according to the light source coming from the upper left side. As a result, these objects show highlighted areas on the left and the darkest area on the right, with gradated shadings in between. Even the bunch of tree leaves, at first individually delineated with thin brush lines, was given appropriate light and shade to display the sense of the foliage's thick bulk. The boy's gesture and the movement, turning back his head toward the dog, and the dog's running motion toward the boy are successfully captured with subtle shading on the boy's body and his wind-blown drapery and sash. Notice the shadows of the dog and the boy on the ground, an unusual feature in Korean painting up to that time. The lower left corner of the painting shows a triangular shaded area that perhaps represents the shadow of a structure outside the picture frame.

No other painting by Sin—known by a contemporary source to have been good at poetry, painting, and calligraphy—remains today.[72] The inscription above the painting is by Sin Kwang-hyŏn, who also signed the painting. This painting marks a distinct stage in the acceptance of Western influence in nineteenth-century Chosŏn painting. It is hoped that more of this artist's works will surface in the future to further our understanding of the Western influence at this time.

Documentary Painting

This section is intended to accomplish two objectives. First, since the majority of the documentary paintings of the late Chosŏn period depict court events, the paintings show palace buildings as a background—architectural drawings known as *kyehwa* (in Chinese, *jiehua*) or "boundary painting." For these, some form of linear perspective system was employed. Second, when an event took place outside the building, within the courtyard, the painting inevitably included a landscape background, which called for the application of the atmospheric perspective technique. With these techniques in mind, important documentary paintings of the late Chosŏn period are discussed here in chronological order.[73]

36 *Winding Covered Veranda of a Palace*, in *Jieziyuan huachuan*, 1679.

The primary goal of documentary painting is to record a particular event as precisely as possible. Therefore, all figures who participated in the event, and all the objects used for the event, should be accounted for in the painting. Because of these preconditions, documentary paintings in this period did not necessarily follow the new Western perspective system, presumably because the actual space would diminish as the parallel lines of the sides of a palace walls recede. In East Asian paintings, when architectural settings were depicted, the traditional practice was to show buildings seen from a slightly high viewpoint. Instead of using one-point perspective, the orthogonals were rendered parallel to each other so that the building interiors could be seen. Western scholars called this method "parallelism." A page from the most often used Chinese painting manual, *Jieziyuan huachuan* (Mustard seed garden manual of painting), originally published in 1679, explains this concept.[74] "Winding Covered Veranda of a Palace" (fig. 36) in the *Figures and Buildings* volume of the manual shows roof ridges and floor tiles as well as the top of the covered verandas with balustrades, all going parallel to each other, even in the buildings far removed from the foreground.

A mid-sixteenth-century Korean painting, presumably by a court painter, *Worship of the Buddha in Palace* (fig. 37), employed exactly the same principle of parallel perspective in the depiction of a palace seen slightly from above. The large building situated slightly to the left of the center in the background contains the triad: a seated Buddha in the middle and flanked by two standing images of

37 Unidentified artist, *Worship of the Buddha in Palace*, mid-sixteenth century. Handscroll, ink and color on silk, 46.5 × 91.4 cm. Collection of Leeum, Samsung Museum of Art, Seoul.

the Bodhisattvas. In the courtyard and in the side yard, there are red tables and figures, some of them preparing food. Other figures are seen inside the buildings as the whole scene is viewed from above. Because of parallel perspective, figures and objects in the background are depicted in the same size as those in the foreground. Yet the palace ground looks spacious.

This same perspective system continued to be used until the mid-eighteenth century in most Korean documentary paintings. However, there was a gradual change in the way buildings were depicted. In 1760 a historic event occurred in

38 *King Yŏngjo Presiding over Martial Arts Test at Mohwa-gwan,* leaf 3 of the album *Ch'ŏn kyech'ŏp,* 1760. Album leaf, ink and color on silk, 27.5 × 39.0 cm. Kyujang-gak Library of Seoul National University.

Seoul: the draining and the clearing of debris that had accumulated in Chŏnggye-chŏn, the stream that flows from the north to the east and south. This event was documented in a series of paintings collected in an album called the *Chunch' ŏn kyechŏp.* The term *kye* means "gathering of likeminded persons," and *ch'ŏp* means "album." In this case, the *kye* members were the group of high officials who participated in the draining event that had been ordered by King Yŏngjo. The officials wanted to commemorate their participation in this event and had the album made in multiple copies so that they each could own a copy.[75]

The third leaf of the album (fig. 38), now in the collection of the Kyujang-gak Library of the Seoul National University, depicts the scene of a martial arts test given by King Yŏngjo in Mohwagwan, an official establishment just outside of Seoul for receiving foreign envoys. A large tiled roof building with a tent in front of it can be seen in the background. The narrow building on the right side, which is supposed to be standing at a ninety-degree angle to the main building, is depicted obliquely nearly in a forty-five-degree angle toward the tent. Rows of tents and the standing guards in red garments on the opposite side form a line that veers toward the center approximately in the same angle as the building on the right. If we extend the lines, they will meet at a point somewhere above the tiled roof of the main building. Inside the tent, figures who are taking the exami-nation are seated in oblique rows on either side toward the small portable throne set in front of the screen of the five peaks, the symbol of the king's presence.[76] The

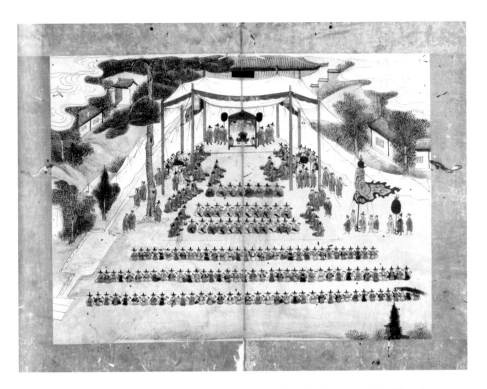

39 *King Yŏngjo Bestowing Gifts on His Subjects at Yŏnghwa-dang,* leaves 1 and 2 of the album *Subjects Presenting Poems,* 1760. Album of thirty leaves, ink and color on paper, each leaf, 37.3 × 24.8 cm. Kyŏngnam University, Masan, South Kyŏngsang-do.

group of figures includes the royal standard bearers in the wide open area, lined up according to the principle of the space-creating device of a quasi-perspective system.

What looks like a close-up image of the previous leaf can be found in another version of the album with the title *Subjects Presenting Poems,* now in the collection of the Kyŏngnam University. Here we find a leaf called "King Yŏngjo Bestowing Gifts on His Subjects at Yŏnghwa-dang" (fig. 39). The building in the background is a different one—this time, the Yŏnghwa-dang in Ch'angdŏk Palace, where the king participated in a ceremonial arrow shooting. Under the tent in front of the tiled roof of the Yŏnghwa-dang, the royal throne is placed in front of the screen of the five peaks, protected by three guards on each side. The six rows of seated officials and the throne ensemble form a triangular shape along with the white drapery on either side that creates a semi-enclosed area for the event. The sides of the small tiled roof buildings just outside the white drapery (the orthogonals in the perspective system) veer toward one point somewhere above the roof of the Yŏnghwa-dang.

The six rows of seated officials give an impression that they were depicted according to the perspective system as do the surrounding objects and buildings (the six rows form a trapezoidal form). But upon closer examination, one realizes

that only the lowermost two lines of thirty-eight figures show a small degree of diminution of the figure size; in the third line there are only thirty-three figures. In the fourth and fifth rows there are only thirteen and ten figures, respectively, and in the final row there are just eight figures. Also, the size of the figures, as they recede into the background, does not become smaller. On the contrary, the figures seated in profile near the throne were depicted larger than the others to emphasize the importance of those positioned near the king. This is in keeping with the spirit of documentary painting. Nevertheless, this leaf gives the viewer a sense of space similar to that in a painting done according to the principles of linear perspective.

Another late eighteenth-century Korean painting shows yet one more step forward toward creating the feeling of space through the adoption of Western perspectives. This one documents a trip by King Chŏngjo and his mother, Lady Hyegyŏng, to Crown Prince Sado's tomb in Hwasŏng and other scenes, including banquet scenes.[77] The iconography of this eight-fold screen called *Hwasŏng nŭnghaeng-tobyŏng* (Screen painting of the visit to the royal tomb in Hwasŏng) can be explained by a detailed record of this event in the form of *ŭigwe*, or the book of state rites.[78] Although the order of the eight panels is not the same, three versions of the same screen remain at present, one each in the collection of Seoul's National Museum of Korea and National Palace Museum as well as in that of the Leeum. In this discussion I adhere to the Leeum version of the screen, according to which the two panels under consideration are panels 7 and 8.

Panel 7, "Royal Retinue in Sihŭng Returning to Seoul" (fig. 40), depicts the long, meandering procession of King Chŏngjo's retinue returning to Seoul from Hwasŏng. The direction of the procession is from the top right to bottom left, and the procession bends nine times on its way to the Sihŭng Detached Palace, a compartment of the buildings on the bottom left, where the royal retinue is to rest a while. Since the highlight of the event is to celebrate his mother, Lady Hyegyŏng, and the sixtieth birthday that year of her husband, Crown Prince Sado, the procession's most grandiose part is that of Lady Hyegyŏng's palanquin and the guards in red uniform that appear on the upper part of the panel, just below the field with trees and rice paddies (fig. 41). Lady Hyegyŏng's large red palanquin has stopped for a while for her meal time rest (see the kitchen tent and the food cart below the guards). King Chŏngjo's royal horse has also stopped so that he can look after his mother's meal.[79]

The whole scene is set in a landscape background done in the traditional blue-and-green style. The hills and the rocks show a great sense of bulk as shadings have been applied appropriately. The clarity of the scene in the lower part of the panel gives way to fussiness as it goes to the topmost part of the panel, where one does not see the bright green colors as on the foreground hills. The size of the figures of the royal procession itself, although not very accurately diminishing, nevertheless does show difference between smaller figures in the upper part and bigger ones in the lower part. The onlookers, seated or standing, were kept strictly outside the royal retinue and are depicted in slightly smaller size than the

40 *(left) Royal Retinue in Sihŭng Returning to
Seoul*, panel 7 of the *Screen of King Chŏngjo's
Visit to His Father's Tomb in Hwasŏng* (Hwasŏng
nŭnghaeng tobyŏng), 1795. Eight-fold screen,
ink and color on silk, each panel 142 × 62 cm.
Collection of the Leeum, Samsung Museum of
Art, Seoul.

41 *(above)* Upper part of panel 7, *Hwasŏng
nŭnghaeng-tobyŏng,* 1795. Collection of the
Leeum, Samsung Museum of Art, Seoul.

guards and standard bearers both for practical reasons and for hierarchical dif-
ferentiations. Without the concept of Western perspective systems, both linear
and atmospheric, this grand composition might not have been possible. Kim
Hong-do, who oversaw the Buddhist triad painting in the main hall of Yongju-sa
discussed earlier, is also recorded to have overseen the design of the woodblock
illustrations of the *Wonhaeng ŭlmyo chŏngri ŭigwe* (Book of state rites for King

42 *Pontoon Bridge at Noryang-jin
Ford*, panel 8 of the *Screen of King
Chŏngjo's Visit to His Father's Tomb
in Hwasŏng* (Hwasŏng nŭnghaeng
tobyŏng), 1795. Eight-fold screen,
ink and color on silk, each panel
142 × 62 cm. Collection of Leeum,
Samsung Museum of Art, Seoul.

43　*Pontoon Bridge at Noryang Ford*, in the *Book of State Rites for King Chŏngjo's Visit to His Father's Tomb in Hwasŏng in the Ŭlmyo Year* (Wonhaeng ŭlmyo chŏngri ŭigwe), 1795.

Chŏngjo's visit to his father's tomb in Hwasŏng in the *ŭlmyo* year, 1795), which served as the basis of this screen painting.[80]

Panel 8, "Pontoon Bridge at Noryang-jin Ford" (fig. 42), depicts the bridge over the Han River at Noryang-jin, where the royal procession was to cross the river. Here it is helpful to see the woodblock illustration of the same bridge in the *Book of State Rites for King Chŏngjo's Visit to His Father's Tomb in Hwasŏng in the Ŭlmyo Year* (1795) (fig. 43). The pontoon bridge is placed in such a way that its entire length can be accommodated in two adjoining pages of the book. The two sides of the bridge will meet at some point over the river as the bridge narrows in the far distance toward the complex of buildings called Yongyang-bongjŏ-chŏng (Pavilion of wiggling dragons and flying phoenix) in Suwon.[81] The part of the bridge near the bottom of the page is Noryang-jin in Seoul. Because of the wide format of the two pages of the *ŭigwe* book, it was possible to render the bridge in perspective to create the full sense of distance.

The format of the screen panel is long and narrow, not allowing enough room to show the narrowing of the bridge at the top of the panel. However, there are other distance-creating devices the artist employed. The distant scene is considerably dimmed compared to the foreground as a result of the atmospheric

44 *Banquet for the Elders in Naknam-hŏn*, panel 1 of the *Screen of King Chŏngjo's Visit to His Father's Tomb in Hwasŏng* (Hwasŏng nŭnghaeng tobyŏng), 1795. Eight-fold screen, ink and color on silk, each panel 142 × 62 cm. Collection of Leeum, Samsung Museum of Art, Seoul.

perspective applied to the scene. Also, the ripples on the river's surface become smaller and dimmer as it recedes in the background. Likewise, figures in the foreground are considerably bigger and crisply rendered to create a definite sense of distance from one end of the bridge to the other. Although these two last panels of the screen depict outdoor scenes exemplifying Western painting techniques, other panels of the indoor scenes adhere to the old parallel perspective, where the two sides of the buildings are parallel to each other. This way, all the figures in the event can be clearly visible in equal size and clarity. For example, the first panel that depicted the "Banquet for the Elders in Naknam-hŏn" (fig. 44) of the Hwasŏng Detached Palace shows no sign of Western perspective in the rendering of the architecture. At the end of the eighteenth century, it was therefore up to the individual Chosŏn artist to choose from the traditional parallel perspective or the new Western perspective systems depending on the theme and the importance of the figures.

One of the most popular themes of the documentary painting of the final phase of the Chosŏn kingdom and the Taehan cheguk (the Great Han empire)

period (1897–1910) was the royal banquet.[82] High officials who participated in various royal banquets wanted to have proof of their participation in the form of *kyebyŏng*, a screen painting commemorating the event to be shared among the participants. Therefore, many of the screens that depict royal banquets of the nineteenth and early twentieth centuries remain today in multiple copies. These banquets took place inside the royal palaces of Seoul, usually with a large tent pitched in front of the main buildings of the palaces, where wooden platforms had been temporarily constructed to accommodate the large number of officials and guests. The depiction of the palace buildings, as well as various items used in the banquets such as large drums and other percussion instruments hanging from stands, called for space-creating devices.

These large-scale banquet screens typically consist of eight or ten panels, with the last one recording the date and the names and the titles of the high officials of the superintendency (*togam*) which oversaw that particular banquet.[83] The first six or eight panels are divided into three or four pairs, each of them accommodating a palace building and the extended floor areas and sometimes the covered enclosure around the building. The ninth panel also contains a banquet scene, even though it is usually rendered small and narrow.[84] The banquet screen that serves as an example of this format is the *Screen of Royal Banquet of the Cyclical Year Musin* (*Musin Chinch'an tobyŏng*) of 1848, which shows a banquet held in Ch'angdŏk Palace.[85] The first two panels (fig. 45) depict the congratulatory rites (*chinha*) held in the Injŏng-jŏn, or the throne hall of the palace in which the officials congratulated King Hŏnjong (r. 1834–1849) for the double happy occasion of the banquet. At the bottom of the panel is the Injŏng-mun (Injŏng Gate), from which the tiled roof–covered walk starts to enclose the entire front part of the Injŏng-jŏn compound. The stately Injŏng-jŏn occupies the top part of the panel. Clouds obscure the scene beyond the roof of the Inchŏng-jŏn only to expose the tips of the pine trees.

The gate and the main throne hall are rendered in full frontal view, while the covered walk on either side shows a combination of the bird's-eye and profile views that allow seeing the columns along the covered walk. Three rows of soldiers encase the officials on the ground, and two additional rows of honor guards in red and white uniform each holding their own appropriate banners and ceremonial weapons stand near the covered walk. The orthogonals in the linear perspective system in this painting consist of these rows of figures and architectural structures. If extended to the back, they will meet at some point above the roof of the Inchŏng-jŏn, outside the painting panel. Nevertheless, as a result of the application of linear perspective, the whole scene looks very spacious and well organized.

Interestingly, two different approaches to perspectives were used by the artists of these respective screens. This is revealed by a comparison of a detail showing the arrangement of the large drum and the suspended musical instruments on the lower left of the first panel (fig. 46) with the same group of instruments from an earlier screen—namely, the 1829 *Kich'uk chinch'an tobyŏng* (Royal banquet screen of the cyclical year *kich'uk*) (fig. 47).[86] In the 1829 detail the large drum is

45 Panels 1 and 2 of the *Screen of Royal Banquet of the Cyclical Year Musin* (Musin chinch'an tobyŏng), 1848. Eight-fold screen, ink and color on silk, each panel, 136.1 × 47.6 cm. Chŏnju National Museum.

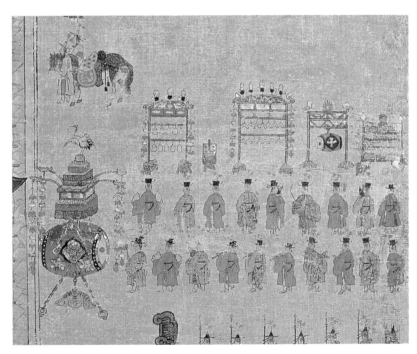

46 *(top)* Detail showing percussion instruments, panel 1 of *Screen of Royal Banquet of the Cyclical Year Musin* (Musin chinch'an tobyŏng), 1848.

47 *(bottom)* Detail showing percussion instruments, panel 3 of *Screen of Royal Banquet of the Cyclical Year Kich'uk* (Kich'uk chinch'an tobyŏng), 1829. Eight-fold screen, ink and color on silk, each panel, 149.0 × 51.7 cm. Collection of Leeum, Samsung Museum of Art, Seoul.

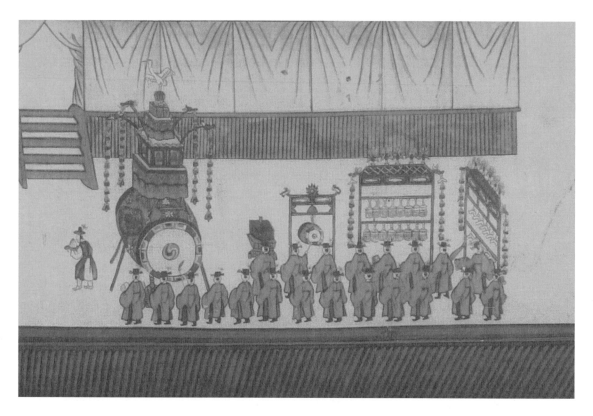

48 Detail showing percussion instruments, panel 3 of the *Screen of Royal Banquet of the Cyclical Year Chŏnghae* (Chŏnghae chinch'an tobyŏng), 1887. Ten-fold screen, ink and color on silk, each panel, 146.7 × 50.42 cm. National Museum of Korea, Seoul.

shown almost strictly in frontal view, although the round side of the panel is seen as a flattened oval shape, and all other frames of the four hanging percussion instruments are arranged in one row, strictly in frontal view. The large drum in the 1848 screen is placed obliquely so that we can see the round end in full and the body of the drum is seen receding to the back. The same is true with the small drum suspended from the frame. The hanging frame for two rows of instruments called *kyŏng* is placed obliquely so that the viewers feel a sense of space.

Although the foreshortening for the two drums is not entirely successful, the whole arrangement of the instruments receding into the background does create a sense of spatial depth that was absent from the 1829 screen. Banquet screens that follow the 1848 screen would always show the same spatial arrangement of the drums and the frames for percussion instruments. A detail from the third panel of the *Screen of Royal Banquet of the Cyclical Year Chŏnghae* (*Chŏnghae chinch'an tobyŏng*) of 1887 (fig. 48) showing the same instrumental group serves as a visual record of the late nineteenth-century handling of the drums and other instruments in space. This is an advancement in technique and understanding of the problem from the earlier screens.[87]

The Influx of Foreign Forces and Their Impact
on Turn-of-the-Century Korean Art

The Korean political and cultural scene at the turn of the century is too extensive to explain fully here. However, some background is necessary to understand the changes that took place during this final phase of the Chosŏn dynasty. Because the last king of Chosŏn, King Kojong (r. 1863–1907), was only twelve years old when he was crowned, his father, Yi Ha-ŭng (1820–1898), took power as the regent. Known in Korean history as the Hŭngsŏn Taewongun, he conducted a series of bloody purges on the Catholics from 1864 to 1866, causing the death of more than seventy-five hundred converts. Nine French Catholic priests were persecuted during these years. In retaliation, the French government sent a naval ship to Kanghwa-do, the island at the mouth of the Han River, near Seoul. Although the French were defeated, this incident inflicted considerable damage on the Chosŏn kingdom.[88] This incident is known in Korean history as Pyŏng'in yang'yo (Disturbance by Westerners in the cyclical year *pyŏng'in*, 1866).

Also in 1866, crew members of the American schooner the *General Sherman* were killed by Koreans in P'yŏngyang. The United States Navy returned in 1871 to retaliate by invading Kanghwa-do, causing much more damage than the French had. This invasion is called the Sinmi yang'yo (Disturbance by Westerners in the cyclical year *sinmi*, 1871). Such threats from Western powers led the Hŭngsŏn Taewongun to declare a policy of isolation in 1871. However, this move was clearly against the rising tide of internationalism throughout East Asia. Qing China was being pried open in the wake of conflicts with Western powers, and Meiji Japan had instituted an open-door policy. Needless to say, there were progressive young scholar-officials who opposed Korea's isolation policy. Gradually, Japan and the Western powers forced Korea to sign diplomatic and commercial treaties—with Japan in 1876, and with the United States in 1882.

Other major incidents include the Military Mutiny of 1882 (*imo gullan*); the Tonghak Rebellion/Movement of 1893–94; the Sino-Japanese War of 1894, which was mostly fought in Korea; the reform of the cyclical year *kabo*,1894 (*kabo kyŏngjang*); the assassination of Queen Min, who was the pro-Chinese and pro-Russian wife of King Kojong; Kojong's flight to the Russian Legation in 1896; and the birth of the Independence Club (Tongnip hyŏphoe) that same year. The club was headed by Dr. Sŏ Chae-p'il (1864–1951), who urged Kojong to declare himself emperor of Korea after his return from the Russian Legation. Kojong did this in 1897, changing the name of the dynasty from Chosŏn to Taehan Cheguk (the Great Empire of Han). The name of South Korea today, Taehan Min'guk (the Republic of the Great Han [People]), is derived from this. Meanwhile, the conflict between Japan and Russia culminated into the Russo-Japanese War of 1905, which ended with Japan's victory. After the war, Japan forced Korea to sign the Protectorate Treaty of 1905 (the Ŭlsa choyak) and gradually extended its domi-

nance over all of Korea. This naturally triggered patriotic Koreans to fight against Japanese imperialism and call for independence. They formed righteous armies (ŭibyŏng) to fight against the Japanese. Emperor Kojong was forced to abdicate in 1907, and his son, Sunjong (r. 1907–1910), succeeded him as emperor for the empire's final three years until Japan annexed Korea in 1910, putting an end to 518 years of Chosŏn rule.

Under such national and international circumstances, the sources of Western influence on Korean painting, hitherto confined to China, began to be diversified. There were several painters of Western origin who visited Korea and left paintings, mostly portraits. These include an Italian painter whose name is not known, who painted a portrait of the scholar-official Kim Kyu-hŭi (1857–?) in 1895; and an American painter of Dutch origin, Hubert Vos (1855–1935), who painted Emperor Kojong's portrait (fig. 49), as well as that of Min Sang-ho (1870–1933) (fig. 50), a well-known diplomat at the court of Emperor Kojong (Vos and his paintings are discussed in detail below).[89] Other artists who left their mark in Korea include a French ceramicist and painter from Paris known as Rémion who was invited by the court to help establish a crafts academy in Seoul; the English painter-traveler A. Henry Savage Landor (1865–1924), who was known to have visited Korea in 1890; and the Scottish female painter Constance Taylor, who was in Korea in 1894.[90]

Added to the presence of the Western painters in Korea, from the early 1880s, photography was introduced from Shanghai and Tokyo, which contributed greatly to the improvement of realism in portraiture. In 1883, Hwang Chŏl (1864–1930) came back from Shanghai, where he had learned photography techniques from the Chinese photographer Zuo Shaoren. Soon he operated a photo studio in his house in Seoul and commercially produced portraits, cityscapes, and landscapes. Kim Yong-won (1842–1935) and Chi Un-yŏng (1851–1935) brought photographic equipments from Tokyo, and Chi became the first photographer to take a portrait photo of Emperor Kojong.[91] As the photography produced perfectly realistic portraits, Hwang Chŏl thought that it was anachronistic to train court painters to produce images that were less than realistic. He even presented a memorial to the throne to abolish the court bureau of painting and to teach the painters the art of photography instead.[92]

Another event that brought about a fresh approach to perspective drawings in Korea was the education of painters in the drawing of machinery in Tianjin. In 1881 the Korean government sponsored the study abroad of the sixty-nine engineering students at the Western Arsenal of the government. Led by the official (Yŏngsŏn-sa) Kim Yun-sik (1835–1920), the students were sent to Tianjin to learn the methods of constructing and operating modern machinery. Among them were the court painters An Chung-sik (1861–1919) and Cho Sŏk-chin (1853–1950), whose chief assignment was to produce the drawings of the new Western machinery. They were the first artists to learn the three-dimensional drawing methods, which no doubt included the linear perspective systems. Therefore, it

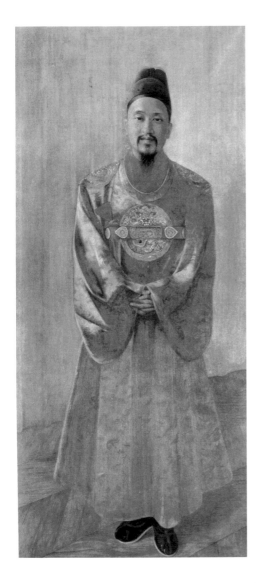

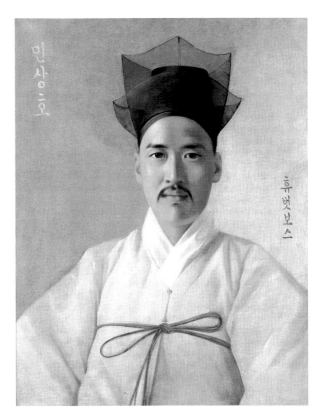

49 *(left)* Hubert Vos, *Portrait of Emperor Kojong*, 1899. Oil on canvas, 198.9 × 91.8 cm. Private collection.

50 *(above)* Hubert Vos, *Portrait of Min Sang-ho*, 1899. Oil on canvas, 76.2 × 61.0 cm. Private collection.

is reasonable to assume that the court documentary painting during the Taehan empire would reflect the more advanced stage of perspective systems.

Also during this period the chemically produced pigments, or the aniline dye, began to be imported and used extensively in almost all painting genres. The red, green, and blue colors in paintings toward the end of the nineteenth century and later tend to be stronger and brighter than those from earlier years. There is documentary evidence to support the appearance of these new chemically produced pigments. In the *Book of State Rites for the Copying of Royal Portraits*, dated to 1900, there is a list of pigments that had been used for the copying of King T'aejo's portrait; the list includes new pigments not mentioned until this time. The new pigments—*yangju* (Western red), *yangnok* (Western green), and *yangchŏng* (Western blue)—were stronger and brighter than the traditional pigments. In the names of these colors the first syllable, *yang*, means "the West." It

is certain that these new pigments were a result of the aniline dye invented in Britain in 1856 by chemist William Henry Perkin.[93]

Exactly when they reached Korea is difficult to pinpoint. However, we find the following passage in the 1874 *Veritable Records of King Kojong*: The king said, "pigments such as *yangchŏng* and *yanghong* [Western red] being used lately belong to Western goods. Since their colors are not right, we should strictly forbid their use."[94] From this, one can surmise that the new pigments came to Korea not too long after their invention in Europe. It is interesting to see the appearance of the *yang* pigments in the list of pigments used for the 1900 portrait-copying event in the palace despite their strict ban by the king. Included among other traditional pigments in the *Book of State Rites for the Copying of Royal Portraits* are twenty packs of *yangju*, half a pack of *yangrok*, and five *ryang* of *yangchŏng*.[95]

This book of state rites also contains several types of illustrations of the screens of the five peaks (*obongbyŏng*). The type called *sappyŏng*, or a "screen on stand" (fig. 51), shows the colors that might be the pigments of the aniline dye. The blue and green as well as the red look quite bright. An undated actual screen of the same type, *Screen of the Five Peaks* (fig. 52), now preserved in the National Palace Museum of Korea, shows the strong red, blue, and green colors used for the sun, the tree trunks, and the mountain peaks. Therefore, we can surmise that this screen dates from the end of the nineteenth century. Other screen paintings produced and used by the royal court at the end of the nineteenth century also display the same use of aniline dyes.

In a documentary painting of the Taehan empire—namely, the 1902 *Screen of Royal Banquet of the Cyclical Year Imin* (*Imin chinyŏn tobyŏng*) (fig. 53)—we notice the robust Western pigments in the coloring of the red columns of the buildings. Also in this screen painting, we find the strongest reflection of the linear perspective system. This banquet celebrated the fifty-first birthday (*mang'uyk*, literally "in sight of sixty") of Emperor Kojong, and on nine of the ten panels of the screen, a series of nine different celebratory events are depicted; the last panel records the name of the officials in charge of the events.[96] At this time, Emperor Kojong joined the Club of the Elders (*kisa*), following King Yŏngjo in 1744. The club had its own office called the Kiroso, or the Office of the Elders, where they met and celebrated various occasions.[97] The first panel (fig. 54) depicts the scene of the enshrinement of the Imperial Album in the Yŏngsu-gak, a building in the Kiroso, after Emperor Kojong had signed it.[98]

While the foreground of the building was depicted with a minimum of recession into the background, and the standing and seated figures mostly appear as seen from the side, the Yŏngsu-gak building itself and its immediate foreground were rendered in quasi-linear perspective. The orthogonals of the building receding into space would meet at a central point just below the roof's white horizontal line. Some inconsistencies notwithstanding (such as the floor mats not adhering to the perspective rule), this is the closest example of Western linear perspective that can be found in Chosŏn documentary paintings. The artist did not mind the

挿屏長八尺三寸廣六尺二寸

51 "Screen on Stand"
(*sapbyŏng*). From the *Book
of State Rites for the Copying
of Royal Portraits* (Yŏngjŏng
mosa togam ŭigwe), 1900.
Changsŏ-gak Library, the
Academy of Korean Studies,
Sŏngnam, Kyŏnggi-do.

52 *Screen of the Five Peaks*,
late-nineteenth century.
Screen on stand, panel, ink
and color on silk, 149.0 × 126.7
cm. National Palace Museum
of Korea, Seoul.

53 Panels 1–4 of the *Screen of Royal Banquet of the Cyclical Year Imin* (Imin chinyŏn tobyŏng), 1902. Ten-fold screen, ink and color on silk, each panel, 162.3 × 59.8 cm. National Center for Korean Traditional Performing Arts, Seoul.

small size of the most important item in the scene, the Imperial Album mounted in gold, because of the diminishing scale in the perspective system.[99]

The list of painters who worked for the 1902 event does not include the two artists An Chung-sik and Cho Sŏk-chin, who were trained in Tianjin, but it is certain that after they returned home, they were able to disseminate the knowledge of the geometric perspective they had learned in Tianjin. They were not in the service of this court banquet most probably because they both served as principal painters of the event of the portrait painting of Emperor Kojong and the Crown Prince, who later became Emperor Sunjong.[100] This event took place three years after Hubert Vos had painted the *Portrait of Emperor Kojong* in oil in 1899. This portrait, a larger-than-lifesize standing image of the emperor wearing the yellow imperial robe with dragon insignia on the front and back, shows nothing in the background to illustrate his imperial status. It is the first oil painting of the portraits of the Chosŏn kings; it is also the first royal portrait with exposed hands.[101] The emperor is wearing a black hat (*iksŏn-gwan*), which Chosŏn kings wore daily in their office, and a pair of black silk boots. The light comes from the upper left, and therefore the upper part of his golden silk garment is highlighted on his shoulder and chest as well as on his sleeves. His black hat and his face are also lighted from the left, creating a definite sense of three-dimensionality of the head.

54 Panel 1 of the *Screen of Royal Banquet of the Cyclical Year Imin* (Imin chinyŏn tobyŏng), 1902. Ten-fold screen, ink and color on silk, each panel, 162.3 × 59.8 cm. National Center for Korean Traditional Performing Arts, Seoul.

However, when compared to other existing portraits of Emperor Kojong, such as the *Portrait of Emperor Kojong* (fig. 55) now in the National Palace Museum of Korea, his face is rendered slenderer than his other images, more like that of a Westerner.[102] In this sense, despite the realistic rendering of the silken robe and the overall three-dimensional quality of the portrait, this oil portrait does not convey the emperor's true image. This point becomes even more convincing when we compare the two portraits with a photo portrait of Emperor Kojong taken around 1900 (fig. 56). The National Palace Museum version is closer to the photo portrait.

Hubert Vos painted another oil portrait at about this same time, that of Min Sang-ho (see fig. 50). It is a bust portrait of the diplomat wearing a black horse-hair hat called *chŏngja-gwan*, named after the two Northern Song philosophers, Cheng I and Cheng Hao. The sitter's name was written in white in *han'gŭl* characters on the upper left corner, while that of the artist was written in black along the frame's right edge. His well-formed facial features gained prominence because of the semitransparent high hat as well as the lifelike portrayal with oil pigments.

The increased realism discernible in these royal portraits at the turn of the century is indicative of the change in the approach to the art of portraiture. It was recorded that in 1902, when Emperor Kojong and the Crown Prince had

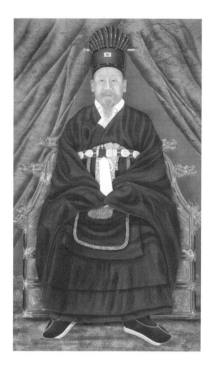

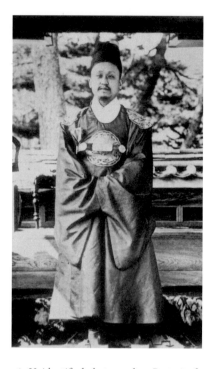

55 *Portrait of Emperor Kojong*, early twentieth century. Hanging scroll, ink and color on silk, 162.5 × 100.0 cm. National Palace Museum of Korea, Seoul.

56 Unidentified photographer, *Portrait of Emperor Kojong*, around 1900. Photograph, size unknown. Taken from *Chuyŏnjip*, 1919.

their portraits painted, they posed for the artists more than fifty times at the Chŏnggwan-hŏn, a Western-style building constructed in Tŏksu-gung, one of the royal palaces of the Chosŏn period in Seoul.[103] Compare this to the occasion when King Sukchong had his portrait painted in 1713. Apparently the monarch posed only a few times for the artists, and they complained that it was difficult for them to dare look up at the face of the king. The artists made a specific request that the king pose during the morning hours, when the light was good for the coloring of the face, although he could pose for them in the afternoon for the coloring of the crown and the robe.[104]

The 1905 *Bust Portrait of Ch'oe Ik-hyŏn* (*ho* Myŏn'am; 1833–1906) by Ch'ae Yong-sin (*ho* Sŏkchi; 1850–1941) (fig. 57) may be cited as the supreme example of Western realism combined with traditional East Asian painting methods. Ch'ae Yong-sin served as a court portrait painter during the Taehan empire, although his long career extended well beyond the fall of the empire in 1910 and into the Japanese occupation period.[105] Consequently, he left numerous portrait paintings of high officials and well-known scholars at the turn of the century. In 1943, two years after his death, some fifty portraits by him were gathered together and exhibited in the Hwashin Gallery in Seoul, which testifies to Ch'ae's achievements as a portrait painter. Since then, research on Ch'ae's portrait paintings has flour-

57 Ch'ae Yong-sin, *Bust Portrait of Ch'oe Ik-hyŏn*, 1905. Framed, ink and color on silk, 51.5 × 41.5 cm. National Museum of Korea, Seoul.

ished.[106] Although he was known to have based his portraits often on photography, his use of traditional media of silk, brush, ink, and colors puts him along the famous traditional portrait painters of Chosŏn, such as Yi Myŏng-gi.[107]

Ch'oe Ik-hyŏn once served at the court of Ch'ŏlchong, but during the time of the Hŭngsŏn Taewongun he was exiled to Cheju Island because he criticized the regent's policies. Ch'oe decided not to serve in public office even after he was released from exile. After the Protectorate Treaty of 1905 (the cyclical year *ŭlsa*) between Korea and Japan, he mobilized the righteous army (*ŭibyŏng*) to fight against the Japanese.[108] He was arrested by the Japanese authorities and sent to Tsushima Island, where he fasted to death in protest.[109] This portrait aptly

shows Ch'oe's righteous and sincere personality. Like most of the portraits by Ch'ae Yong-sin, it is a frontal image with strong eyes staring at the viewers. The eyes are modeled with extremely fine brush lines to create a sense of convexity, and even the eyelashes are individually depicted in short lines. The sunken areas around his eyes are given dark brown shading by means of repeated brush lines. His wrinkled face, likewise, is finely modeled with brown lines of varying tonality. The technique of shading by means of repeated fine lines is similar to that of Western pen or pencil drawings, yet the result here is that of traditional fine shading with an immensely increased sense of realism.

Western painting techniques that came to Korea by way of China in the seventeenth century gradually changed the painting styles of Chosŏn. Over nearly two and a half centuries, almost all painting genres had displayed the influence of the new techniques. Changes took place in portraiture, animal paintings, documentary paintings, and the *ch'aekka-do,* or scholars' paraphernalia arranged in neat bookcases. In all of these paintings, Korean painters were able to achieve the effect of three-dimensionality, lifelikeness, and the feeling of space and depth. These are the qualities at which the Chosŏn scholars who visited Yanjing as emissaries marveled. Admiringly, they recorded these techniques in their writings. Scholars and scholar-painters who did not visit China also became familiar with these qualities through Western books that had been translated into Chinese. They expressed their observations on the new techniques, some of which were introduced in this chapter. With the influx of foreign political and cultural forces to Chosŏn at the turn of the century, Western influences on Korean art took on a fresh dimension. Realism in portraiture reached new heights aided by photography; architectural drawings displayed a more precise understanding of the one-point perspective system; and the importation of chemical dyes brought about brighter colors even in court paintings.

Chapter 3 examines landscape painting of the late Chosŏn period: *chin'gyŏng sansu-hwa,* or "true-view landscape painting." This genre is considered to be the one that expressed most eloquently the ethos of the Korean people in the history of Korean painting. One cannot deny, however, the fact that the most "Korean" of Korean paintings was in part developed as a result of the Western influence.

3

TRUE-VIEW LANDSCAPE PAINTING

S tudies abound in recent decades on the subject of Korean true-view landscape paintings. Names of scholars who have contributed to the understanding of the subject are mentioned here, along with their pioneering essays and monographs, written mostly in Korean. My essay "Artistic Tradition and the Depiction of Reality: True-View Landscape Painting of the Chosŏn Dynasty," published in *Arts of Korea* (New York: Metropolitan Museum of Art, 1998), was the first major essay in English in which previous Korean scholarship on the subject was analytically and synthetically introduced. My monograph *Korean Landscape Painting: Continuity and Innovation through the Ages* (Seoul: Hollym, 2006) contains two chapters (chapters 5 and 6) devoted to the subject. Ch'oe Wan-su's earlier work on Chŏng Sŏn (1676–1759), the pioneer of true-view landscape painting, was translated and edited by Youngsook Pak and Roderick Whitfield and published as *Korean True-view Landscape: Paintings by Chong Son (1676–1759)* (London: Saffron Korea Library, 2005).[1] In 2009, Ch'oe Wan-su published in Korean his lifetime of research on Chŏng Sŏn in three volumes under the title *Kyŏmjae Chŏng Sŏn*, a massive work totaling 1,388 pages with 206 illustrations and 147 reference figures.[2] What follows is a discussion of true-view landscape painting based on my two previous works in English, with the addition of new research on the theme since then.

The term "true view" is a translation of the Korean term *chin'gyŏng* (Chinese *zhenjing*; Japanese *shinkei*), which means "real scenery." In Korea today the term

designates not simply realistic depictions of landscapes but paintings of Korean sites executed in techniques and in a manner first developed during the eighteenth century to portray specifically Korean scenery. The development of true-view landscape painting should be understood in the larger context of Korea's intellectual history from the late seventeenth century on as described in chapter 2. Chosŏn intellectuals' growing awareness of and interest in things Korean as a form of the School of Practical learning, which led to the investigation into history, language, geography, and land, also led to the development of paintings that depicted Korea's own land.

Probably the best example of an eighteenth-century true-view landscape painting is Chŏng Sŏn's *Clearing after Rain on Mount Inwang* (see fig. 1), dated to 1751. Mount Inwang, or Inwang-san, is located on the northwestern edge of the inner city wall of the capital, Hanyang, during the Chosŏn period. The peak is clearly visible to the northwest of the Kyŏngbok-gung, the main palace of the Chosŏn kingdom. As seen in the photograph (see fig. 2) taken in 2010, Chŏng Sŏn's painting shows an unmistakable resemblance to the real mountain, although the viewpoint is somewhat different. In this painting the artist used bold, sweeping axe-cut texture strokes in dark ink to portray the massive rocky faces on top of the mountain emerging from the mist just after the rain. In response to such an image the noted critic and painter Kang Se-hwang (1713–1791), in a recorded colophon to an album of paintings by the artist, wrote: "Chŏng Kyŏmjae [Sŏn] excelled in true-view landscape painting of the Eastern Nation [Tongguk chin'gyŏng]."[3] The "Eastern Nation" of which he speaks, of course, is Korea.

The Chinese term for "real scenery" (*zhenjing*) appears as early as the tenth century, in a treatise by Jing Hao (active ca. 870–ca. 930) titled "A Note on the Art of the Brush" (in his *Bifaji*). In his classification of paintings into four grades (divine, marvelous, distinctive, and skillful), Jing Hao explains that in paintings belonging to the "distinctive" class, the traces of the brush and ink are "unfathomable," causing the disparity with real scenery.[4] About a century later, during the Northern Song dynasty (960–1127), we find the term "real landscape" (*zhen shanshui*) in a celebrated treatise on landscape painting by Guo Xi (ca. 1000–ca. 1090), *Linchuan gaozhi* (The lofty message of forest and streams).[5] In the Chinese texts the terms *zhenjing* and *zhen shanshui* seem to point to the exact meaning of the words, a representational depiction of the scenery, or topography. In modern Korean scholarship, however, *chin'gyŏng sansu* refers not to "real-scenery landscape painting" but to the meaning of "true-view landscape painting."

To understand what is meant by "true view," it is helpful to review how the expression has evolved over time. Recent studies revealed that during the late Chosŏn period, the word *chin'gyŏng* was usually written with the character *kyŏng*, meaning "boundary" or "realm," rather than with the character meaning "scenery."[6] This character, however, referred not to locations in the real world but to the realm of the immortals (*sŏn'gyŏng*), indeed one quite apart from the mundane world. Though by the early eighteenth century the character *kyŏng* ("boundary")

was replaced with *kyŏng* ("scenery"), when speaking of true-view landscapes, other connotations adhered to the term. *Chin'gyŏng* is often used interchangeably with *silgyŏng*, meaning "real scenery." (In fact, recent visitors to North Korea find that its artists use the term *silgyong* to describe their real scenery work.) The character *sil* (Chinese *shi*) means "real" but does not commonly imply "truth," in the philosophical sense of the term, as does the character *chin*.

In a recent study reviewing a group of words sharing the syllable *chin*—*chinmun* ("true writing"), *chinsi* ("true poetry"), *chinhwa* ("true painting")—it was found that in the eighteenth-century context, all of these words imply an ideal artistic state close to that encompassed in the term "workings of heaven" (Korean *chŏn'gi*; Chinese *tianji*), which has been defined as the "instinctive, natural operation of the artist's mind in a state of inspiration."[7] Therefore, when eighteenth-century Korean scholars used the term *chin'gyŏng*, they seem to have had more than "real scenery" in mind; the term encompasses scenery that, although true to actual Korean landscapes, is also the most exemplary and the most ideal in the country, such as that of Mount Kŭmgang (Diamond Mountain). Located along the east coast in the province of Northern Kang'won, in present-day North Korea, Mount Kŭmgang is indeed well represented in true-view landscape paintings of the eighteenth and nineteenth centuries.

Other words sharing the character *chin* that are not conceptual but more concrete in meaning also shed light on the semantic range of the term *chin'gyŏng*. The Chosŏn dynasty's books of state rites (*ŭigwe*) on royal weddings as well as on the painting and copying of royal portraits contain detailed lists of the materials used.[8] Among the lists of pigments and inks used in the painting of screens or portraits, the *ŭigwe* books recorded sets of contrasting terms employing the initial syllable *tang* or *chin*; for instance, *tangbun* and *chinbun*, or *tangmuk* and *chinmuk*.[9] In Korea and Japan, beginning in the Tang period (618–907), articles of Chinese origin were referred to with the prefix *tang*. Thus in these pairs of words, *tangbun* refers to Chinese white pigment as opposed to Korean white pigment; and *tangmuk* refers to ink sticks made in China in contrast to *chinmuk*, domestically produced ink sticks. The *Dictionary of Korean Terms Composed of Chinese Characters* (Han'guk hanjaŏ sajŏn) defines the term *chinmuk* as "ink of the best quality."[10] In the historical and cultural context of the late Chosŏn period, the term *chin'gyŏng sansu* probably refers to a painting that depicted specifically Korean scenery, which was regarded as ideally the most beautiful and the best in the country.

Extending these multiple layers of meaning that distinguish and elucidate what is specifically Korean about true-view painting is an inscription by Kang Se-hwang on another true-view landscape by Kang Hŭi-ŏn (1710–before 1784), titled *Mount Inwang Seen from Tohwa-dong* (fig. 58). This is the back side of the same mountain depicted by Chŏng Sŏn (see fig. 61). In his inscription Kang draws attention not to an idealized treatment of a Korean scene but rather to the mimetic aspect of the representation: "Painters of true-view landscapes

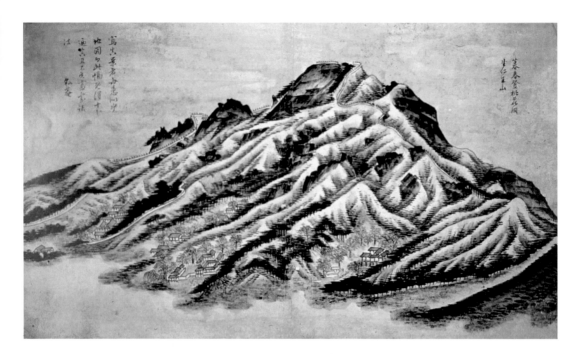

58 Kang Hŭi-ŏn, *Mount Inwang Seen from Tohwa-dong*, second half of the eighteenth century. Album leaf, ink and light color on paper, 24.6 × 42.6 cm. Private collection, Korea.

[*chingyŏng*] are always worried that their paintings might look like maps. However, this painting successfully captures the resemblance [to real scenery] while not sacrificing the [old] masters' methods."[11] Kang Se-hwang's inscription on Kang Hŭi-ŏn's painting elucidates two seemingly opposed qualities of true-view painting as the genre was developing in the eighteenth century. The first is what might be seen as the traditional aspect of *chingyŏng*—that is, its concern with following the "old masters' methods." By this, Kang is referring to traditional Chinese painting methods, which Kang Hŭi-ŏn clearly had accessed in his depiction of a Korean scene. The second aspect is the innovative and novel treatment of the landscape, employing new brush methods and compositions of the painter's own devising to suit the particular scenery being depicted, which Chŏng Sŏn has evidently accomplished.

In the eighteenth century, painting of Korean scenery took on new importance. Though there was a tradition of "real scenery" landscape painting before the late Chosŏn period, certain social, cultural, and intellectual forces caused Koreans to consider the distinctiveness of Korea itself. This, in turn, led them to pay more attention to the painting of the country's topography. Because of this focus, true-view landscape painting began to develop and to follow a diverse course for two-and-a-half centuries, from the second half of the seventeenth century to the late nineteenth century. In the process, true-view landscape painting interacted with other painting traditions and styles and produced prominent

artists whose works exemplify the stages of the style's development. Before we explore this process, let us consider the prelude to true-view landscape painting.

The Origins of True-View Landscape Painting: Paintings of Korean Sites before the Mid-seventeenth Century

No maps prior to the early Chosŏn period survive, although such maps, with accurately rendered topography, were made for practical purposes, primarily military.[12] Kang Se-hwang's inscription on Kang Hŭi-ŏn's painting of Mount Inwang refers to the rendering of actual sites in maps, which in fact were produced by court painters. Indeed, some late Chosŏn maps display an artistic quality nearly equal to that of landscape paintings. Since there are so few landscape paintings from the Koryŏ dynasty (918–1392) or earlier, we must turn to literary evidence for information concerning earlier paintings of Korean sites. One artist whose works have been documented is the famous Koryŏ painter Yi Nyŏng (active ca. 1122–1146). Among his paintings commemorating Korean sites were *Scenery along the Yesŏng River, The South Gate of Chŏnsu-sa, Landscape of Chin Yang,* and *Eight Scenes of Songdo* (Songdo referring to the capital of Koryŏ, present-day Kaesŏng).[13]

The only surviving example of an early depiction of Korean scenery is a small lacquer screen on which is painted what is believed to be the earliest representation of Mount Kŭmgang as the background of the two Bodhisattvas: *Standing Bodhisattva Dharmodgata and Seated Bodhisattva Ksitigarbha* by Noyŏng (fig. 59). According to the inscription on the left edge of the seated Buddhist image, the painter of the screen was a monk named Noyŏng of the Sŏnwon-sa, a temple on Kanghwa Island, and the date of execution was 1307. Measuring only 22.5 × 13.0 centimeters, the screen depicts a seated Ksitigarbha in the lower half of the panel with a standing Bodhisattva Dharmodgata at the upper right. In the mid left of the panel, we see a tiny kneeling image of King T'aejo (r. 918–943) of Koryŏ in prayer.[14] The rest of the space is filled with wavy lines that represent rocks amid sea waves and jagged mountain peaks emerging from clouds. Noyŏng's depiction of the jagged granite peaks so typical of Mount Kŭmgang was to be followed by many painters of the late Chosŏn period.

In the early years of the Chosŏn dynasty, with the establishment of the new capital at Hanyang (present-day Seoul), painting was drafted into service to extol the capital's natural beauty as well as the majestic appearance of its palace buildings and fortresses; a screen painting titled *Eight Scenes of the New Capital,* recorded in the *Veritable Records of King T'aejo* (r. 1392–1398), is one example.[15] Although by the fourteenth century it was traditional practice to have painting sets of eighteen scenes, the titles of the scenes depicted in this series indicate that it departs somewhat from tradition by representing not only natural scenery but also scenes of human activities in and around the new capital. These

59 Noyŏng, *Standing Bodhisattva Dharmodgata and Seated Bodhisattva Ksitigarbha*, dated to
1307. Lacquer screen with gold pigment, 22.5 × 13.0 cm. National Museum of Korea, Seoul.

scenes include the Kijŏn (the area surrounding the capital); the walled city and its palaces and gardens; official buildings; residential buildings; East Gate military training grounds; boat traffic on the Sŏ-gang (a section of the Han River); passersby along the South Ford; and horses in the Northern Suburbs.[16]

Although no paintings of these titles survive, their mention in the *Veritable Records* indicates that works depicting the actual scenery in and around the capital city were produced at the beginning of the Chosŏn dynasty. The *Veritable Records* reveal that paintings of scenic spots in Korea were much in demand by emissaries from the Ming court, the most frequently requested being those of Mount Kŭmgang.[17] The Yanghwa-jin, a scenic ford along the Han River in Seoul, and Samgak-san, a mountain north of Seoul, seem to have been favorite subjects. For instance, upon his departure for China, Yun Feng, a Ming envoy to the court of King Munjong (r. 1450–1452), asked for a set of paintings of the four seasons at the Yanghwa ford as a gift.[18] In 1560, Korean officials traveling to P'yŏng'yang, to pay respect to the portrait of King T'aejo kept in the portrait hall Yŏngsung-jŏn, were ordered by King Myŏngjong (r. 1545–1567) to take along a court painter to have the scenery in P'yŏng'yang painted and mounted as a screen.[19] The oldest extant screen painting that depicts P'yŏng'yang is the *General View of P'yŏng'ang* attributed to Yi Ching (1581–after 1645).[20] Documents show that this city, which served as the dynasty's Western capital , was a subject of painting throughout the Chosŏn period.

One genre of painting from the early Chosŏn to include actual Korean sites was documentary paintings. Because they depict social events at specific sites, the landscape background of these documentary paintings should be considered real scenery or "true view." Among the early examples of such paintings are those documenting gatherings of scholars or officials who served together at a specific government office. Known as *kyehoe-do*, these paintings were produced in multiple copies so that each participant in the gathering could own one.[21] A typical example of the sixteenth-century *kyehoe-do* is the *Gathering of Scholars at the Toksŏ-dang Reading Hall* (fig. 60). Most of these commemorative gathering paintings were done on a wide hanging-scroll format that is horizontally divided into two parts: the upper portion contains the title and the painting, while the lower part is reserved for inscription and colophons. In this case the lower portion of the painting contains a list of names of the scholars who spent their officially granted period of reading recess together in the Toksŏ-dang, the government-sponsored reading hall built in 1517 in the Tumo-p'o area along the shore of the Han River. The Sino-Korean title of the painting is written across the top from right to left in decorative seal script.

The Chosŏn period "sabbatical system for the young elite scholars of the Chiphyŏn-jŏn, or the Hall of the Worthies," was initiated during the reign of King Sejong the Great (r. 1418–1450). The building depicted in this painting existed from 1517 to 1592. The date of the painting can be deduced from the dates of the scholars whose names appear in the lower portion. All together, there are

60　Unidentified artist, *Gathering of Scholars at the Toksŏ-dang Reading Hall*, ca. 1570.
Hanging scroll, ink on silk, 102.0 × 57.5 cm. Seoul National University Museum.

ten names listed along with such personal data as family place of origin, sobriquets, dates of birth, years of success in state examinations, and so on.[22] Judging from these dates, we surmise that the date of the gathering was sometime in 1569 or 1570, most likely in 1569, when Yi I wrote the *Discourse at Tongho* (Tongho mundap) during his stay in the hall. The hall was also called Tongho Tŏksŏ-dang as the Han River forms a lake-like pool at this spot where it turns southward from its westerly flow out to the Yellow Sea. This painting must have been commissioned very soon after 1569 to commemorate the time the participants spent together at the Reading Hall.

It is possible today to identify the exact location of the hall and to point to aspects of the mountain setting surrounding the hall. Although the scenery is much changed since the sixteenth century, one can still identify the Maebong-san on which the Reading Hall is nestled as well as the river in front of it.[23] In this sense the painting can be considered representative of sixteenth-century real scenery painting. That the scenic spots along the Han River were frequently recorded in painting is documented in the *Veritable Records of King Chungjong* (r. 1506–1544). In 1537 a scene of boating on the river was painted and presented to two Chinese emissaries to the court of King Chungjong. They were recorded to have been overwhelmed by the beauty of the painting, exclaiming: "This is indeed a priceless treasure!"[24]

An early seventeenth-century painting of the same format as *kyehoe-do*, but this time representing a villa once owned by the well-known Neo-Confucian scholar Chŏng Yŏ-ch'ang (*ho* Iltu; 1450–1504), can also be qualified as a "real-scenery" painting. It is the *Old Villa in the Hwagae District* by Yi Ching (*ho* Hŏju; 1581–after 1645) (fig. 61), who was one of several painters of Yi royal descent active during the mid-Chosŏn period.[25] According to the inscription on the lower half of the wide hanging scroll, the painter did not visit the actual site of the villa at the foot of Chiri-san, a scenic mountain that rises at the juncture where the three provinces—North Chŏlla, South Chŏlla and South Kyŏngsang—meet. The Hwagae district is located in South Kyŏngsang. Instead, Yi worked from documentary evidence and other Chosŏn period paintings of villas. Thus the painting is rather like a generalized poetic landscape of the Chiri-san area with its numerous peaks seen from a distance. For comparison, one can cite an eighteenth-century painting by the literati painter Kim Yun-gyŏm (*ho* Chinjae; 1711–1775) titled *Complete View of Mount Chiri Seen from Kŭmdae* (fig. 62), a rock located in Kahŭng Village in South Kyŏngsang.[26] Common in both paintings are distant peaks that appear through the dense clouds. Although Yi Ching's painting cannot be said to be a representation of an identifiable site, it represents a Chosŏn period tradition of a villa painting at a specific site.

Another documentary painting with a famous site as its setting produced by the court painting bureau, the Tohwa-sŏ, is the seventeenth-century handscroll by Han Si-gak (*ho* Sŏltan; 1621–?), titled *Special State Examination for Applicants from the Northern Frontier,* dated to 1664 (fig. 63). The site depicted is Ch'ilbo-san

61 Yi Ching, *Old Villa in the Hwagae District*, 1643. Hanging scroll, ink and light color on silk, 89.3 × 56.0 cm. National Museum of Korea, Seoul.

(Seven-jewel mountain) in Kilchu, North Hamgyŏng-do.[27] Because of the mountain's unusual rock formations and beautiful ridges on either side of the main peak, Mount Ch'ilbo is considered one of the eight scenic spots of Hamgyŏng. The site is also known as Mount Kŭmgang of the Hamgyŏng-do, Mount Kŭmgang or the Diamond Mountain being the standard evoked when expressing the highest praise for beautiful scenery. The examination scenes unfold under a backdrop of mountain peaks rendered in the archaic blue-and-green landscape style. In the right half of the scroll, we find the distinctive needle-like peaks of Mount Ch'ilbo. The primary purpose of this late seventeenth-century handscroll painting lies in its documentary function.

62 Kim Yun-gyŏm, *Complete View of Mount Chiri Seen from Kŭmdae*, eighteenth century.
Ink and color on paper, 29.6 × 34.7 cm. National Museum of Korea, Seoul.

Han Si-gak also painted a set of six paintings of the same mountain to be
mounted together in an album that consists of a series of poems written by Kim
Su-hang (*ho* Mungok; 1629–1689) and six other scholar-officials who served as
examiners. Called *Records of Rhyme Poems Composed at the Northern Frontier*
(*Pukgwan Such'angrok*), the set of paintings marks a milestone in the develop-
ment of true-view landscape painting in that it depicts actual Korean scenery,
and the paintings were produced solely to record the scenery.[28] Of the six paint-
ing leaves, the first two depict the seaside view of Kilchu, while the rest of the
four leaves represent the views of Mount Ch'ilbo.

The fact that this album consists of one complete view and several other
detailed views of the mountain is especially noteworthy. This practice is fol-
lowed by later painters of true-view landscape paintings such as Chŏng Sŏn, who
painted albums of Mount Kŭmgang with one complete view and several detailed

63 Han Si-gak, *Special State Examination for Applicants from the Northern Frontier*, 1664.
Handscroll, ink and color on silk, 57.9 × 674.1 cm. National Museum of Korea, Seoul.

views of the mountain. "Complete View of Mount Ch'ilbo" (fig. 64), which
appears in two consecutive leaves (23 and 24), shows a flowerlike composition of
outer peaks that surround the inner peaks. The right half of the composition con-
tains the needle-like peaks of the Thousand-Buddha Peaks (Chŏnbul-am), which
were also featured in the distance in the handscroll *Special State Examination for
Applicants from the Northern Frontier* (fig. 65). This section, together with several
other nearby peaks and terraces, was depicted in a separate leaf (17) under the
title *Diamond Peak* (Kŭmgang-bong) (fig. 66). Though somewhat stylized, Han
Si-gak no doubt pioneered the true-view landscape tradition through this album
of paintings and poetry.

True-view landscape painting, interestingly, was also developed through the transformation of a specifically Chinese theme—namely, the mountain retreat of Zhu Xi (1130–1200), the great Southern Song Neo-Confucian scholar.[29] Zhu had chosen Mount Wuyi (Mui-san), in western Fujian, as the site for his retirement. There he had a complex of buildings and pavilions built along the Nine-Bend Stream (Korean Kugok-kye; Chinese Jiuquxi) to be used by him and his disciples for teaching, study, and contemplation. It is not clear whether Zhu Xi's hermitage was painted as a series forming a long handscroll during his lifetime or shortly thereafter. The first recorded accounts of paintings called *The Nine-Bend Stream at Wuyi* or with similar titles appear during the Yuan dynasty (1272–1368).[30] The

64 Han Si-gak, *Complete View of Mount Ch'ilbo*, leaves 23 and 24 of the album *Records of Rhyme Poems Composed at the Northern Frontier* (Pukgwan Such'angrok), mid-seventeenth century. Album of thirty-two leaves, ink and color on silk, each leaf, 29.6 × 23.5 cm. Private collection, Seoul.

basis for the pictorial representation is Zhu Xi's poem "Boating Song [along the Stream] at Mount Wuyi," which describes the natural beauty of his mountain abode. Probably the earliest surviving painting of this theme is *Boating [along the Stream] at Mount Wuyi* (fig. 67) by Fang Cong-I (ca. 1302–1393), which represents one of the mountain's unusually formed peaks in a hanging-scroll format.

The "nine-bend stream" tradition and its pictorial representation made their way to Korea in the early years of the Chosŏn dynasty, when Neo-Confucianism was adopted by the court as the state's official ideology. Korean Neo-Confucian scholars composed poems in rhyme with Zhu Xi's poem and styled their works after the landscape paintings of Mount Wuyi and the Nine-Bend Stream, including Zhu Xi's hermitage. One group of scholars, headed by the philosopher-teacher Yi I (*ho* Yulgok; 1536–1584), became adherents of poetry and painting on the theme of the Nine-Bend Stream of Mount Wuyi. An example of how Zhu Xi was revered is the long handscroll *Nine-Bend Stream of Mount Wuyi* by Yi Sŏng-gil (1562–?), dated to 1592 (fig. 68). Since the painting bears a great deal of affinity to the actual topography of Mount Wuyi (fig. 69), Korean painters may have actually seen Chinese representations of the subject. The eminent Neo-Confucian

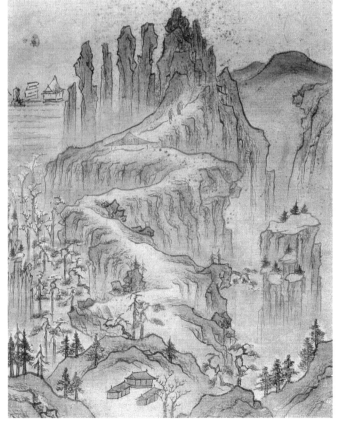

65 *(above)* Han Si-gak,
*Special State Examination for
Applicants from the Northern
Frontier,* 1664 (detail)

66 *(left)* Han Si-gak,
Diamond Peak, leaf 17 of
the album *Records of Rhyme
Poems Composed at the
Northern Frontier,* mid-
seventeenth century.

67 Fang Cong-I, *Boating [along the Stream] at Mount Wuyi,* late fourteenth century. Hanging scroll, ink on paper, 74.4 × 27.8 cm. National Palace Museum, T'aipei [from Suzuki Kei, *Chugoku kaigashi* (Tokyo, Kichikawa kobunkan), vol. 2-2, fig. 71].

philosopher Yi Hwang (*ho* T'oegye; 1501–1570) is said to have seen several copies of the painting in circulation and had some of them copied by court painters.[31]

Yi I thought it more fitting for Korean scholars to build their own hermitages (Korean *chŏngsa*; Chinese *jingshe*) in natural settings similar to that of the Chinese model. The first of these was the hermitage complex known as Sŏktam Chŏngsa, built by Yi I in 1578 along a nine-bend stream in Sŏktam, in the Kosan district of the province of Hwanghae. In 1576, Yi composed a poem in Korean, "Song of the Nine-Bend [Stream] of Kosan," extolling the natural beauty of each of the nine scenes. Significantly, Yi I's choice of a Korean location for his hermitage and his use of the Korean language for his poem are consistent with the new direction of Neo-Confucian philosophy that he was advocating.[32] This growing independence from the Chinese scholarly and intellectual tradition beginning in the late sixteenth century is sure evidence that Koreans were also becoming more aware of all things Korean, including their land and its depiction in painting.

Scenes from around Yi I's Sŏktam hermitage in Kosan were painted by many

68 (above) Detail of Yi Sŏng-gil, *Nine-Bend Stream of Mount Wuyi*, dated to 1592. Handscroll, ink and light color on paper, 33.5 × 398.5 cm. National Museum of Korea, Seoul.

69 (left) Mount Wuyi, Fujian, 2003. Photograph by S. W. Kang.

artists from the nineteenth century on, and perhaps the most well known is a joint work by ten painters including Kim Hong-do (1745–1806).[33] However, there seems to be no evidence that any scenes were painted during Yi I's lifetime.[34] In the seventeenth century, Korean Neo-Confucian scholars who followed Yi I's scholarly lineage had the scenery surrounding their own retreats painted by famous court painters. One such example is the *Nine-Bend Stream of Kogun*, painted in 1682 by the well-known court painter Cho Se-gŏl (*ho* P'aech'ŏn; 1636–1705).[35] The subject of the painting is the mountain hermitage of the scholar-official Kim Su-jŭng (*ho* Kogun; 1624–1701), who was none other than the elder brother of Kim Su-hang, who had commissioned the *Pukgwan Such'angrok* album painted by Han Si-gak. Kim Su-jŭng retired to the Hwach'ŏn district of Kang'won in 1675 when his brother Su-hang was exiled along with Song Si-yŏl (1607–1689). Having searched for a site for his hermitage, he decided on the area called Sat'an, the name of which he subsequently changed to Kogun after his sobriquet, and had his hermitage (Kogun Chŏngsa) built along the tributary of the Han River.

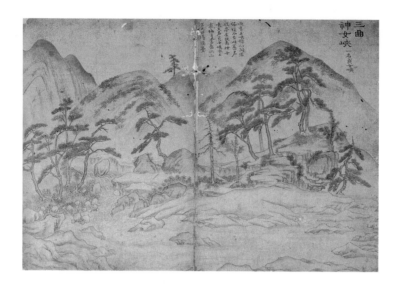

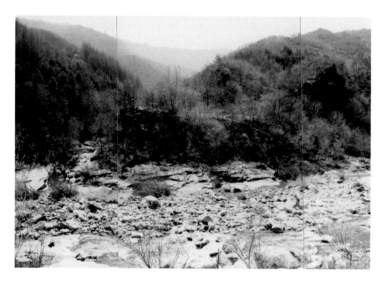

70 *(top)* Cho Se-gŏl, *Valley of the Goddess*, leaf 3 of the album *Nine-Bend Stream of Kogun*, 1682. Album of nine leaves, ink and color on silk, each leaf 42.5 × 64.0 cm. National Museum of Korea, Seoul.

71 *(bottom)* Valley of the Goddess, Hwach'ŏn, Kang'won-do, 1997. Photograph by Yun Chin-yŏng.

The *Album of Nine-Bend Stream of Kogun* consists of nine leaves of paintings, each depicting one "bend" of the stream. The album also contains colophons and poems by Song Si-yŏl and others. Yun Chin-yŏng was the first scholar who visited, identified, and photographed with great difficulty the matching scenes with those depicted in the album.[36] If we take two paintings and their matching "true

72 *(top)* Cho Se-gŏl, *White-Cloud Pond*, leaf 4 of *Nine-Bend Stream of Kogun*, 1682. Album of nine leaves, ink and color on silk, each leaf 42.5 × 64.0 cm. National Museum of Korea, Seoul.

73 *(bottom)* White-Cloud Pond, Hwach'ŏn, Kang'won-do, 1997. Photograph by Yun Chin-yŏng.

views," one is the "third-bend" called the "Valley of the Goddess" (Sinnyŏ-hyŏp) (figs. 70 and 71), and the other is the "fourth-bend" called the "White-Cloud Pond" (Paegun-dam) (figs. 72 and 73). In both sets the formation of the rocks on the shore of the stream as well as the mountain peaks and the valley near the stream are all closely identifiable; Cho Se-gŏl's delineation of the horizontal

stacks of the rocks in the "White-Cloud Pond" give an immediate clue to iden-
tification of the unusual formation of the rocks in the scenery, which has not
changed much during the intervening centuries. Scattered rocks and the plateau-
like flat tops of the rocks, and the valley with a receding peak painted in light
ink, can be matched with the scenery with the same characteristics. Thus the
"nine-bend stream" painting, though of Chinese origin, contributed much to the
development of true-view painting in the centuries to follow.

Establishing the Tradition of True-View Landscape Painting: Chŏng Sŏn and His Followers

The artist traditionally acknowledged as the leading exponent of the new trend
in landscape painting in the early eighteenth century is Chŏng Sŏn, who signed
his paintings most often with his studio name Kyŏmjae, or Studio of Modesty.[37]
Chŏng, from an impoverished family of the *yangban* ruling class, was favored
by the members of the powerful Andong Kim family because of his painting
skills and his knowledge of astronomy and the calendar through his study of
the *Book of Changes*. Until recently, there has not been much information on
Chŏng's official career, but thanks to the detailed studies by Kang Kwan-sik based
on the records in the *Diaries of the Royal Secretariat* (Sŭngjŏnwon Ilgi), we now
possess more concrete knowledge on Chŏng's official career.[38] The belief that
Chŏng served at the court bureau of painting, according to Kang, stemmed from
a series of misinterpretations of literary traditions. Instead, Kang contends that
in 1716, when Chŏng was forty-one, he was recommended to the court, where he
served as astronomy instructor at the Office of Meteorology.[39] This position was
typically occupied by technocrats from the *chung'in,* or middle-people class, but
from time to time *yangban* class scholar-officials were made to serve in this posi-
tion to provide better education at the office.[40]

 Throughout his long career Chŏng served mostly in the capital, except for sev-
eral local government posts he held from time to time. He served as district mag-
istrates of Hayang (1721–26), Chŏngha (1733–35), and Yangch'ŏn (1740–45). These
local posts gave him fortunate opportunities to immerse himself in the beautiful
scenery of the respective districts, which he turned into memorable true-view
landscape paintings.[41] Chŏng's official post continued even after his retirement
from Yangch'ŏn until he was eighty-one, when he was given the second rank B
(*chong ip'um*) title of *agyŏng* (equivalent to the ministerial rank) in the office of
honored elders without any official duty (Chungch'ubu). King Yŏngjo's special
interest in Chŏng Sŏn was such that in 1772, thirteen years after Chŏng's death, a
second rank A posthumous title of Hansŏng p'anyun, or mayor of Hansŏng, the
capital city, was bestowed on Chŏng.[42]

 These new disclosures of facts concerning Chŏng Sŏn's career shed light in
understanding his life and painting from a fresh perspective. However, because

his first post as astronomy instructor was not acquired through the normal route of state examination, but through recommendations of several powerful political and literary figures, Chŏng seems to have faced some resistance every time he was promoted to a higher rank. He also seems to have had difficulty being acknowledged as a de facto literati painter by some contemporaries. When King Yŏngjo wanted to promote Chŏng to the second rank B, many scholar-officials at court expressed their stiff opposition, saying that Chŏng's merit chiefly lay in the lowly skill (chŏn'gi)—that is, painting.[43] In fact, other scholar-officials who reached a rank as high as Chŏng during the Chosŏn period would usually have collected writings of some kind, whereas, even through today, Chŏng is not known to have left any form of writings. His paintings would be matched with poems of other contemporary literati around him. In this sense Chŏng's career as the leading painter of one period was similar to that of a professional painter.

The coterie of scholar-officials instrumental in the formation of Chŏng Sŏn's art and thought, and especially in the development of true-view landscape painting, included three of the six brothers of the powerful Kim family of Andong, North Kyŏngsang: Ch'ang-jip (ho Mong'wa; 1648–1722), Ch'ang-hyŏp (ho Nong'am; 1651–1708), and Ch'ang-hŭp (ho Sam'yŏn; 1653–1722). Others were Yi Pyŏng-yŏn (ho Sachŏn; 1671–1751), one of the most accomplished poets of the time; Yi Ha-gon (ho Tut'a; 1677–1724), a scholar painter who recorded his views on painting in Tut'a-ch'o (Draft writings of Tut'a); and Cho Yŏng-sŏk (ho Kwanajae; 1686–1761), a well-known scholar painter who left an interesting album of genre paintings and who was Chŏng Sŏn's close friend and neighbor as well as the composer of Chŏng's eulogy upon his death. According to Cho, Chŏng Sŏn's profound knowledge of the Chinese Classics (especially the Doctrine of the Mean, the Great Learning, and the Book of Changes) was overshadowed by his fame in painting, just as the case of Ouyang Xiu (1007–1072), whose skill in politics was overshadowed by his literary fame.[44]

Because many of these scholar-officials, and Chŏng Sŏn, lived in the shadow of Mount Paegak, located in the northern part of Seoul behind the Kyŏngbok Palace, and composed poetry as well, this group has been referred to by Ch'oe Wan-su as the Poetry Society of Paegak (Paegak sadan), although it never existed formally as such.[45] However, it is true that the development and efflorescence of true-view landscape painting at this time owed much to the collaboration of these literary figures. They often traveled to scenic places with Chŏng Sŏn and wrote poems for his paintings. In fact, many of Chŏng's true-view landscapes that depicted the area where they lived, and those of Mount Kŭmgang, can be matched with their poetry.

As has been pointed out by many scholars, the basic elements of Chŏng Sŏn's chin'gyŏng style were derived from Chinese Southern School painting.[46] This school took root in Korea as early as the second half of the seventeenth century, when painting manuals published in China made their way to Chosŏn.[47] Among these manuals, those that reached Korea at a relatively early stage include Gu

Bing's *Gushi lidai mingong huapu* (or *Gushi huapu*, Painting manual compiled by Master Gu, 1603), the *Tangshi huapu* (Painting models for Tang poetry, Wanli era), the *Shijuzhai shuhuapu* (Ten Bamboo Studio manual of painting and calligraphy, 1627), and a little later the *Ziezi yuan huachuan* (Mustard Seed Garden manual of painting, published in two stages, in 1679 and 1701).[48]

There were also a fair number of Chinese paintings in Korea brought back by Chosŏn emissaries to the Qing court. Although most Chinese paintings that now remain in Korea in several public and private collections date from the late Qing period, we know from travel diaries and other collected writings that Chinese paintings of the Ming period and earlier were seen by seventeenth- and eighteenth-century Korean scholar painters.[49] Cho Yŏng-sŏk's eulogy for Chŏng, quoted earlier, contains the following: "[Chŏng] studied the Six Essentials [of Jing Hao] and the Six Laws of [Xie He] everyday till he was competent with the theories in them, and . . . studied ancient paintings to the degree unknown before. . . . He also learned from [painting methods of] Ni Yunlin [Zan], Mi Namgong [Fu], and Dong Huating [Qichang], and was able to respond [to] the sudden turn of the brush style by using the large wet strokes."[50] Additional sources of information on landscape compositions came from other Chinese publications that contain landscape illustrations, such as *Hainei qiguan* (Wondrous scenery of our nation), edited by Yang Erzeng and published in 1609, and *Mingshan shengkaiji* (Records of famous mountains and scenic spots), first published in 1633 in which twenty-four illustrations of famous mountains and scenic spots were combined with poems. Documentary evidence proves that the former was brought to Korea in 1631 by Ko Yong-hu (*ho* Chŏngsa; 1577–?), who visited Yanjing in 1630 as the winter solstice emissary to the Ming court and returned to Korea in June 1631.[51] The latter must have been known to Korean scholars in various names such as *Mingshan-ji* (Records of famous mountains) or *Zhongguo mingshan-ji* (Records of famous mountains of China) by the mid- to late seventeenth century.[52] Therefore, even though Chŏng Sŏn's true-view landscape paintings purport to be the paintings of Korean scenery done in Chŏng's own brush techniques, many of them, especially the early ones, display indebtedness to Chinese painting styles and compositions.

Many of the true-view landscape paintings of the late Chosŏn period represent aspects of Mount Kŭmgang located in the northern part of the province of Kang'won along the coast of the East Sea. It is a mountain range replete with symbolism and having various appellations. Of these, seasonal appellations that appear in painting titles are Kaegol-san (All bone mountain) in winter, when the rocky peaks are exposed, and P'ung'ak-san (Autumn foliage mountain), when colorful leaves cover the mountainsides.[53] Mount Kŭmgang covers a large area, with its peaks said to number as many as "twelve thousand."[54] The area is customarily divided into three main parts: Outer Kŭmgang (Oegŭmgang), Inner Kŭmgang (Naegŭmgang), and coastal Kŭmgang (Haegŭmgang). The dividing line between Outer and Inner Kŭmgang is Piro-bong, the mountain's highest

peak. Sometimes the whole area is simply referred to as "Sea and Mountains" (Hae'ak or Haesan), and painting albums containing a series of views of the mountain are most frequently called *Album of Sea and Mountains* (Haesan-chŏp). Since the area is to the east of the Chosŏn capital, Hanyang (Seoul), such albums are also called *Albums of Travel to the East* (Tong'yu-chŏp).

In the true-view landscapes of Chŏng Sŏn and his contemporaries, the most visible stylistic elements of Southern School painting are the hemp-fiber texture strokes (long, nearly parallel, somewhat wavy brushstrokes used to describe the texture of earth); Mi ink-dots (soft dots of ink of varying size and degrees of tonality applied horizontally to the surface of mountains to represent vegetation), named after the eleventh-century Chinese painter Mi Fu (1051–1107); and folded-ribbon strokes (dry, light strokes created by dragging the brush sideways and turning it at a ninety-degree angle from horizontal to vertical to depict rocky surfaces). Of these, Mi ink-dots feature most frequently in Chŏng Sŏn's works throughout his career. Although Chŏng Sŏn lived to the age of eighty-three and left behind an enormous body of work, his dated paintings, which fall between the years 1711 to 1751, are relatively few. The earlier date apparently marks Chŏng Sŏn's first visit to Mount Kŭmgang, when he painted the so-called the *Album of Paintings of Mount P'ung'ak [Mount Kŭmgang in Autumn] of the Sinmyo Year,* 1711.[55] This album contains thirteen leaves of paintings along with a colophon written in 1867 by a descendant of a certain Paeksŏk, whom one scholar has identified as Pak T'ae-yu (*ho* Paeksŏk; 1648–1746), a high-ranking official during the reigns of Kings Sukchong (r. 1674–1720) and Yŏngjo (r. 1724–1776). According to the colophon, Pak was accompanied on his second trip to Kŭmgang-san by Chŏng Sŏn, who produced a series of paintings of the mountain for which Pak's friends later wrote poetry.[56] Although the reliability of this late colophon can be questioned, all the paintings in the album show Chŏng's early style.

The *Album of Paintings of Mount P'ung'ak [Mount Kŭmgang in Autumn] of the Sinmyo Year* begins with "P'igŭm-jŏng," a pavilion in the town of Kŭmsŏng on the way to Mount Kŭmgang from Seoul (fig. 74). The scenery opens with a soft earthen shoreline that goes diagonally into the distance from left to right. A few trees grow along the shoreline, where P'igŭm-jŏng pavilion is snuggly situated. Beyond the trees and the pavilion, a band of clouds obscures the lower parts of the mountain peaks rendered in soft ink and light color, accentuated with a series of soft Mi ink-dots. The overall impression of this leaf is not much different from a Chinese painting in the line of Mi Fu and Gao Kegong, and therefore there is nothing in it that is particularly Korean true-view. In the second leaf, *Viewing Mount Kŭmgang from Tanbal-ryŏng* (fig. 75), the high ridge in the province of Kang'wŏn on the way to Mount Kŭmgang, Chŏng Sŏn also employed the same technique to depict the foreground mountain where a few travelers are looking over beyond the mist-filled valley. Chŏng has shown a completely different style in portraying the needle-like peaks of the Mount Kŭmgang that appear in the distance. Sharp linear strokes delineate the peaks, and the use of white pigment

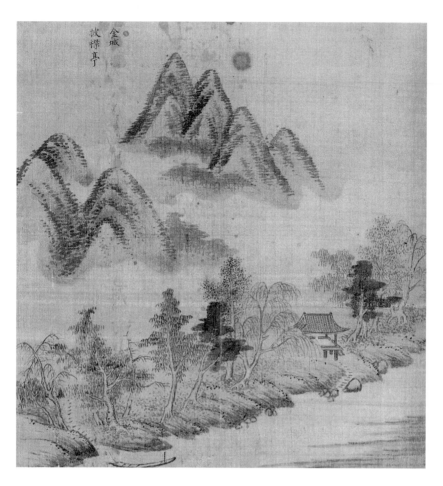

74　Chŏng Sŏn, *P'igŭm-jŏng*, leaf 1 of *Album of Mount P'ung'ak [Mount Kŭmgang in Autumn]
of the Sinmyo Year,* 1711. Album of fourteen leaves, ink and color on silk, each leaf 33.6 × 35.8
cm. National Museum of Korea, Seoul.

on the tips of the peaks may be considered Chŏng's independent style from the
Chinese tradition. The same manner of depicting the peaks appears repeatedly
in his later paintings.

　Chŏng Sŏn's second trip to Mount Kŭmgang the following year, in 1712, is
better documented. During this trip he painted another album of thirty leaves,
Album of Realistic Representations of Sea and Mountains (Hae'ak chŏnsin-chŏp),
which, although no longer extant, is recorded along with poems by four of Chŏng
Sŏn's contemporaries describing the scenes depicted in the collected works of
various scholar-officials.[57] Chŏng's third documented trip took place in 1747,
when he produced yet another album of the same title. Yi Pyŏng-yŏn's colophons
to these paintings confirm the dates of Chŏng's travel. It is not clear whether
he made more trips to the area between 1712 and 1747. However, a recent study
shows that Chŏng painted many images of Mount Kŭmgang based on earlier

75 Chŏng Sŏn, *Viewing Mount Kŭmgang from Tanbal-ryŏng*, leaf 2 of *Album of Mount P'ung'ak [Mount Kŭmgang in Autumn] of the Sinmyo Year*, 1711. 33.6 × 35.8 cm. Kansong Art Museum, Seoul.

sketches. A case in point are several of his paintings that depict the Chang'an-sa temple in all of which the Flying Rainbow Bridge (Pihong-gyo) is shown prominently. However, as documented by several scholars who traveled to that area, the bridge was destroyed by fire in 1723.[58]

One of Chŏng Sŏn's favorite compositions seems to have been what is known as the "complete view of Mount Kŭmgang" (Kŭmgang chŏndo), which he painted many times after his first visit to the mountain in 1711. The best known version is the *Complete View of Mount Kŭmgang* in the collection of Leeum, Samsung Museum of Art (fig. 76), which bears an inscription with a date corresponding to 1734. Another one is the undated, much smaller painting in the collection of the Kansong Art Museum, *General View of Inner Mount Kŭmgang* (P'ung'ak naesan chŏngram) (fig. 77). The third version is leaf 10 of the the *Album of the Realistic Images of the Sea and Mountain*, titled *Inner Mount Kumgang* (Kŭmgang naesan)

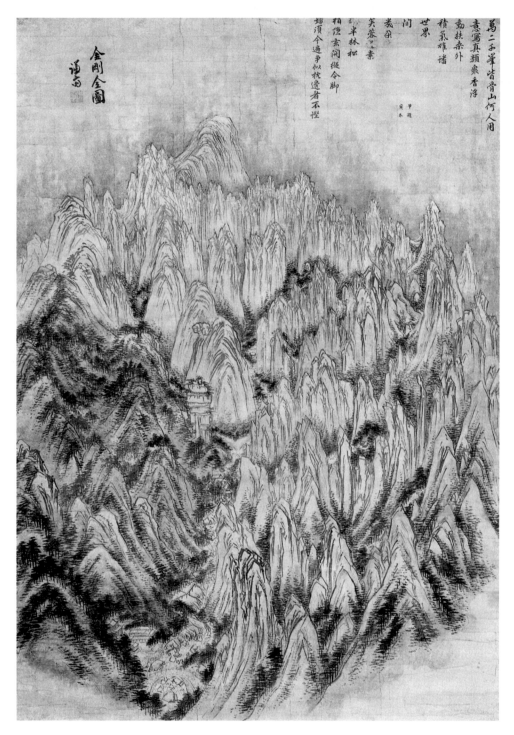

76 Chŏng Sŏn, *Complete View of Mount Kŭmgang*, 1734. Hanging scroll, ink and light color on paper, 130.8 × 94 cm. Collection of Leeum, Samsung Museum of Art, Seoul.

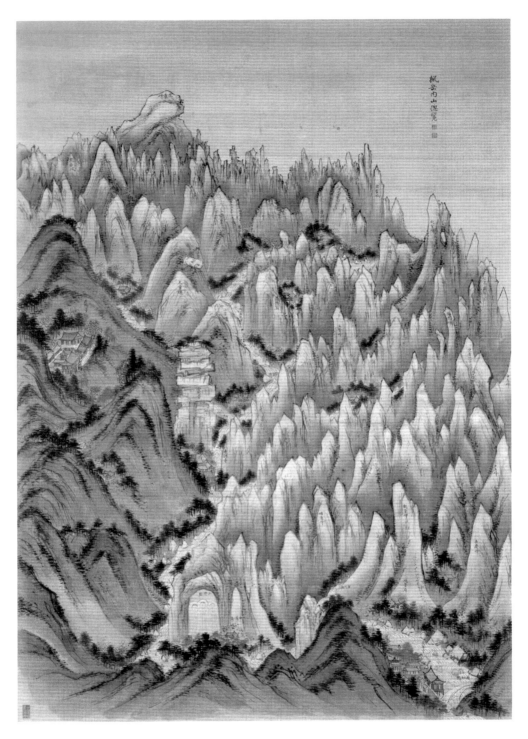

77 Chŏng Sŏn, *General View of Inner Mount Kŭmgang*, mid-eighteenth century. Hanging scroll, ink and color on silk, 100.8 × 73.8 cm. Kansong Art Museum, Seoul.

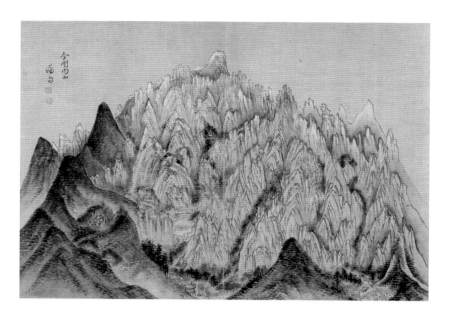

78 Chŏng Sŏn, *Inner Mount Kŭmgang*, leaf 10 of *Album of Realistic Images of the Sea and Mountain*, 1747. Album of twenty-one leaves, ink and color on paper, each leaf 60.3 × 42.2 cm. Kansong Art Museum, Seoul.

(fig. 78), painted just after his trip to the mountain in 1747, which is also kept in the Kansong Art Museum. A careful study of the calligraphic style of the inscription by Kang Kwan-sik, however, revealed that the inscription and the date on the Leeum painting were written not by Chŏng Sŏn but by someone much later, probably in the same cyclical year, *kapin,* sixty years later.[59]

Kang Kwan-sik, through careful comparisons of the brushworks of the Leeum painting and those of 1730s paintings of—namely, the *Album of Famous Scenes of Kwandong*, dated to 1738—convincingly argues that the Leeum painting's brushworks display a more confident and relaxed movement of the brush than the ones in the 1738 album.[60] This, he argues, points to a date later than 1738.[61] As a reference, leaf 7 of the album, *Mang'yang-jŏng* (fig. 79), is shown here. Kang further argues that the brushworks in the Leeum painting show more affinity to those with *Inner Mount Kŭmgang* in the 1747 album (see fig. 78), which Chŏng painted at the very mature age of seventy-three.[62] In both paintings Chŏng used his signature brushstroke of dry, straight lines for depicting the rocky peaks in the distance, which is now known as "Kyŏmjae's vertical texture strokes" (Kyŏmjae sujik chun).

The Leeum painting and other "complete view" paintings share in common compositional as well as stylistic similarity: the low, densely vegetated earthen peaks, in the foreground and on the left edge of the painting, support the sharp rocky peaks in the center and in the background forming a shape of a flower bud. Stylistically, the "complete view" paintings show the heavy reliance on the Mi ink-dots for the depiction of the earthen peaks, while "Kyŏmjae's vertical

79 Chŏng Sŏn, *Mang'yang-jŏng*, leaf 7 of *Album of Famous Scenes of Kwandong*, 1738. Album of eleven leaves, ink and color on paper, each leaf 32.3 × 57.8 cm. Kansong Art Museum, Seoul.

texture strokes" (Kyŏmjae sujik chun) depict the rocky peaks. This compositional structure has been characterized by many as embodying the contrasting concept of *yin* and *yang,* and the resulting creation of the circular shape of the *T'aiji* (Korean *T'aegŭk*), or the Great Ultimate.[63] The *yin* elements are the soft earthen peaks depicted in wet, darker ink tone; their arrangement in a concave shape; and the arch-shaped Flying Rainbow Bridge positioned at the lowermost spot of the painting. The corresponding *yang* elements are the hard rocky peaks depicted in dry brushstrokes and lighter ink washes, their encasement within the concave *yin* earthen peaks, and the prominent convex shape of the Piro-bong, or Vairocana Buddha peak, and its position at the top of the composition. Such *yin-yang* contrast and harmony in the composition has been attributed to Chŏng Sŏn's profound understanding of the principles and philosophy of the *Book of Changes*. Kang Kwan-sik had asserted that of the three "complete view" paintings, the Leeum version is the most advanced stage of "abstraction" in that the right and left edges of the bottom of the painting were left empty to create the spherical mountain, not just the two-dimensional *T'aiji* circle. This Kang considers as a reflection of Chŏng's understanding of the Western astronomy in which the universe, the heavenly bodies as well as the earth, is viewed as spherical.[64]

Although the poetic inscription with a date on the painting is now believed to have been written by a later person, they also confirm with the *yin* and *yang* concept in their arrangements: the last characters of the poem's eleven vertical lines form a semicircle (*yin*) in which the angular block of four characters, *kap*

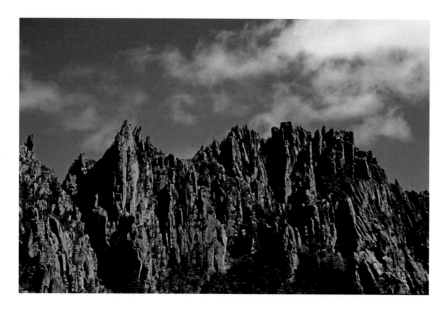

80 *(top)* Rocky peaks of Mount Kŭmgang, 1999. Photograph by Yi Sŏng-mi.

sin tong che (written in winter of the year *kapsin*), (*yang*) is placed. It is instructive to present it in English as the poem both describes the scene painted and alludes to the profundity associated with Mount Kŭmgang:

> *Twelve thousand peaks of All Bone Mountain,*
> *Who would even try to portray their true images?*
> *Their layers of fragrance* [65] *float beyond the pusang tree,* [66]
> *Their accumulated qi swells expansively throughout the world.*
> *Rocky peaks, like the lotus flowers, emit whiteness;*
> *Pine and juniper forests obscure the entrance to the profound.*
> *This careful sojourn, on foot through Mount Kŭmgang,*
> *How can it be compared with the views from one's pillows?* [67]

The last line of the poem is a reference to a famous remark by the fourth-century Chinese painter-theorist Zong Bing (375–443): when he grows old and is no longer able to climb mountains, he plans to cover his bedroom walls with images of mountains he had seen and, lying on his bed, roam around them with his eyes. [68]

Although Chŏng's "complete view" painting purports to be the "true view" of Mount Kŭmgang, as can be understood from the previous discussion, it hardly is. First, his painting is more conceptual than natural, as it is nearly impossible to have such a view of the entire mountain from any spot. That is to say, it is a conceptual composition of the vast mountain area with many of the identifiable prominent spots within the mountain; at the entrance to the mountain is the arch-shaped Flying-Rainbow Bridge beyond which we can find the Chang'an-sa

81 *(bottom)* Upper part of Chŏng Sŏn, *Complete View of Mount Kŭmgang*, 1734.

temple complex; in the heart of the "flower bud" to the right of the earthen peaks, we see the prominent tall stone structure of Myŏnggyŏng-dae, or the Clear-Mirror Terrace; at the apex of the mountain is the Piro-bong, or the Vairocana Buddha peak. This list of famous spots could go on. In fact, in the smaller undated Kansong painting, *General View of Inner Mount Kŭmgang* (see fig. 77), many of these spots were labeled in neat characters.[69] This labeling practice undoubtedly comes from traditional map making that had continued for centuries and flourished in the eighteenth century as interest in the geography of Korea increased.[70] The *Complete View of Mount Kŭmgang* composition can also be related to the tradition of the "Nine-Bend Stream of Mount Wuyi," which was painted both as one complete view and as nine separate compositions; Chŏng actually painted many of the individual spots in a small album format. The same can be said of the *Pukgwan Such'angrok* album by Han Si-gak.

Turning to the aspect of true-view painting, and examining Chŏng's power of realism expressed in the Leeum "complete view" painting, we realize that it did capture the mountain's realistic image, especially the depiction of the rocky peaks on the top. When we juxtapose a photograph of the mountain's rocky peaks (fig. 80) with the top section of the Leeum "complete view" painting (fig. 81), we realize that Chŏng's rendition of the rocky peaks comes very close to the real image as seen in the photograph. Furthermore, a description of the mountain by a contemporary literati, Yi Man-bu (1664–1732), sheds some light in understanding the eighteenth-century cultural milieu in which painting and literature went hand in hand in capturing the "true view" of the Korean land. Yi Man-bu wrote: "Before me rise twelve thousand peaks winding sinuously into the distance. Looking at

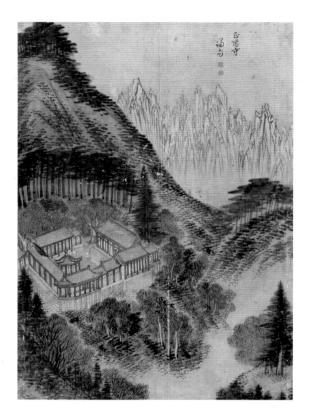

82 Chŏng Sŏn, *Chŏngyang-sa*, scroll in *The Eight Paintings of Sea and Mountains*, first half of the eighteenth century. Hanging scroll, ink and light color on paper, 56.0 × 42.8 cm. Kansong Art Museum, Seoul.

83 Chŏng Sŏn, *Hyŏlmang-bong* (View hole peak), first half of the eighteenth century. Album leaf, ink and light color on silk, 33.0 × 22.0 cm. Seoul National University Museum.

those jagged, craggy peaks soaring into the sky, I am seized with such awe and exhilaration that I feel as if I am immersed in fresh water."[71]

Besides these "complete views," Chŏng Sŏn painted individual scenes of particular areas of Mount Kŭmgang as components of albums or screens. The numbers of scenes vary—sometimes eight, in other cases thirty or more.[72] He also painted small-scale works depicting one peak or one temple from the "complete view." The undated hanging scroll *Chŏngyang-sa* (fig. 82), which is one from the set, *The Eight Paintings of Sea and Mountains* in the Kansong Art Museum, depicts the temple situated at the upper-middle level on the left edge of his *Complete View*.[73] This painting and the *Hyŏlmang-bong* (fig. 83), or the "View hole peak," so named because of the round opening near its top through which the blue sky can be seen, in the collection of the Seoul National University's Art Museum, seem to represent Chŏng's mature work of 1750s. They both display his confident brush lines of powerful Kyŏmjae vertical texture strokes, which seem to have been done in such speed and free movement of the hand. Appended to

the latter is a poetic inscription by an unidentified writer, whose sobriquet is Old Man of the Snow Country (Sŏlguk No'in):

> A huge mountain suddenly appears with peaks of exceptional beauty. I built a thatched hut on a small, flat spot among them. Because of the passing clouds, it is almost impossible to see sunlight, even during the day. Earlier I composed a poem:

> > *Leisurely clouds, unaware of the four seasons,*
> > *Cover this valley year round.*
> > *By chance, if the pouring rain stops,*
> > *Nothing else will intrude on my delightful seclusion.*[74]

The mountain peaks appear to be floating above the clouds, somewhat in the same manner as the Leeum "complete view" painting, and the light blue wash on the lower part of the peaks gives the appearance of rain mentioned in the poem. The blue tint softens the hard, solid image of the rocky peaks in Chŏng Sŏn's typical vertical strokes.

Another large-scale painting of Chŏng's Mount Kŭmgang is the *Gate Rocks at T'ongch'ŏn* (fig. 84), a representation of the unusual rock formations along the eastern coast: two enormous rock monoliths that appear to form a massive gate. Chŏng painted the scene in several versions in both small and large formats, the most impressive of which is this large hanging scroll in the collection of the Kansong Art Museum. In this ink monochrome work Chŏng focused on the severity of the scene, which he conveyed by contrasting horizontal and vertical brushstrokes as well as light and dark ink. He modeled the faces of the columnar rocks in his distinctive vertical strokes of dark ink. Perhaps even more striking than the depiction of the rocks is the linear rendering of the billowing waves, which seem to engulf the rocks. A man carrying a staff and dressed in a typical Korean costume with a broad-brimmed horse-hair hat, followed by a young servant, passes through the "gate." He is looking backward in fear of being overtaken by the surging tide. In the foreground another group of figures, a man on horseback accompanied by two servants, seems unafraid to confront the waves. The unusual treatment of the waves makes this work one of the most arresting depictions of the sea in East Asian painting.

Chŏng Sŏn's true-view landscape paintings cover a wide range of scenes in and around Seoul, where he spent much of his life. In the *Album of Scenic Spots of Seoul and Vicinity* (Kyŏnggyo myŏngsŭng-chŏp), painted between 1740 and 1741, he depicted a series of sights along the Han River.[75] In these leaves he opted for a more traditional composition and employed the blue and green colors that he had used in earlier works. A leaf titled *Apku-jŏng* (fig. 85) depicts a pavilion by the river built for Han Myŏng-hoe (*ho* Apkujŏng; 1415–1487), a court official of considerable power and wealth who served Kings Sejo (r. 1455–68), Yejong (r.

84 Chŏng Sŏn, *Gate Rocks at T'ongch'ŏn*, first half of the eighteenth century. Hanging scroll, ink on paper, 131.6 × 53.4 cm. Kansong Art Museum, Seoul.

1468–1469), and Sŏngjong (r. 1469–1494). The pavilion, named after Han's sobriquet, which means "intimate with the gulls," has been conspicuously placed high on a cliff overlooking the river, its banks dotted with houses of other well-to-do officials. The tall mountain to the far right can be identified as Namsan, the central mountain of Seoul. In this painting Chŏng portrayed a peaceful suburban scene of the mid-eighteenth-century Chosŏn capital.[76] An album leaf titled *Tongjak-chin* (fig. 86), which depicts the ford at the southwestern section of today's Seoul, was executed in the same style as the *Album of Scenic Spots of Seoul and Vicinity.* This area, now known as Tongjak-tong, is well known for its National Cemetery. The Han River peacefully flows in the foreground beyond which is seen the mountain done in mostly greenish colors.

Chŏng Sŏn also painted a series of landscapes titled *Chŏngp'ung-gye* that depicts a scenic valley in the northwestern part of Seoul at the foot of Mount Inwang. The largest and the best known work of his late period is the *Chŏngp'ung Valley,* or "valley stream of cool breeze" (fig. 87), dated by his inscription to 1739 (the cyclical year *kyemi*) and now in the collection of the Kansong Art Museum. A recent study by Kang Kwan-sik revealed that Chŏng's ancestors, as well as those of the powerful Andong Kim brothers who promoted Chŏng's paintings, had been living in this area for generations, at least since the early seventeenth century.[77] Kang contends that Chŏng Sŏn's great-great grandfather, Chŏng Yŏn (1541–?), and the same of the Kim brothers, Kim Kŭk-hyo (1542–1618), formed a gathering of Nine Elders (Kuro-hoe) regularly enjoyed elegant poetry and drinking parties in the Chŏngp'ung-gye area, where Kim had a grand manor. There also remains a copy of an album painting apparently produced in commemoration of an elegant gathering at Chŏngp'ung-gye, originally done in 1620.[78]

Because of special family relations between the Kims and Chŏng, all together there are at least six works of the subject, the Chŏngp'ung Valley, in various collections, making one of the most frequently painted subjects by the artist next to Mount Kŭmgang.[79] Of the six known works, four are small-scale album leaves, while two are relatively large hanging scrolls. Besides the one in the Kansong collection, another *Chŏngp'ung Valley,* probably created earlier than the Kansong painting, is in the collection of the Korea University Museum in Seoul (fig. 88). Like most scenic spots in and around Seoul that Chŏng painted, the area called Chŏng'un-dong today, has changed a great deal. However, there remains a literary piece by Kim Yang-gŭn (*ho* Tong'ya; 1734–1799) titled *P'unggye-chipsŭnggi* (Record of the scenic spots around the Chŏngp'ung Valley), written in 1766 (just seven years after Chŏng Sŏn's death in 1759), in which the thatched pavilion, the houses, rocks and trees, streams and pools, and other landscape elements are carefully described.[80]

In both the Kansong and the Korea University paintings of the Chŏngp'ung Valley, the thatched pavilion, which Kim Yang-gŭn identified as T'aego-jŏng (the Pavilion of Time Immemorial), can readily be identified under a large leafy tree

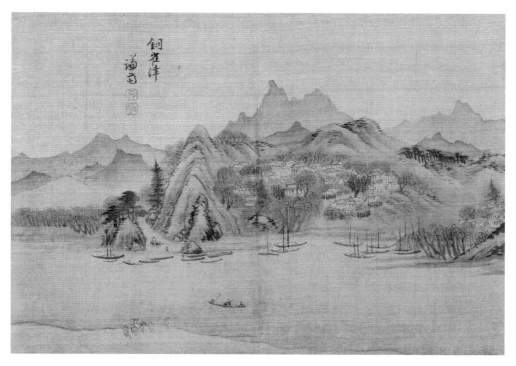

85 *(top)* Chŏng Sŏn, *Apku-jŏng*, leaf of *Album of Scenic Spots of Seoul and Vicinity*, 1740–41.
Album of twenty-five leaves, ink and color on silk, 31.2 × 41.6 cm. Kansong Art Museum,
Seoul.

86 *(bottom)* Chŏng Sŏn, *Tongjak-chin*, ca. 1744. Album leaf, ink and color on silk, 32.6 × 43.6
cm. Private collection, Korea.

87 Chŏng Sŏn, *Chŏngp'ung Valley*, dated to 1739. Hanging scroll, ink and color on silk, 133.0 × 58.8 cm. Kansong Art Museum, Seoul.

88 Chŏng Sŏn, *Chŏngp'ung Valley*, mid-eighteenth century. Framed hanging scroll, ink and color on silk, 96.5 × 36.0 cm. Korea University Museum, Seoul.

somewhere in the middle of the paintings. Although the Kansong painting is much larger than the Korea University painting, the former seems like a closer-up view of the lower two-thirds of the latter, as it shows fewer elements than the latter, each element being larger and more sparsely positioned. That is to say, the artist was more selective in composing the Kansong scroll. Instead of depicting the scenery as it is, he placed the pavilion, the big evergreen tree, and the house right in the middle, and he reduced the number of rocky boulders. Also, the boulder just behind the house was simplified to show the dark, flat, cliffside and the top with a few pine trees. In the Korea University painting, there is a smaller boulder just below this rock, and three more prominent boulders can be identi-fied. In the Kansong painting, only one large boulder on top was included. At first sight, the painting gives an impression of a flat surface with a series of dark ink facets, be it a boulder or a tree, which create a sweeping zigzag movement from the top boulder to the tree in the lower-right corner. In short, if the Korea University painting can be called a "true-view" landscape painting, the Kansong painting may be termed an "abstract" painting based on the true-view of the Korea University painting.

Chŏng Sŏn's last dated true-view landscape painting, introduced at the begin-ning of this chapter as the best example of an eighteenth-century true-view landscape painting, is *Clearing after Rain on Mount Inwang* (see fig. 1), dated by inscription to 1751.[81] It seems that in his late years Chŏng maintained an ideal balance between the simplified and "abstract" approach to forms in landscape and the depiction of "true" or "real" images of the scenery. In this painting of Mount Inwang emerging from the mist after rain, the viewer is faced with the simple and powerful rocky peaks executed with a series of bold axe-cut strokes of black ink, and the soft, mist-covered areas of the lower part of the mountain sparsely textured with the Mi ink-dots. With this harmonious combination of the contrasting treatment of the rocks and the mist, the artist was able to create an unforgettable image of Mount Inwang.

Chŏng Sŏn's Contemporaries and Followers

All eighteenth-century Korean artists painted some form of true-view land-scapes. Although Chŏng's presence was preeminent in the second quarter of the eighteenth century, there were several literati painters—such as Hŏ P'il (*ho* Yŏn'gaek; 1709–1761), Yi In-sang (*ho* Nŭnghogwan; 1710–1760), and Yi Yun-Yŏng (*ho* Yunji; 1714–1759)—who maintained relative independence from Chŏng Sŏn, even when they painted true-view landscapes. Besides being a good painter, Hŏ P'il excelled in poetry and calligraphy, especially in seal and clerical scripts, and was therefore praised as *samjŏl* (three excellences). Throughout his career he painted true-view landscapes including Mount Kŭmgang scenery. The fan-shaped *Mount Kŭmgang* (fig. 89) in the Korea University Museum is typical of

89 Hŏ P'il, *Mount Kŭmgang*, mid-eighteenth century. Framed fan, ink on paper, 21.8 × 58.8 cm. Korea University Museum, Seoul.

his dry brushwork based on his calligraphic training. The mountain fills the fan-shaped picture plane with the highest peak, Piro-bong, at its apex, and the temple Chŏngyang-sa at the bottom. Hŏ employed dry brushstrokes mostly for the depiction of the rocky peaks while applying loose Mi ink-dots rather sparsely for the surrounding earthen mountains and for what appear to be pine trees. The result is a unique representation of the Mount Kŭmgang, very different from those by Chŏng Sŏn.

Yi In-sang and Yi Yun-yŏng were particularly close friends and left paintings with inscriptions in which their friendship and time spent together at certain locations were celebrated. Both artists were also highly regarded men of letters. Yi Yun-yŏng was the fourteenth-generation descendant of the famed late Koryŏ scholar Yi Saek (*ho* Mog'ŭn; 1328–1396) whom all Yi family members from Hansan, South Ch'ungchŏng (including this author) revere as their fountainhead. Yi Yun-yŏng left many true-view landscapes of the places painted by others, such as the three fan-shaped paintings of scenery of the Kwandong area that is now in the Korea University Museum.[82]

We will examine a painting that depicts the scene with a history-laden temple titled *Koran-sa Temple* dated to 1748 (fig. 90), now in a private collection in Seoul. The painting shows the temple and the cliff along the river called Paengma-gang, or White Horse River, in Puyŏ, the last capital of the kingdom of Paekche. The cliff is called Nakhwa-am, or the Cliff of Falling Flowers. The legend has it that when the kingdom of Paekche fell in 660, three thousand Paekche court ladies plunged themselves into the river to avoid being subjugated to the combined forces of Silla and Tang China. In the inscription on the upper-left corner of the painting, the artist tells us that he and Yi In-sang were together in the spring of 1748 (*mujin* year) on

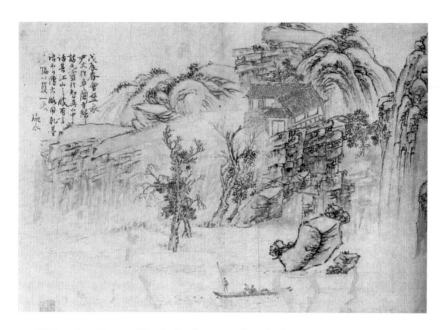

90 Yi Yun-yŏng, *Koran-sa Temple*, dated to 1748. Album leaf, ink and color on paper, 29.5 × 43.5 cm. Private collection, Seoul.

Mount Chiri, where they shared their thoughts on the beautiful scenery of Koran-sa. However, he felt that the words were inadequate to express the beauty of the scenery and decided to sketch it with dry brushstrokes. The temple is perched on top of the cliff overlooking the ever-flowing river. Yi's scene is a poignant reminder of both the history of the site and the passage of time. His sensitive use of dry brush and soft colors transforms tragic history into visual elegance and grace.

Yi In-sang could not advance to higher office because of his ancestry: his great grandfather was an illegitimate son. His last position in office was that of a magistrate of a small district, an office of the sixth rank in a bureaucracy of nine ranks.[83] He decided to retire from office in 1752, to spend the rest of his life pursuing his own interest in the arts. Yi's paintings of pine trees, the symbol of integrity, and other landscapes were done mostly in dry brushstrokes, typical of a fastidious literati painter. He also painted several Mount Kŭmgang landscapes with rather soft, wet brushstrokes.[84] Next we examine an unusual depiction of one of the sites of Mount Kŭmgang—namely, the Nine-Dragon Waterfall Pond that has been painted by many artists, including Chŏng Sŏn and Kim Hong-do.[85]

According to Yi In-sang's own inscription on the lower-left corner, his *Nine-Dragon Pond* (fig. 91), now in the National Museum of Korea, was painted in 1752, fifteen years after he had visited the site. He said in his inscription that he painted it using a brush that was all worn out with very light ink. Thus he was barely able to draw the "bone," let alone the "flesh" of the scenery. Indeed, if we compare the painting of the same site by Kim Hong-do (fig. 113), or the photograph of the site (fig. 134), Yi In-sang's painting seems "ethereal," like a ghostly echo of the lush

91 Yi In-sang, *Nine-Dragon Pond*, dated to 1752. Hanging scoll, ink and light color on paper, 118.2 × 58.5 cm. National Museum of Korea, Seoul.

waterfall and the rocky cliff of Kim's version. The waterfall looks like a bundle of very fine threads hanging on the cliff surface. Some rock forms on either side of the waterfall delineated with sharp lines look very different from the actual site, which makes us think that Yi did this painting from his memory of long ago. It is truly a landscape not viewed through the artist's eye, but rather one viewed through his mind, to which we can apply the phrase "images of mind."[86] The painting seems to reflect his lonely life away from home and family while serving as the district magistrate of Ŭmjuk, the position he soon abandoned for retirement. Although it purports to be a true-view landscape, his *Nine-Dragon Pond* is a world apart from any other true-view landscapes of most eighteenth-century painters.[87]

Unlike Yi In-sang and Yi Yun-yŏng, younger contemporaries of Chŏng Sŏn who painted true-view landscapes inevitably fell under his influence. His long and prolific career, mostly spent in the capital, and his friendship and close association with the most learned, sophisticated, and powerful figures (such as the Kim brothers and the poet Yi Pyŏng-yŏn) of the time naturally attracted many younger artists to him. Modern scholars speak of the "followers of Kyŏmjae"

(Kyŏmjae ilp'a) or the School of Chŏng Sŏn (Chŏng Sŏn p'a), although these designations were not current in the eighteenth century.[88] As a concept, the School of Chŏng Sŏn is not particularly meaningful when we consider that the adoption or emulation of Chŏng's style was not confined to any generation or social classes. However, it has by now become firmly established as a term in Korean art history for referring to a wide range of artists whose paintings show traces of direct or indirect influences of Chŏng Sŏn's art.

It is customary to divide Chŏng Sŏn's followers into two groups, distinguished primarily by their age. The first group includes those born before the 1740s: Kim Yun-gyŏm (*ho* Chinjae; 1711–1775); Ch'oe Puk (*ho* Hosaenggwan; 1712–ca. 1786); Chŏng Hwang (*ho* Son'am; 1735–?), Chŏng's grandson; and Kang Hŭi-ŏn (*ho* Tamjol; 1738–before 1784). Most of them were Chŏng Sŏn's pupils. Of this group Ch'oe Puk might not be pleased to be included here. Ch'oe was an exceptionally free and eccentric artist, and his paintings display strong personal characteristics that outweigh any affinity with Chŏng Sŏn's style.

The second group is composed of artists born after the 1740s and thus active during the late eighteenth century and early nineteenth century: Kim Ŭng-hwan (*ho* Tamjoltang; 1742–1789); the brothers Kim Tŭk-sin (*ho* Kŭngjae; 1754–1852) and Kim Sŏk-sin (*ho* Ch'owon; 1758–?); among others. One artist who is not usually included in this group is Sim Sa-jŏng (*ho* Hyŏnjae; 1707–1769). He was a member of the *yangban* class but was not permitted to hold office because his grandfather had participated in the attempted coup against the Crown Prince, the future King Yŏngjo. Although Sim Sa-jŏng is often referred to as Chŏng Sŏn's disciple, there is little evidence to support this identification.[89] Kim Yu-sŏng (*ho* Sŏam; 1725–?) is also considered a follower of Chŏng, and in fact he painted true-view landscapes of the temple, Naksan-sa, and Mount Kŭmgang dated to 1764, just after he went to Japan as an official painter accompanying the Korean Mission to Japan in 1763.[90] But, as the professor of art history Burglind Jungmann has shown, Kim Yu-sŏng is usually given credit for his role in transmitting Southern School painting styles to Japan.[91]

Kim Yun-gyŏm was an illegitimate son of Kim Ch'ang-ŏp, one of the Kim brothers who were patrons of Chŏng Sŏn. Thus Kim Yun-gyŏm might have had an opportunity to learn painting from Chŏng.[92] He left many true-view landscape paintings of the Mount Kŭmgang area, including the eastern coastal regions, and also of the southern part of the peninsula. *Myogilsang* (fig. 92), a leaf from the *Album of Paintings of Mount Kŭmgang*, twelve leaves in all, was painted in 1768. The artist's inscription appears on the upper-right corner of the painting: "Playfully done in winter of the year *muja* [1768] to fulfill a long overdue promise to the Venerable Tae [T'ae'ong]."[93] Myogilsang, another name for Manjushri, the bodhisattva of wisdom, which became the title of this painting, comes from the name of a temple, Myogilsang-am. This Koryŏ dynasty temple had been laid waste in the late Chosŏn period, leaving only the rock-cut image, *Myogilsang Buddha* (fig. 93), carved in the late Koryŏ period.[94] Therefore the image itself is

92 *(top)* Kim Yun-gyŏm, *Myogilsang*, leaf 8 of *Album of Paintings of Mount Kŭmgang*, dated to 1768. Album of twelve leaves (four leaves missing), ink and light color on paper, 27.7 × 38.8 cm. National Museum of Korea, Seoul.

93 *(bottom)* *Myogilsang Buddha,* rock-cut image of the Buddha, late Koryŏ period. Height about 15 m. Inner Mount Kŭmgang, Hoeyang, Kangwon-do. Photograph by Yi T'ae-ho.

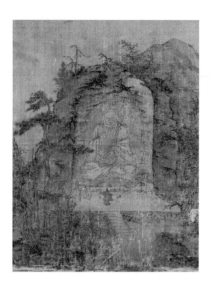

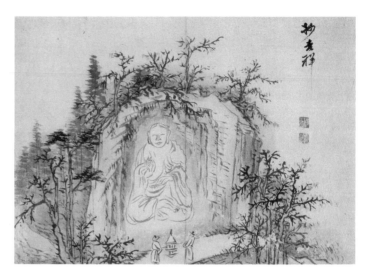

94 Kim Hong-do, *Myogilsang,* late eighteenth century. Ink and light color on paper, 52.6 × 41.5 cm. (detail) National Museum of Korea, Seoul.

95 Ŏm Ch'i-uk, *Myogilsang,* early nineteenth century. Album leaf, ink and light color on paper, 27.9 × 38.8 cm. National Museum of Korea, Seoul.

not that of Myogilsang but that of the Buddha. In this painting Kim employed soft, wet brushwork and light colors to create an overall effect of tranquility, which contrasts strongly with the awe-inspiring images of jagged cliffs and rocky peaks in Chŏng Sŏn's paintings. The elder artist's legacy can be found in the simplified vertical depiction of the background, in the rocky face of the Buddha, and in the straight and simple depiction of the trees.

When we compare Kim's depiction of the seated Myogilsang with the Koryŏ period image, we realize that Kim did not really care about the similarity with the real image, but he interpreted it freely or more in human terms. Kim Hong-do (1745–1806) and Ŏm Ch'i-uk (active in the nineteenth century) also painted the same site with the figure of the Buddha in the center (figs. 94 and 95), and like Kim Yun-gyŏm, they also infused their own personalities into their "true-view" paintings.[95] It is evident that these artists relied more on their memories than on the actual observations when they painted these "true-view" paintings; even the size and the form of the stone lantern and the relative position of the lantern to the Buddha are quite different in all three paintings.

Ch'oe Puk was a professional painter from the *chung'in* class, whose exceptional talent in poetry, painting, and calligraphy brought him into contact with contemporary literati.[96] He executed a number of paintings that have placed him among the members of the School of Chŏng Sŏn. One of these is the well-known painting titled *P'yohun-sa* (fig. 96). The temple can be spotted in the center of Chŏng Sŏn's undated *General View of Inner Mount Kŭmgang* (see fig. 77), just below the tall column of boulders called Kŭmgang-dae, or Diamond Terrace.

96 Ch'oe Puk, *P'yohun-sa*, late eighteenth century. Album leaf, ink and light color on paper, 38.5 × 57.3 cm. Private collection.

Together with Chŏngyang-sa and Chang'an-sa, the temple is one of the most frequently painted sites of Mount Kŭmgang. In his composition here, Ch'oe Puk has placed the temple compound on the far left so that it stands just beyond the earthen peaks. His viewpoint seems quite high so that his painting has ample space for the stone bridge and the stream, behind which rises a screen of rocky peaks. The needle-like peaks in the far distance, the identifying feature of Mount Kŭmgang, add to the sense of distance and space. Ch'oe's brush lines are not as sharp as those of Chŏng Sŏn's vertical strokes, and more on the blunt side, which shows his own personal traits.

Kang Hŭi-ŏn was a court meteorologist belonging to the *chung'in* class.[97] He was taught painting by Chŏng Sŏn at the latter's home in the northern part of Seoul. His paintings therefore display Chŏng's influence in subject matters as well as brushwork. His album leaf *Mount Inwang Seen from Tohwa-dong* (see fig. 58) depicts the scenery on the opposite side of the same mountain as shown in Chŏng Sŏn's *Clearing after Rain on Mount Inwang* (see fig. 1).[98] The sweeping strokes of dark ink on the apex of the mountain similar to axe-cut texture strokes, and the lavish use of Mi ink-dots as well as the simplified rendering of the pine trees, are all evidence of Chŏng Sŏn's influence. The critic and painter Kang Se-hwang's inscription on this painting was quoted at the beginning of this chapter, where the meaning of the term *chin'gyŏng* was discussed.

In Kang's inscription (the artist's "not sacrificing the [old] master's methods") includes indebtedness to Chŏng Sŏn. However, more surprising in this painting is Kang Hŭi-ŏn's use of light blue to define the empty space in the upper part of

97 Kang Hŭi-ŏn, *Morning Fog over the North Palace*, late
eighteenth century. Album leaf, ink and light color on paper,
26.0 × 21.5 cm. Private collection, Seoul.

the painting as the sky. Although Chŏng Sŏn's *Complete View of Mount Kŭmgang*
in Leeum, Samsung Museum of Art (see fig. 76) shows some blue color around
the rocky peaks, the master did not treat the space above the mountain peaks
as the real sky as Kang has done. Kang's use of modulated blue here makes this
painting perhaps the most "natural" depiction of the sky in eighteenth-century
Korean painting. Both the title of the painting written on the upper right and
Kang Se-hwang's inscription on the upper left seem to be suspended in the blue
sky. Here we are reminded of the remark by Hong Tae-yong (*ho* Tamhŏn; 1731–
1783), who visited Yanjing in 1765 and saw a wall painting in the northern hall of
the observatory in the capital, "even to the faraway limits of the sky right colors
were applied." What is meant by the "right colors," of course, is the natural color
of the sky. Kang Hŭi-ŏn, being a court meteorologist, might have been more con-
scious about the true color of the sky. He might also have had a chance to look at
Western paintings brought back to Korea by the Chosŏn emissaries to Yanjing.

Another "natural" and "weather-sensitive" painting that reflects the influence
of the Western linear-perspective system is Kang Hŭi-ŏn's *Morning Fog over the
North Palace* (Pukkwŏl chomu-do) (fig. 97). The painting depicts the broad ave-
nue at whose end appears Kwanghwa-mun, the main gate to the Kyŏngbok Pal-

ace. Since the palace is situated at the northern end of the inner wall of Hanyang, it is sometimes referred to as *pukkwŏl*, or the North Palace. The entire scene is bathed with heavy fog through which trees, figures, and the palace rooftops can barely be seen. The broad avenue narrows as it approaches the palace gate in what seems like a one-point perspective drawing, and the size of the figures from the foreground to the back diminishes accordingly. Thus a feeling of vast space and depth is created. Kang Se-hwang's colophon attached to the painting reads: "The artist told me that his leather shoes were dampened by the morning fog while waiting for the fog to descend on the area. Having heard this, I appreciate better the wondrous qualities of this painting." This means that the artist had waited for a long time to capture in his painting the fog's special atmospheric effect over the palace. There are other paintings that depict the effect of the fog or mist over landscapes, but this painting stands out as one of the best of this kind, perhaps because of the artist's special knowledge of the natural atmosphere.

Among the second-generation followers of Chŏng Sŏn, Kim Ŭng-hwan can be singled out as the most devoted painter of true-view landscapes. Kim's style, unlike other followers of the master, reveals fewer personal characteristics. His *Complete View of Mount Kŭmgang* (fig. 98), painted for Kim Hong-do with whom he served in the court bureau of painting at the same time, bears the inscription: "In the spring of the cyclical year *imjin* [1772], Tamjol-tang painted [this] for Sŏho[Kim Hong-do] in imitation of the *Complete View of Mount Kŭmgang*." Although the inscription does not specify whose "complete view" is imitated, there are obvious similarities to Chŏng Sŏn's work. As in Chŏng's work, Kim's painting depicts both rocky and earthen peaks. Here the earthen peaks appear in the left corner of the composition, sheltering in ascending order the three famous temples of Chang'an-sa, P'yohun-sa, and Chŏngyang-sa. Also, Kim has made liberal use of Mi ink-dots combined with light blue ink washes to the rocky peaks, which are drawn in outlines. These similarities are rather superficial, as the landscape conveys nothing of the majestic effect of the mountain as evoked by Chŏng Sŏn in his paintings. Instead, there is a great deal of mannerism and stylization suggesting that Kim Ŭng-hwan copied this scene "in imitation of Chŏng Sŏn's painting," and not from firsthand observation. This imitative quality is particularly evident in the rigid repetition of the V-shaped valleys. But this painting also serves as an important precedent of being a work produced by a Korean court painter "in imitation" of a Korean, not a Chinese master.[99]

Of the brothers Kim Tŭk-sin and Kim Sŏk-sin, the former is usually discussed in the context of the late Chosŏn period genre painting although both painted landscapes.[100] Kim Sŏk-sin's well-known album leaf *Tobong-do* (fig. 99) depicts the scenic view of Mount Tobong, which is now within the northern city limits of Seoul but was outside of Chosŏn capital, Hanyang.[101] The Prominent peak, Insu-bong, is seen on the left half of the leaf. As Chŏng Sŏn did in his *Clearing after Rain on Mount Inwang*, Kim used the dark ink strokes to portray the brilliant granite peak. Kim seems to have exaggerated the lesser peaks to the

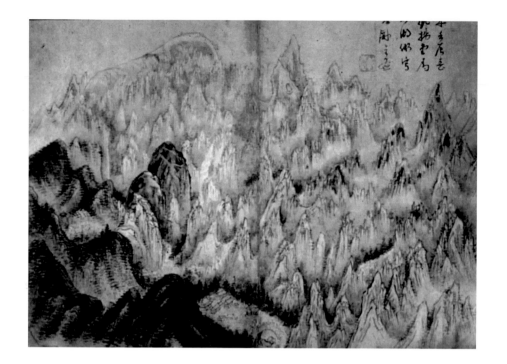

98 *(top)* Kim Ŭng-hwan, *Complete View of Mount Kumgang*, dated to 1772. Album leaf, ink and light color on paper, 22.3 × 35.2 cm. Private collection, Korea.

99 *(bottom)* Kim Sŏk-sin, *Mount Tobong*, early nineteenth century, leaf from the album *Tobong-chŏp*, ink and light color on paper, 36.6 × 53.7 cm. Private collection, Seoul.

left of the Insu-bong to make them resemble Chŏng Sŏn's depiction of Mount Kŭmgang's rocky peaks. This shows how powerful Chŏng's influence was on the post–Chŏng-era painters.

The Second Phase of True-View Landscape Painting: Kang Se-hwang (1713–1791), Kim Hong-do (1745–1806), and Others

Next we discuss works of those painters who reached a new height in the development of true-view landscape painting, be they professional or literati painters. By the late eighteenth century, the artistic milieu was so fluid that it seems unnatural to distinguish the painting styles by the painters' social status. Brush idioms of Chinese literati painting, such as Mi ink-dots or hemp-fiber texture strokes, were freely adopted by all classes of painters when they painted landscapes, be they true-view or traditional themes derived from Chinese landscape motifs. All court painters belonged to the *chung'in* or "middle people" class (the technical or commercial class), but by the late eighteenth and early nineteenth century, a new group of *chung'in*, mostly court translators who were well versed in Chinese Classics, joined the world of high culture hitherto reserved for the *yangban* class.[102] The second phase of true-view landscape painting should be understood in the context of this transformed artistic milieu.

The leader in this new art scene is definitely the famous critic and scholar-official painter Kang Se-hwang, whose critical remarks on other painters' works in the form of inscription or colophon have been quoted earlier in this chapter.[103] His attitude of stressing the importance of "adhering to old masters methods" was made known in the inscription on Kang Hŭi-ŏn's *Mount Inwang Seen from Tohwa-dong* (see fig. 58). However, he seems to have been equally interested in the depiction of scenery as the eye saw it. Kang Se-hwang's true-view "pilgrimage" to Kŭmgang-san took place in 1788, and he recorded it in a travel diary as well as in paintings.[104] During this trip he met by chance Kim Hong-do and Kim Ŭng-hwan. The two younger artists were sketching the scenery of the famous mountain by the order of King Chŏngjo. In the preface to a short piece bidding farewell to Kim Hong-do and Kim Ŭng-hwan, Kang Se-hwang praised the two for their skillful and beautiful rendering of Mount Kŭmgang: "Some say that if mountains and waters had spirits, they would abhor being portrayed in such minute detail. But I don't think so. When people want to have their portraits painted, they invite the best painter and treat him with propriety. They will be satisfied if their portraits finally resemble them closely without missing a hair. Therefore, I think the mountain spirit would not abhor this utmost likeness of their images."[105] Since Kang himself was a portrait painter who left several self-portraits, his analogy between portraits and true-view painting is natural and understandable. On one occasion, comparing the paintings of Mount Kŭmgang by Chŏng Sŏn and Sim Sa-jŏng, he complained that Chŏng's paintings did not

100　Kang Se-hwang, *Approach to Yŏngt'ong-dong*, leaf from the *Album of a Journey to Songdo*, ca. 1757. Album of sixteen leaves, ink and light color on paper, 32.8 × 53.4 cm. National Museum of Korea, Seoul.

achieve the true likeness of the mountain because Chŏng had painted it in a disorderly manner using hemp-fiber texture strokes.[106]

Chapter 2 discussed Kang's interest in Western painting techniques, expressed in his realistic rendering of his self-portraits and in his colophon to Kim Tŏk-sŏng's painting.[107] His interest in realistic depiction of the landscape as well as other elements of Western painting techniques—such as perspective, correct sense of depth and distance, and adherence to traditional methods—can best be seen in his *Album of a Journey to Songdo* (Songdo kihaeng-chŏp).[108] Although the album does not bear a date, there is convincing evidence that the paintings were done in 1757, when Kang made a trip to Songdo at the age of forty-five.[109] The album is a truly novel work in that the artist expressed his firsthand impression of the unusual scenery he saw on the journey with such fresh feelings.

The seventh leaf, *Approach to Yŏngt'ong-dong* (Yŏngt'ongdong-gu) (fig. 100), perhaps epitomizes the spirit of the album. Kang's own inscription aptly describes the wondrous scene: "The stones at the approach to Yŏngt'ong-dong are as big as houses. They are even more surprising because they are covered with green moss. It is said that a dragon rose out of the pool here, but that is rather incredible. Nonetheless, this is a rare sight to behold." Enormous boulders occupy most of the foreground, their imposing size punctuated by the tiny figure of a traveler astride a donkey followed by the even smaller figure of a servant as the pair heads

101 Kang Se-hwang, *Taehŭng-sa*, leaf from the *Album of a Journey to Songdo*, ca. 1757. Album of sixteen leaves, ink and color on paper, 32.8 × 53.4 cm. National Museum of Korea, Seoul.

toward the narrow gorge on the right. The rocks are outlined with sharp ink and colored with light blue and green mixed with ink and earth colors. The effect is fresh and transparent, very similar to a Western watercolor. Beyond these rocks and to the right of the gorge, earthen peaks seem to rise softly. The effect was achieved by Kang's use of Mi ink-dots, which creates an impression of shading. The rocks diminish in size as they become more distant, and the gorge narrows as it winds into the mountains. This careful attention to the scale gives the viewer an unambiguous sense of depth and distance. The album's first leaf, *The View of Songdo*, is usually cited as a painting that reflects the semblance of the Western one-point perspective in its depiction of Songdo's main avenue receding into the background.[110]

The fifth leaf, *Taehŭng-sa* (fig. 101), however, reflects another interesting aspect of Western influence in that the painter's viewpoint—that is, looking up from below, or from the ground—can be clearly discernible in the depiction of the underside of the temple roof's eve on the left.[111] Although three other smaller structures that frame the courtyard do not adhere to the same viewpoint, perhaps because of their distance from the painter's eye, they are arranged in perspective to create a feeling of depth. No Korean painting before this one shows the underside of the temple roof, as if looking up from the ground, showing the colorful wooden members of the brackets under the eve. Kang Se-hwang's care-

ful observation and the innovative application of the actual viewpoint of the artist makes this painting one of the milestones on the road to modernity in Korean painting history.

Kim Hong-do, whose name is almost synonymous to Korean genre painting, also left a sizable body of true-view landscape paintings.[112] He worked closely with Kang Se-hwang from his childhood and later, in 1774, they served briefly together at the court bureau called *sap'o-sŏ* that oversaw palace gardens and vegetable fields.[113] Perhaps through his closeness to Kang, he was also keenly aware of the new trends in painting. As mentioned earlier, in 1788 he went to Mount Kŭmgang under the order of King Chŏngjo, who wanted the artist to visit the famous scenic spots and sketch the scenery on the spot based on the artist's direct observations. According to Kang Se-hwang, Kim Hong-do and Kim Ŭng-hwan sketched more than one hundred scenes of Mount Kŭmgang and the vicinity.[114]

A set of eight undated hanging scrolls that depict various aspects of the Mount Kŭmgang area, known as *Sea and Mountains* (Haesan tobyŏng) in the collection of the Kansong Art Museum, has been considered to be the works produced soon after his 1788 trip to Mount Kŭmgang.[115] Of these, the fifth scroll, *Immortal-Calling Pavilion* (Hwansŏn-jŏng) (fig. 102), displays Kim's receptive attitude toward Western perspective techniques.[116] The unusual formation of the rocks along the eastern coastal region of Mount Kŭmgang, known as *ch'ongsŏk* (or "bundle-stones") are captured in the foreground, while in the distance the low-lying hills and the zigzag coastal lines gradually recede. About the midpoint to the right, one can spot the Immortal-Calling Pavilion on the flat terrace by the cone-shaped bundle-stones. The vastness of the space created by the diminishing size of the small peaks in the background, as well as the application of the atmospheric perspective in this scene, makes this painting technically one of the most "advanced" of the late eighteenth century. The inscription, although not by the artist, expresses the wonders of the rock formation and presumed it to be the playfulness of the divine creator when he was too busy.

In the second scroll, *Flying-Phoenix Waterfall* (Pibong-p'ok) (fig. 103), one can discern Kim's close observation of nature without sacrificing traditional brush methods. Kim used the lotus vein and horse-tooth texture strokes to convey the unusual formation of the rock surface of a cliff more than a hundred meters high, from the top of which "flies" the narrow streaks of the waterfall. A comparison of this painting with a recent photograph of the actual waterfall (fig. 104) shows how the artist transformed nature while remaining faithful to the site's natural features. Painted on silk, this set of paintings reveals more deliberate, less relaxed brushwork than that of Kim's 1795 *Album of the Ŭlmyo Year* or the 1796 *Album of the Pyŏngjin Year,* which also contain true-view landscapes.[117]

Painted when Kim Hong-do was fifty years old, the 1795 *Album of the Ŭlmyo Year* now consists of only three leaves, while the original form remains unknown. On the leaf titled *Ch'ongsŏk-chŏng* (Bundle-stones pavilion) (fig. 105), which depicts the pavilion near the bundle-stones, there is an inscription: "Painted in

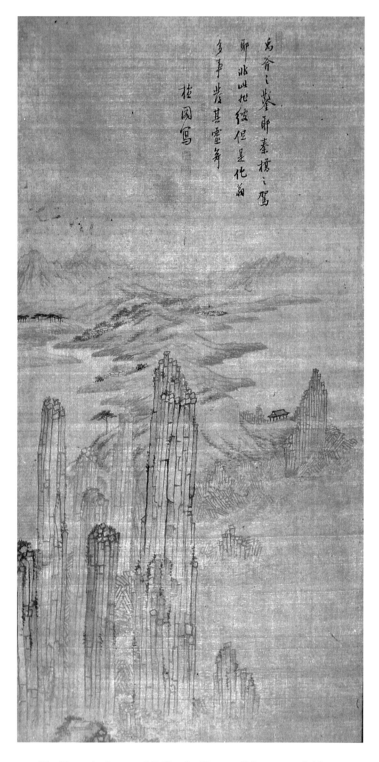

102 Kim Hong-do, *Immortal-Calling Pavilion*, scroll from a set of eight hanging scrolls, *Sea and Mountains*, late eighteenth century. Ink on silk, 91.4 × 41.0 cm. Kansong Art Museum, Seoul.

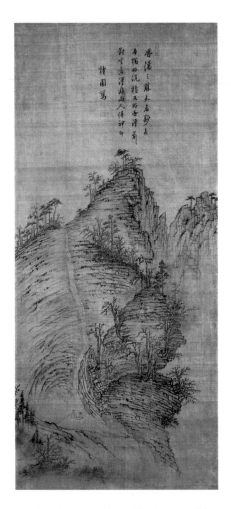

103 Kim Hong-do, *Flying-Phoenix Waterfall*,
scroll from a set of eight hanging scrolls, *Sea
and Mountains*, late eighteenth century. Ink
on silk, 91.4 × 41.0 cm (detail). Kansong Art
Museum, Seoul.

104 Pibong-p'ok (Flying-Phoenix Waterfall),
Mount Kŭmgang, Kangwon-do, 1999.
Photograph by Yi Sŏng-mi.

mid-autumn of the *ŭlmyo* [1795] year, and presented to Kim Kyŏng-rim."[118] The
painting represents essentially the same bundle-stone pillars shown in Kim's
Immortal-Calling Pavilion, but this time they are viewed from a slightly different
angle so that the background would mostly be the Eastern Sea, and the pavilion,
Ch'ongsŏk-jong, appears to the right on a plateau with a few pine trees. The view
of the unusual rock formations by the sea was captured from yet another angle
in a recent photograph (fig. 106). In Kim's painting the stone pillars were ren-
dered much slenderer than they actually are, and the Eastern Sea beyond them
was given an equal emphasis so that there is an ample feeling of spatial depth.
Such slender depiction of the columns deviates much from the actual scenery,

105 *(above)* Kim Hong-do,
Ch'ŏngsŏk-chŏng (Bundle-stones
pavilion), leaf from the *Album
of the Ŭlmyo Year*, 1795. Ink and
light color on paper, 23.2 × 27.7
cm. Private collection, Korea.

106 *(left)* Ch'ŏngsŏk-chŏng,
Coastal Mount Kŭmgang,
Kangwon-do, 1998.
Photograph by Yi T'ae-ho.

but the artist exercised his freedom in his composition, which is not unusual in true-view landscape paintings. The brushwork in general conveys a feeling of relaxation and ease, often found in Kim Hong-do's late works in which he seems to be more inclined toward the spirit of literati painting.[119]

The three true-view landscapes contained in the 1796 *Album of the Pyŏngjin Year* are from the series of scenery collectively known as the Eight Scenes of Tanyang in South Ch'ungch'ŏng Province. The leaf *Oksun-bong* (Bamboo-shoot pinnacles), which bears the cyclical date as well as the artist's signature and seals, features a group of rocky columns emerging from an earthen mound (see fig. 126). Another leaf, *Sa'in-am* (Official's rock) (fig. 107), represents a large clifflike rock formation in front of a stream. It seems that Kim Hong-do took considerable compositional freedom and deviated somewhat from the rock's original shape, as can be seen in a comparison between the photograph taken from an approximately same viewpoint and the painting (fig. 108). Kim's intention was to emphasize the rock's majestic appearance against the mountain's backdrop. Kim employed folded-ribbon texture strokes in delineating the patterns of the rectangular texture on the cliff's surface. This is the texture stroke originally developed by the Yuan dynasty painter Ni Zan (1301–1374) and later became one of the stylistic elements of Southern School literati painting in China as well as in Korea. Thus Kim Hong-do, in his late years, even when doing signature Korean true-view landscapes, worked both compositionally and technically with a great deal of individual freedom.

Two painters of different background, the court painter Yi In-mun (*ho* Kosong yusugwan; 1745–1821) and the literati painter Chŏng Su-yŏng (*ho* Chiujae; 1743–1831), who were born around the same time but outlived Kim Hong-do, deserve mention at this point. Yi In-mun's true-view landscape paintings generally show technical similarities to those of Kim Hong-do in many cases as they both worked in the court bureau of painting. However, Yi In-mun's other landscape paintings display his broad and deep understanding of the techniques of various Chinese masters. Because of Kim Hong-do's domineering position at the bureau, however, Yi In-mun seems to have been in Kim's shade much of the time, and therefore the artistic value of his paintings has been underestimated. Chŏng Su-yŏng comes from an illustrious family of scholars of the School of Practical Learning. His great-grandfather was Chŏng Sang-gi (1678–1752), the famed cartographer who made the Map of the Eastern Nation (Tongguk chido). Following the family tradition, Chŏng Su-yŏng also traveled widely and left a large body of true-view landscape paintings.

Among Yi Yin-mun's paintings, perhaps the album leaf *Mount Kŭmgang Viewed from Tanbal-ryŏng Ridge* (Tanbal-ryŏng mang Kŭmgang) (fig. 109) can be singled out as the work that displays Yi's personal style. Here the artist gives us a dramatic view of the mountain emerging in the distance from a sea of dense fog. A recent photograph of the rocky peaks of Mount Kŭmgang (fig. 110) shrouded in clouds approximates the upper portion of Yi's painting. Yi Man-bu, the well-known

107 *(top)* Kim Hong-do, *Sa'in-am* (Official's rock), leaf from the *Album of the Pyŏngjin Year*, 1796. Album of twenty leaves, ink and light color on paper, 26.7 × 31.6 cm. Collection of Leeum, Samsung Museum of Art, Seoul.

108 *(bottom)* Sa'in-am (Official's rock), Tanyang, North Ch'ungch'ŏng-do, 1992. Photograph from *Encyclopedia of Korean People and Culture*, vol. 6, p. 108.

109 *(top)* Yi Yin-mun, *Mount Kŭmgang Viewed from Tanbal-ryŏng Ridge*, late eighteenth century. Album leaf, ink and light color on paper, 23.0 × 45.0 cm. Private collection, Korea.

110 *(bottom)* Rocky Peaks of Mount Kŭmgang, Kangwon-do, ca. 1998. Photograph courtesy of the *Chung'ang Ilbo*, Seoul.

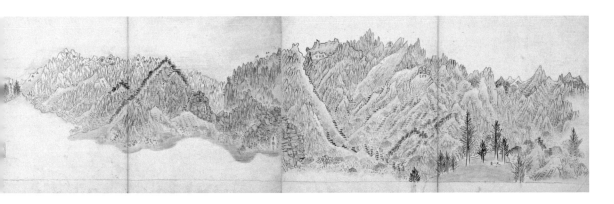

111 Chŏng Su-yŏng, *Mount Kŭmgang Viewed from Chŏnil-Terrace*, four leaves from the
Album of Sea and Mountains (Haesan-chŏp), dated to 1799. Album of twenty-six leaves, ink
and light color on paper, 37.2 × 123.8 cm. National Museum of Korea, Seoul.

scholar and author of *Records of Traveling in the Land* (Chihaeng-rok), recorded
his travel experience after visiting the same spot:

> After following the trail for thirty *li* [approximately twelve kilometers],
> I reached the summit of a hill called Tanbal-ryŏng, a ridge of Mount
> Chŏnma. . . . [Mount] Kŭmgang rose to the east. Everywhere I turned, its
> peaks soared, looking like jewels, silver, snowflakes, and ice, stacked one atop
> another, until they reached heaven and there was no more sky to behold in
> the east and beyond. . . . Monk Hyemil said, "People who come here to view
> Mount Kŭmgang regret [seeing] the dense clouds that always obscure the
> mountain top, but today the sky is absolutely clear, allowing a clear view of
> the summit. How lucky you are to have such a rare opportunity."[120]

In this painting Yi In-mun created a unique image of Mount Kŭmgang consist-
ing of discrete yet interrelated landscape elements and a heavy reliance on ink
wash to impart volume and rhythm to the icicle-like distant peaks. The painting
is completely comprehensible without reference to Chŏng Sŏn or Kim Hong-do.

Chŏng Su-yŏng, being an independent literati painter, also worked in a style
that does not have any echoes of the earlier true-view masters' styles. His avid
travel resulted in many depictions of the scenic spots along the Han River and
also of the Mount Kŭmgang area. His *Album of Sea and Mountains* (Haesan-
chŏp) was produced two years after his trip to the area in 1797. The album con-
tains twenty-two leaves of paintings and two leaves of calligraphy of his travel
diary *Records of Travel to the East* (Tongyu-gi).[121] The paintings were done either
on single or double leaves, or sometimes four consecutive leaves are given for
one scene. Such is the sixth painting in the album, which forms an image of a
vast expanse of landscape titled *Mount Kŭmgang Viewed from Chŏnil-Terrace*
(Chŏnil-tae mang Kŭmgang) (fig. 111). Many of the topographical features and

names of temples are identified by inscriptions next to them. The sense of space is enhanced by the pronounced recession of the mountains in the left half of the painting. Chŏng wrote in his *Records of Travel to the East*: "When I reached to the top of the hill, the whole area was filled with an expanse of clouds spreading horizontally, reaching to the sky."[122]

The Final Phase of True-View Landscape Painting

POPULARIZATION AND DECLINE OF THE MOUNT KŬMGANG THEME

During the half century after the death of Chŏng Sŏn, true-view landscape painting reached a new height with paintings by artists Kang Se-hwang, Kim Hong-do, Yi In-mun, and others. By the beginning of the nineteenth century, true-view landscape painting was no longer a special genre of landscape painting but within the vocabulary of every painter, be they professional, literati, or *chung'in* class painters. Mount Kŭmgang paintings had become so popular, they were being mass-produced. In this context we examine the set of five albums of Mount Kŭmgang that are attributed to Kim Hong-do.

As mentioned, Kim Hong-do and his fellow court painter Kim Ŭng-hwan took a sketching trip to Mount Kŭmgang under King Chŏngjo's order. Some scholars have linked this trip with the set of five albums, each containing twelve leaves of paintings and inscribed with the title *Kŭmgang Chŏndo* (Complete view of Mount Kŭmgang).[123] This set of five albums came to light for the first time in 1995 under the title *Album of the Four Districts of Kŭmgang* (Kŭmgang sagun-chŏp), at the exhibition that celebrated the 250th anniversary of Kim Hong-do's birth, organized jointly by the National Museum of Korea and the Samsung Foundation of Culture.[124] Although the presence of a body of Mount Kŭmgang paintings by Kim Hong-do was known by various literary sources, this newly "released" set of albums and the documentary evidence were less than tightly linked, making it difficult to identify the set with what were mentioned in literary sources.[125] However, since this set of albums came to be known by the new title, *Album of the Four Districts of Kŭmgang* (Kŭmgang sagun-chŏp), when it made its public appearance, I refer to it by its new title here. This will also avoid the confusion with other paintings called *Complete View of Mount Kŭmgang*.

It is generally agreed that the two intaglio seals reading "Tanwon" (the artist's sobriquet) and "Hong-do" on the upper part of each of the album's sixty leaves, as well as the calligraphy of the inscribed titles that identify the sites on each leaf, are spurious.[126] The leaves in the *Four District* album are characterized by crisp brushwork, well-defined forms, and the use of cool, light colors. Above all, the sense of immense space, the sharp definition of the rocks, and the distinctness of forms result in a certain surreal quality. It is true that Kim's hanging scroll

112　Kim Hong-do, *Tanwon-do*, 1784.
Hanging scroll, ink and light color on paper,
135.0 × 78.5 cm. Private collection.

113　Kim Hong-do, *Nine-Dragons
[Waterfall] Pond*, scroll from a set of eight
hanging scrolls, *Sea and Mountains*, late
eighteenth century. Ink on silk, 91.4 × 41.0
cm. Kansong Art Museum, Seoul.

Immortal-Calling Pavilion (Hwansŏn-jŏng)" (see fig. 102) also conveys a great
sense of distance, but it does not give us the "surreal" feeling as some of the
Four District Album paintings do. Although the organizers of the 1995 exhibition
accepted the *Four Districts* set as Kim Hong-do's work, there are other scholars
who expressed dissenting opinions including myself.[127]

Kim Hong-do's works of the mid-1780s and later tended to show more relaxed
brushwork as seen in the famous hanging scroll *Tanwon-do* (fig. 112), which shows
his own home and garden, dated to 1784. A comparison between the undated
Nine-Dragons [Waterfall] Pond (Kuryong-yŏn) (fig. 113), which is one of the eight
paintings of the set *Sea and Mountains* in the Kansong Art Museum, and the
painting of the same scene from the *Four District Album* (fig. 114) also reveals two
distinct approaches to representation, not to mention the brushstrokes. The for-
mer adheres to the realistic approach to form, enough to give us the feeling of the

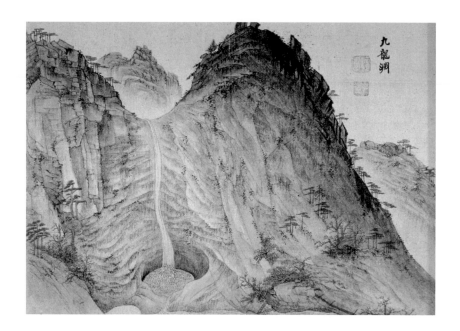

114 *(top)* Kim Hong-do, *Nine-Dragons [Waterfall] Pond* (Kuryong-yŏn), leaf from the *Album of the Four Districts of Kŭmgang,* date undetermined. Set of five albums with sixty leaves, ink and light color on silk, 30.4 × 43.7 cm. Private collection, Seoul.

115 *(bottom)* Kim Hong-do, *Chʼŏngsŏk-chŏng* (Bundle-stones pavilion), leaf from the *Album of the Four Districts of Kŭmgang,* date undetermined. Set of five albums with sixty leaves, ink and light color on silk, 30.4 × 43.7 cm. Private collection, Seoul.

rocks and trees in nature with soft but powerful brushstrokes and ever-changing ink tones, while in the latter the artist seems to have striven to capture every little detail to the degree of being surreal. Kim Hong-do was very much aware of Western realism, which he adopted to a certain degree but not as exaggerated as here. A comparison of a leaf, *Ch'ŏngsŏk-chŏng* (Bundle-stones pavilion) (fig. 115), from the *Four District Album* with a leaf of the same scene from the 1795 *Album of the Ŭlmyo Year* (see fig. 105) also shows the same kind of difference. The two leaves differ vastly both in the use of the brush and the handling of the space. The tense delineation of the rocks and the pavilion in the *Four Districts* leaf as well as the poor choice of an artificial horizon line for the seascape seem alien to the treatment of the same elements in the 1795 album leaf. There, Kim achieved the sense of distance by the gradually fading waves out to the distant sea.

The importance of attributing the *Four District Album* to Kim Hong-do, however, cannot be underestimated as there are three other known sets of albums that share nearly identical compositions. The first set, the *Album of Sea and Mountains* (Haesan-ch'ŏp), attributed to Kim Hong-do, consists of forty leaves.[128] The second set, *Album of a Kŭmgang Journey While at Rest* (Kŭmgang wayu-ch'ŏp), also once attributed to Kim, is an album of thirty leaves.[129] Finally, the third set, *Album of Travel to the East* (Tongyu-ch'ŏp), contains twenty-eight leaves painted by an unidentified artist, along with poems and travel diaries of a well-known scholar-official, Yi P'ung-ik (*ho* Yukwandang; 1804–1887). Yi took a monthlong trip in 1825 to all the scenic places of the inner, outer, and coastal regions of Mount Kŭmgang, presumably accompanied by his favorite court painter who could produce a set of paintings of all the scenery visited. The *Album of Travel to the East* is a set of ten albums of paintings, diaries, and poems, now in the collection of the Sŏnggyun-gwan University Museum in Seoul.[130] One of the writers of the two prefaces to this album, Pak Hoe-su (1786–1861), indicates that the album was completed shortly before 1844, the date of his own preface. That these various albums contain identical compositions indicates that manuals of "model compositions" of Mount Kŭmgang scenery existed by the end of the eighteenth century. Kim Hong-do and Kim Ŭng-hwan produced more than a hundred sketches of Mount Kŭmgang in 1788. Being the most prominent court painters of their time, the two could have used their sketches to create a pool of "Mount Kŭmgang model-compositions" from which not only they but also other court painters could draw when producing sets of albums of Mount Kŭmgang scenery.

Although none is known to have survived, it is quite possible that some sets of model compositions from the royal bureau of painting were produced as woodblock prints for circulation. As is well known, in China famous scenic spots were made into woodblock prints and widely circulated.[131] The possibility of the existence of such prints is supported by the woodblock-printed court record of King Chŏngjo's 1975 trip to his father's tomb in Hwasŏng (*Wonhaeng ŭlmyo chŏngri ŭigwe*), or the record of the construction of Hwaŏng (*Hwasŏng sŏngyŏk ŭigwe*).

116 "Complete View of Hwasŏng," a page in *Hwasŏng sŏngyŏk ŭigwe*, 1801. Changsŏ-gak Library, Academy of Korean Studies, Sŏngnam, Kyŏnggi-do.

This type of document, known as *ŭigwe* (book of state rites), contains many pages of woodblock illustrations, including some landscape settings. The first illustration from the book *Hwasŏng sŏngyŏk ŭigwe*, a page titled "Complete View of Hwasŏng" (fig. 116), is a good example. It shows the entire view of the citadel with all the establishments such as the gates, palace buildings, beacon towers, and so on set amid the outlying country scenery. Also, Kim Hongdo is known to have done the drawings for the woodblocks of the *Illustrated Book of Five Human Relations* (Oryun haengsil-to) published in 1797, which contains many landscape scenes with human figures.

Given this connection, it is interesting to find an album of eight woodblock prints titled *Album of Mount Kŭmgang and Its Old Temples* (Kŭmgangsan-jung koch'al-chŏp), now in a Japanese collection.[132] Many of the leaves bear inscriptions of both Korean and Chinese characters, but they are not clearly legible. The last leaf, identified by its inscription as *Hyŏngsan (Ch. Hengshan)* (fig. 117), which is not one of the peaks of Mount Kŭmgang but a famous Chinese mountain nevertheless depicts pinnacle-like peaks commonly found in Mount Kŭmgang paintings. It is puzzling why this album has the title it has. Perhaps the title alone suggests the likelihood of the existence of woodblock illustrations of Mount Kŭmgang scenery.[133]

If we further pursue this path to find proof of Mount Kŭmgang paintings from the post–Kim Hong-do era, our effort is amply awarded. There are Mount Kŭmgang images executed in brushstrokes that are hard to explain without

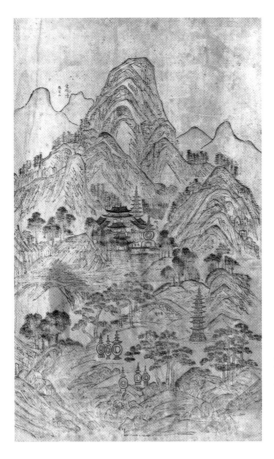

117 *Hyŏngsan (Ch. Hengshan)*, leaf from the *Album of Mount Kŭmgang and Its Old Temples*, date undetermined. Woodblock prints, 61.6 × 37.2 cm. Toyama Museum of Fine Arts, Toyama, Japan.

assuming the existence of the woodblock models behind them. From the *Album of a Kŭmgang Journey While at Rest,* the sixth painting, with a title inscribed *Haegŭmgang humyŏn* (Back view of coastal Kŭmgang) (fig. 118), displays brush-strokes that show a minimum of undulation as if in a woodblock print.[134] Even when we consider the formation of the rocks, which tend to have regularized patterns on their the surface, the rendering of the rocks shows traits that are found more in woodblock prints than in a painting done with a brush.

To confirm our suspicion, let us look at an album leaf depicting the same scenery with an inscription of *Haegŭmgang Chŏnmyŏn* (Front view of coastal Kŭmgang) (fig. 119) from the *Album of Sea and Mountains* (Haesan-chŏp) by the Yi royal descendant and a literati painter Yi Ŭi-sŏng (*ho* Chŏngryu; 1775–1883), now in a private collection in Korea. Both this leaf and the aforementioned one share a compositional prototype that is found in the *Album of the Four Districts.* In Yi's rendering of the site, the brushstrokes that delineate the rock formations are all of uniform thickness, with only a slight variation in ink tone, and there is no further texturing of the rock surfaces. These qualities of line and ink point to an origin in print, not in painting. The sea waves are also depicted in choppy lines of uniform thickness, very different from the billowing sea waves executed with

118 Unidentified artist, *Haegŭmgang humyŏn* (Back view of coastal Kŭmgang), leaf from the
Album of a Kŭmgang Journey While at Rest, date undetermined. Album of forty leaves, ink
and light color on paper, 36.5 × 44.4 cm. Pak Chu-hwan collection, Seoul.

swift, modulated brushstrokes as seen in Chŏng Sŏn's hanging scroll *Gate Rocks
at T'ongch'ŏn* (see fig. 84).

In this context it is useful to examine two albums of Mount Kŭmgang by the
artist Kim Ha-jong (*ho* Yudang; 1793–after 1875). Kim is considered one of the
most noteworthy nineteenth-century painters of true-view landscapes solely
because of these two sets of albums of Mount Kŭmgang.[135] The first set is the
Album of Sea and Mountains (Haesan-chŏp) dated to 1815, consisting of twenty-
five leaves.[136] The second is a set of four albums titled *Autumn Foliage Mountain
Handscroll* (P'ung'ak-kwon) done fifty years after the first one in 1865.[137] Accord-
ing to the writings on Mount Kŭmgang contained in the fifth album by the well-
known scholar-official Yi Yu-won (*ho* Kyulsan; 1814–1888) who traveled to the
area, he asked Kim Ha-jong, then eighty years old, to paint the scenery. The first
album was dated formerly to 1875, but the date has been revised to 1815 (the same
cyclical year, *ŭlhae*, sixty years earlier) in accordance with the dates of one of the
colophon writers, Yi Kwang-mun (*ho* Sohwa; 1778–1838). Also, stylistically the
first album shows brushstrokes that are energetic but tense, while the second
album shows a much more relaxed, mature brushwork of the same person in
old age.

Kim Ha-jong comes from the Kyŏngju Kim family of court painters: he is the
third son of the court painter Kim Tŭk-sin and the grandnephew of Kim Ŭng-

119 Yi Ŭi-sŏng, *Haehŭmgang Chŏnmyŏn* (Front view of coastal Kŭmgang), leaf from the *Album of Sea and Mountains*, early nineteenth century. Set of albums with twenty leaves, ink light color on paper, 32.0 × 48.0 cm. Private collection, Korea.

hwan, who took the sketching trip to Mount Kŭmgang along with Kim Hong-do and might have produced a set of Mount Kŭmgang model compositions. Therefore, it is not surprising to find nearly identical compositions between Kim Ha-jong's Mount Kŭmgang paintings and those in the *Album of the Four Districts*. *Nine-Dragons Waterfall* leaf from the *Album of the Four Districts* (fig. 114) and the same in Kim Ha-jong's 1815 album (fig. 120) display enough similarity to assume that they were derived from a common source. The difference would be that the younger Kim's brushstrokes are broader and bolder, with less use of texture strokes than the work from the *Album of the Four Districts*.

My 1999 photograph of the site (fig. 121) reveals that Kim's composition is closely based on observation of the actual scene. The two sets also contain the depiction of the *Clear-Mirror Terrace* (Myŏngyŏng-dae) that show nearly identical composition with the same in the *Album of the Four Districts*.[138] Kim Ha-jong's *Clear-Mirror Terrace* (Myŏngyŏng-dae) from the 1865 album (fig. 122) displays the brushwork of the mature artist in that the leaf shows more relaxed and soft strokes as well as less contrast in ink tones. Except for the difference of the brushworks that identify the artist's works of different ages, there is enough similarity to assume the common source for Kim Ha-jong's two paintings as well as the same composition from the *Album of the Four Districts*.

Although there are some leaves in Kim Ha-jong's 1865 album that deviate from

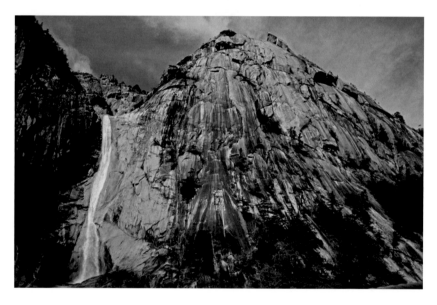

120 *(top)* Kim Ha-jong, *Nine-Dragons Waterfall* leaf from *Album of Sea and Mountains*, dated to 1815. Set of albums with twenty-five leaves, ink and light color on silk, 29.7 × 43.3 cm. National Museum of Korea, Seoul.

121 *(bottom)* Kuryong-yŏn (Nine-Dragons Pond), Mount Kŭmgang, Kangwon-do, 1999. Photograph by Yi Sŏng-mi.

122 Kim Ha-jong, *Clear-Mirror Terrace*, leaf from the *Album of Autumn Foliage Mountain*, dated to 1865. Set of four albums with fifty-eight leaves, ink and light color on paper, 49.3 × 61.6 cm. Private collection, Korea.

the compositions of the *Album of the Four Districts*, in general all the Mount Kŭmgang albums we have discussed here display enough similarities in composition. Thus, it is fair to say that by the nineteenth century, Mount Kŭmgang paintings produced in the court circles depended on a set of model compositions presumably made at the end of the eighteenth century by Kim Hong-do and Kim Ŭng-hwan after their 1788 sketching trip. To this date, however, no such model books in print have been found, nor their existence documented. But indications are such model composition books existed at the court painting bureau, contributing to the popularization as well as the decline of Mount Kŭmgang paintings for lack of fresh approach to the true-view landscape painting.[139]

PAINTERS OF INDEPENDENT INCLINATION AND DIVERSE THEMES

Professional true-view painters of this period include, among others, Ŏm Ch'i-uk (*ho* Kwanho; active in the nineteenth century), Cho Chŏng-gyu (*ho* Imjŏn; 1791–?), Paek Ŭn-bae (*ho* Imdang; 1820–1901),[140] and Yu Suk (*ho* Hyesan; 1827–1873). Cho's paintings of Mount Kŭmgang are characterized by bold touches, personal brushwork, and simplified forms.[141] Yu Suk is better known for his figure paintings, although he left a fair amount of true-view landscapes. His *Segŏm-jŏng Pavilion* in the National Museum of Korea shows that he was still under strong

influence of Chŏng Sŏn, especially in the employment of repetitive brushstrokes for pine trees.[142]

When there were no previous models to follow, artists seemed to be free from the true-view idioms developed by Chŏng Sŏn or Kim Hong-do, be they brushstrokes or compositions. This seems to be the case of Paek Ŭn-bae's true-view paintings. Paek is better known for his figure paintings of Buddhist, Daoist, or Confucian origins. He also left a body of landscapes that are not true-view landscapes. The hanging scroll that depicts the famous scene in South Hamgyŏng, *Kugyŏng-dae* (Terrace of tortoise-scene), is a rare example of Paek's true-view landscape (fig. 123). *Kugyŏng-dae* is one of the ten scenes of the set called Ten Scenes of Hamhŭng. Hamhŭng is located in South Hamgyŏng, and the place had been considered "holy" during the Chosŏn dynasty because it is the birthplace of the dynasty's founder, Yi Sŏng-gye (1335–1408). The area boasts scenic forests and mountains comparable to those of Mount Kŭmgang.

In 1674, when literary figure and Prime Minister Nam Ku-man (*ho* Yakchŏn; 1629–1711) was serving as the governor of Hamhŭng, he selected ten scenes in the area and named them the Ten Scenes of Hamhŭng. He composed a descriptive note on each of the ten scenes.[143] At present, only two of the ten paintings with Nam Ku-man's inscriptions survive, and one of them is *Kugyŏng-dae* (Tortoise-scene terrace).[144] The terrace itself overlooks the East Sea and therefore became the favorite spot for watching the sunrise. At first sight the painting looks so surreal, until one reads Nam Ku-man's descriptive note, which Paek Ŭn-bae transcribed in the space above the horizon. In order to understand Paek's unique composition and depiction of the scenery, it is helpful to quote some parts of the inscription.

> There is a strangely shaped rock by the shore about forty *li* to the east of
> Hamhŭng. Its shape resembles a huge tortoise standing ten *chang* high[145] the
> top of which seems large enough to seat forty or fifty people. The four sides
> of the rock [under the terrace] were eroded by the constantly attacking sea
> waves, and became porous, some parts resembling a beehive. The strange
> shape is hard to describe in words. Below the terrace is a flat rock that clearly
> bears patterns of a tortoise shell. . . . The drawings look so precise that it is
> not an exaggeration to say that they were done by a brush. . . . [On the shore]
> several peaks stand as if bowing to each other, rising above the clouds. . . .
> The rising sun and moon are all under one's eye. [I] wrote this in the spring of
> the *mujin* year (1868).[146]

Paek Ŭn-bae's panting is a near-literal description of the scene: the huge stone terrace juts out to the sea diagonally from the painting's right edge to the left in the middle ground. On top of the terrace three seated and two standing men are seen overlooking the sunrise. The rising sun appears as a small red disc just above the horizon to the left. The eroded underside of the terrace looks indeed

123　Paek Ŭn-bae, *Kugyŏng-dae* (Terrace of tortoise-scene), dated to 1868. Hanging
scroll, ink and light color on paper, 1,105 × 52.2 cm. Seoul Museum of History.

grotesque with pores and strangely jutting parts that are "supported" by the stylized whitecaps created by the constantly moving waves as they hit the rocks. Surrounded by these small rock formations is the flat area of the rock that bears the patterns of a tortoise shell. A band of clouds separates this part from another smaller "terrace" with a jutting rock in the background, also surrounded by the whitecaps. The foreground and the smaller hills along the painting's right edge are "inhabited" by small houses and trees. Several boats are moored against the hill in the foreground.

Paek Ŭn-bae's rendering of the sea waves in this painting can be contrasted to that of Chŏng Sŏn's in his *Gate Rocks at T'ongchŏn* (see fig. 84). While the latter employs free-flowing brushstrokes to depict the bellowing waves that fill nearly two-thirds of the scroll's height, the former uses carefully delineated almost stylized wave shapes that have been repeated, filling each of the "units" of the waves with finer brush lines. The waves sizes are nearly the same from the foreground to the horizon. Paek also depicted the whitecaps in a stylized manner found in court screen paintings such as the *Ten Symbols Longevity*, or the *Screen of the Five Peaks*.[147] As a result, Paek's painting lacks a sense of depth or atmosphere, although there are bands of clouds or mist. Paek, having served as a court painter for a long time, came to produce this unique true-view landscape painting in which the traditions of true-view landscape and the court decorative painting have been amalgamated.

We encounter fresh visions of true-view landscapes in some of the paintings by literati painters. Yun Che-hong (*ho* Haksan; 1760–after 1840), whose political life was marred with repeated exiles and reinstatements to office, finally rose to the position of Grand Censor in 1840. He left a fair amount of paintings he had done in his leisure, including true-view landscapes.[148] In his *Bamboo-Shoot Pinnacles* (Oksun-bong) (fig. 124), which is the second leaf of his *Album of Finger-Painting Landscapes* of eight leaves in the Leeum collection, he composed his painting with only two "bamboo shoots," a pavilion in the foreground, and a nebulously formed mountain with a waterfall in the background. The Oksun-bong is one of the eight scenic spots of Tanyang, North Ch'ungchŏng. The photograph of the spot (fig. 125) taken from a different angle shows the two isolated "shoots" on the left plus several more "shoots" forming a block of rocks to the right of the two isolated ones. Kim Hong-do's 1796 *Bamboo-Shoot Pinnacles* (Oksun-bong) (fig. 126), one of the leaves in his *Album of the Pyŏngjin Year*, depicts the site as seen from approximately the same angle as the photograph of Oksun-bong. If we take the photograph as the basis for understanding the structure of the Bamboo-Shoot Peaks, Yun's composition captured the two "shoots" viewed from the right diagonally to the left so that the taller shoot stands to the right of the shorter one.

The ink lines, done by his fingers in this painting, outline the rock forms, trees, and the pavilion while the smearing of lighter ink defines the forms of the background mountain and the misty atmosphere.[149] Yun's technique is very different from that of other finger painters in China, Korea, and Japan. While others

124　Yun Che-hong, *Bamboo-Shoot Pinnacles* (Oksun-bong), leaf from the *Album of Finger-Painting Landscapes*, early nineteenth century. Album of eight leaves, ink on paper, 67.0 × 45.5 cm. Collection of Leeum, Samsung Museum of Art, Seoul.

used their fingernails as well as fingers, Yun used only his fingers, thus creating clear, softer lines.[150] His inscription on the upper-left corner of the painting was also written with fingers. In it he states that he always regretted the fact that there was no thatched pavilion under Oksun-bong, but he has done this leaf in imitation of the painting of the same scene by Yi Nŭngho (Yi In-sang). Judging from this inscription, Yun frequently visited the site but created this painting not from observation but by copying Yi In-sang's painting. Yi In-sang died four years before Yun was born, so the two literati painters could not have known each other. However, Yi retired in Tanyang and could have painted some of the eight scenic spots of Tanyang, including Bamboo-Shoot Peak, although none has survived.

Yun's position in the history of Chosŏn painting is unique in that he left a number of true-view landscape paintings done in finger painting, and he wrote the inscriptions using his fingers. Not only in his painting *Bamboo-Shoot Pinnacles* but also in others, he often expressed his indebtedness to earlier Korean masters. He stated that his painting was done in the style of a Korean painter instead of a Chinese master of an earlier period. Because of Yun's unique finger-painting style, he is often classified as a painter of the "novel style" (*isaek hwap'ung*), a term

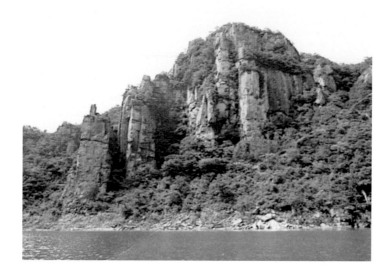

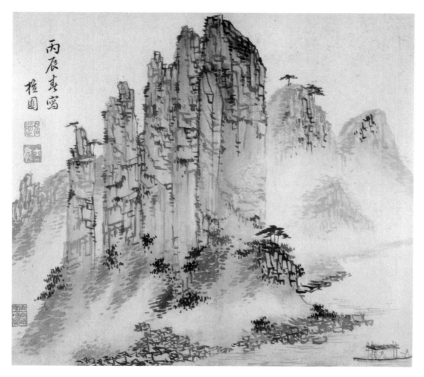

125 *(top)* Oksun-bong, Tanyang, North Ch'ungch'ŏng-do, date unknown. Photograph from the Digital Archives, the Academy of Korean Studies, Sŏngnam, Kyŏnggi-do.

126 *(bottom)* Kim Hong-do, *Bamboo-Shoot Pinnacles* (Oksun-bong), leaf from the *Album of the Pyŏngjin Year*, 1796. Album of twenty leaves, ink and light color on paper, 26.7 × 31.6 cm. Collection of Leeum, Samsung Museum of Art, Seoul.

coined by Professor Ahn Hwi-joon to designate painting styles of several late nineteenth-century painters, including Yun Che-hong, Kim Su-ch'ŏl (*ho* Puksan; active mid-nineteenth century), Kim Ch'ang-su (*ho* Haksan; active mid-nineteenth century), and Hong Se-sŏp (*ho* Sŏkch'ang; 1832–1884).[151] This group of artists is usually credited to have bridged the late Chosŏn period painting with that of the modern period. That is, they have shown the possibilities of emancipating themselves from the age-old brush and ink conventions and compositions by introducing new modes of composition as well as brush and ink methods.

The literati painter Yi Pang-un (*ho* Kiya; 1761–after 1815) is better known for paintings based on Chinese landscape themes, such as his *Wangchuan Villa* (Korean *Mangch'ŏn-do*; Chinese *Wangchuan-tu*) and the *Odes of Bin* (Korean *Pinp'ung-do*; Chinese *Binfeng-tu*), which combine landscape background with figures.[152] Yi Pang-un's death date had been known to be 1791 until recently. More of Yi's true-view landscape paintings have come to light, however, and the dates of his activities have been extended to after 1815.[153] The *Album of Calligraphy and Painting of the Scenic Spots of the Four Districts and Three Immortals' Waters and Rocks* (Sagun kangsan samsŏn susŏk sŏhwa-ch'ŏp), now in the collection of the Kungmin University Museum in Seoul, contains a series of Yi's newly disclosed true-view landscapes.[154] The "four districts" here refer to Tanyang, Chŏngp'ung, Chech'ŏn, and Yŏngp'ung in today's North Ch'ungch'ŏng, famous for their scenic beauty. The "three immortals" refer to the three scenic spots—Hasŏn-am (Lower immortal's rock), Chungsŏn-am (Middle immortal's rock), and Sangsŏn-am (Upper immortal's rock)—that are the first three of Tanyang's eight scenic spots. This album does not include any of the scenes of the "three immortals." According to the colophon to the album by a certain Kim Yang-ji (dates unknown) dated to 1803, the album was created as a result of the 1802 travel to the areas by Kim's friend, An Suk (dates unknown), then governor of Chŏngp'ung, who asked Yi Pang-un to paint the scenery he had seen.[155] The fifteen-leaf album contains eight leaves of true-view landscapes, some with poetic inscriptions presumably done by An Suk.[156]

Of the eight leaves, the two considered visually most interesting are discussed here. Leaf 5, *Kudam* (Tortoise pond) (fig. 127), seems most original and daring in its composition and use of brush and ink. The name, Tortoise Pond, comes from the shape of the stone peak and its reflection on the water resembling a tortoise. A 2001 photograph of the scene (fig. 128), though it does not include the foreground shore and the pavilion, still catches the peak's general shape. Yi Pang-un's depiction of the scenery could be different from what we see today as the pool of water in the photograph represents Lake Ch'ungju (Ch'ungju-ho), the largest artificial lake in Korea, measuring 67.5 square kilometers, created as a result of the construction of the Ch'ungju Dam in 1985.

Yi's composition resembles a large flower bud: the rocky cliffs on the leaf's left and right edges and the foreground shore together form an outer layer; the pool of water with the curiously shaped "floating" rocks, some with tortoise shell

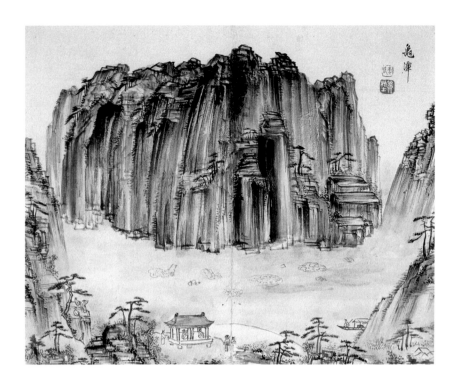

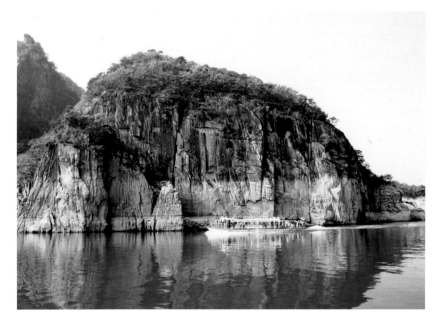

127 *(top)* Yi Pang-un, *Kudam* (Tortoise pond), leaf 5 from *Album of Calligraphy and Painting of the Scenic Spots of the Four Districts and Three Immortals' Waters and Rocks*, early nineteenth century. Album of fifteen leaves, ca. 1802–3. Album leaf, ink and light color on paper, 32.5 × 26.0 cm. Kungmin University Museum, Seoul.

128 *(bottom)* Kudam (Tortoise pond), Tanyang, North Ch'ungch'ŏng-do. Photograph by Yi Sŏng-mi, 2001.

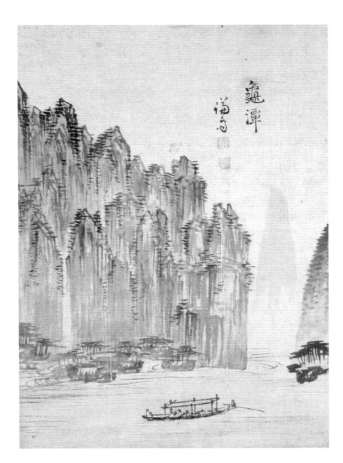

129　Chŏng Sŏn, *Kudam*
(Tortoise pond), 1737.
Album leaf, ink and light
color on silk, 26.8 × 20.3
cm. Korea University
Museum, Seoul.

design, serves as the middle layer; finally the Tortoise Peak, being supported by
the water, represents the inner core of the flower that has not yet bloomed.[157]
The downward brushstrokes on the surface of this core, a combination of very
dark ink strokes and flying whites, bend slightly inward, creating a tension that
binds tightly the separate strands of the rocks that together form the Tortoise
Peak. Also, the entire peak, being bound in this way, echoes the shape of a large
crouching tortoise. Light blue and green washes applied on the water and on the
rocky peak add to the elegant appearance of the scenery. The inclusion of the
pavilion in the foreground is an expression of his deference to another literati
painter, Yi Yŏng-yun, who had a pavilion built in Tanyang in 1752 and named it
Ch'angha-jŏng (Blue mist pavilion).

Because of the dark, downward brushstrokes, this painting has been com-
pared with Chŏng Sŏn's 1737 work *Kudam,* in the collection of Korea University
Museum (fig. 129).[158] To be sure, we find Chŏng Sŏn's heritage in Yi's straight
downward brushstrokes and application of very dark ink on key spots. However,
in terms of the composition and the use of ink and light colors, Yi Pang-un's work
is beyond comparison. It took nearly a century for a Korean painter to overcome
the towering figure of Chŏng Sŏn and his achievements in true-view landscape

水簾

峯名猶未信松眠俗忽忱玄
開簾看真面滿坐更輕寒
顆顆敷料英玉縭
虔款當守霞輕裁

130 *(top)* Yi Pang-un, *Suryŏm* (Bamboo-
curtain waterfall), leaf 6 from the *Album of
Calligraphy and Painting of the Scenic Spots
of the Four Districts and Three Immortals'
Waters and Rocks*, ca. 1802–3. Album leaf,
ink and light color on paper, 32.5 × 26.0
cm. Kungmin University Museum, Seoul.

131 *(right)* Suryŏm (Bamboo-
curtain waterfall), Chechŏn, North
Ch'ungch'ŏng-do, date unknown.
Photograph from http://blog
.naver.com/chyobe1800?Redirec
t=Log&logNo=70034174341.

painting, to express his own visions and thoughts in a unique composition and style. It is no surprise that this was achieved not by a court painter but by a free-spirited literati painter.

Leaf 6 in the album, *Suryŏm* (Bamboo-curtain waterfall) (fig. 130), depicts an unusual form of the waterfall in the Chŏngp'ung district. The poem on the left half of the leaf describes the high and wide waterfall resembling a bamboo curtain hanging in midair, scattering the jade beads like drops of water, and a poet who fell asleep with his forehead exposed forgetting about the high summer heat. The Bamboo-Curtain Waterfall, as seen in a recent photograph of the site (fig.131), flows down from the upper-right corner of the leaf and widens as it falls perpendicularly until the strands of water fall over the rocks on the lower level, creating foam and whitecaps while moving onto the next levels. Although it is hard to identify one of the two figures seated on the flat area to the right of the waterfall as the poet in the poem, the whole scenery with its wide waterfall, pine trees, and other sparse vegetation painted in light ink and light colors makes the viewer feel the freshness of the air and forget the summer's heat. For this leaf, Yi Pang-un employed a set of completely different brush techniques from those he used for the *Kudam* leaf. Such versatility seems to stem from his free spirit, not bound by tradition.

Conclusion

This chapter has examined the vicissitudes of true-view landscape painting during the late Chosŏn period, from the early eighteenth century to the late nineteenth century. Since the time when Chŏng Sŏn established the tradition, almost all Korean painters have painted some form of true-view landscape painting, sometimes under heavy influence of the master. Chŏng Sŏn was followed by Kim Hong-do and Kang Se-hwang and others in the late eighteenth century, all of whom worked together to bring the celebrated tradition to its height, making it one of the most unique artistic expression of the Korean people. At the same time, the very popularization of true-view landscapes inevitably brought about the decline of the tradition. This was more so with paintings of Mount Kŭmgang themes. Kim Hong-do and Kim Ŭng-hwan most probably produced a set of model compositions based on more than a hundred sketches of the area's sea and mountain scenery under the order of King Chŏngjo in 1788. The presence of such model compositions was destined to lead to mechanical repetition and distortion of the original without any new spirit, which can be characterized as mannerism, and decline in the quality of Mount Kŭmgang paintings in the second half of the nineteenth century.

Korean artists also established sets of themes based on scenery other than Mount Kŭmgang such as the Eight Scenes of Tanyang or the Ten Scenes of Hamhŭng and others. Even during the late nineteenth century, we find paint-

ers who excelled in these themes and came up with impressive unique stylistic innovations for depicting the scenery. This was done by professional painters as well as literati painters. When scenery to be depicted did not have a model to follow, even professional painters came up with fresh, daring representations, as in the case of Paek Ŭn-bae with his *Kugyŏng-dae* (Terrace of tortoise-scene) (fig. 123). Free-spirited literati painters, however, even when there were precedents to follow, opted for unique representations of their own. This made the final phase of true-view landscape painting more meaningful, leaving the possibility of the true-view tradition open for the painters of the twentieth century. Although the twentieth century proper lies beyond the scope of this book, I conclude with a discussion of three twentieth-century works as one possibility of what the future may hold for Korean painting of the true-view tradition.

As a member of the last generation of court painters, An Chung-sik (*ho* Simjŏn; 1861–1919) may be credited with carrying on the true-view tradition into the twentieth century. He was part of a group of trainees sent to Tianjin to learn three-dimensional drawing methods that no doubt included linear perspective systems. His true-view landscape *Spring Morning over Mount Paegak* (Paegak ch'unhyo) of 1915 (fig. 132), now in the National Museum of Korea, is a good example of the combination of Western influence and the true-view tradition, the sign of "modernity" we have pursued throughout this book. The painting depicts Mount Paegak (also called Pugak), with the Kyŏngbok Palace nestled under it preceded by the broad avenue leading to Kwanghwa-mun, the main gate of the palace. The stone structures near the gate veer toward the gate's center in perspective, and the palace buildings partly hidden by the trees and fogs diminish in scale to create the feeling of distance. On either side of the bottom of the painting, trees and the two stone *haechis* (mythical animals) serve as the *repoussoirs* (objects in the foreground of a painting that gives a distinct sense of distance between the foreground and background) that push what is beyond them further back. Above the clouds over the palace buildings rises the majestic main peak of the mountain as if to approach the viewer with its heavy bulk. This sense of volume is created by effective use of shading. Additional peaks in the distance complete the composition of this realistic true-view image of the early twentieth century.[159]

An Chung-sik was followed by a group of painters collectively known as the "four great masters of landscape painting" of the twentieth century. All born in the last decade of the nineteenth century, these artists had long, prolific lives.[160] They are Yi Sang-bŏm (*ho* Chŏngjŏn; 1897–1972), No Su-hyŏn (*ho* Simsan; 1891–1978), Pyŏn Kwan-sik (*ho* Sojŏng; 1899–1976), and Hŏ Paek-ryŏn (*ho* Ŭijae; 1891–1977). Although they painted unspecified, generalized views of Korea's country-side in the form of seasonal landscapes, all of these artists painted true-view landscapes of famous sites, especially those of Mount Kŭmgang.

Perhaps the most impressive true-view landscape created by this group of painters was Pyŏn Kwan-sik's *Pearl Pond in Inner Kŭmgang* (Nae Kŭmgang Chinju-dam) dated to 1960 (fig. 133), now in the Leeum collection. Its imposing

132 An Chung-sik, *Spring Morning over Mount Paegak*, dated to 1915. Hanging scroll, ink and color on silk, 125.9 × 51.5 cm. National Museum of Korea, Seoul.

dimensions of 263 × 121 centimeters supersede all true-view landscapes of earlier periods. In this monumental painting, Pyŏn seems to have attempted to synthesize all of the past landscape traditions. It is impossible to single out what brush conventions he had in mind when he executed this true-view of a popular spot on Mount Kŭmgang. He challenges us not to think in those terms as we look at this unique depiction of a scene that has been repeatedly painted in the past.[161] The effective use of concentrated dark ink for the foreground rocks and middle-ground trees is a hallmark of Pyŏn's landscape depictions, which sets his landscapes apart from those of the other three painters. The lighter ink tones applied on the distant peaks creates an immense distance in this painting. This could well be the most memorable true-view landscape of the mid-twentieth century, as was Chŏng Sŏn's *Clearing after Mount Inwang* (see fig. 1) in the mid-eighteenth century.

Mount Kŭmgang became out of reach for most South Koreans when the country was divided in 1948. Therefore Pyŏn Kwan-sik and other painters of his generation produced Mount Kŭmgang paintings based on their earlier trips to the region. It was not until 1998 when the North Korean government decided to open parts of the Mount Kŭmgang area for tourism. This incident prompted a new wave of interest in true-view representations of the Mount Kŭmgang area. In April 1999 the leading daily paper, *Tong-a Ilbo*, invited fifteen contemporary

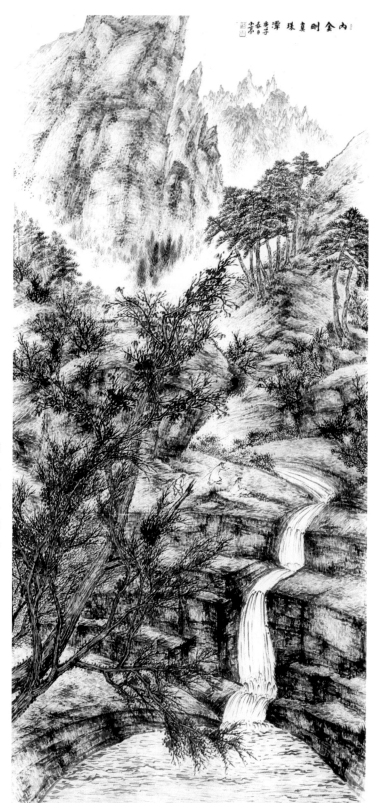

內金剛真珠潭
庚子
春日
素

133 Pyŏn Kwan-sik, *Pearl Pond
in Inner Kŭmgang*, dated to 1960.
Hanging scroll, ink and light
color on paper, 263 × 121 cm.
Collection of Leeum, Samsung
Museum of Art, Seoul.

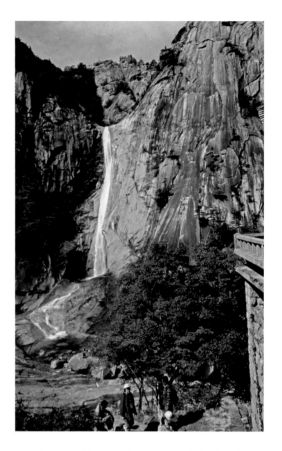

134　Yun Sŏk-nam (Yun Seong-nam), *Nine-Dragons Waterfall*, dated 1999. Mixed media, beads, oil, and acrylic on white pine-wood panels, 250 × 400 × 70 cm. Collection of the artist. Seoul.

135　Kuryong-p'ok (Nine-dragons waterfall), Mount Kŭmgang, 1999. Photograph by Yi Sŏng-mi.

artists to take a historic sketch trip to Mount Kŭmgang for the first time since 1948. The Ilmin Museum of Art, which is the newspaper's own art museum, held a large exhibition, *Dream Journey to Kŭmgang: Three Hundred Years of Mount Kŭmgang Paintings* (Mong'yu Kŭmgang). The works of the fifteen contemporary artists produced after their trip were exhibited along with paintings from the Chosŏn dynasty.[162] The contemporary artwork covered such diverse media as drawing, painting, sculpture, film, collage, and installation, reflecting the late twentieth-century art scene.

Among the contemporary artwork from the 1999 exhibition is the 2.5-meter-high installation by Yun Sŏk-nam (Yun Seong-nam; 1939–), titled *Nine-Dragons Waterfall* (fig. 134), which is constructed of painted pinewood panels and glass beads. The Nine-Dragons Waterfall in Mount Kŭmgang, seen in this photograph from 1999 (fig. 135), measures some fifty meters high and ends in a large pool created by the falling water. Yun Sŏk-nam's installation, as monumental as

Pyŏn Kwan-sik's painting, is interpreted as the yin-yang dualism represented by the female aspect of the waterfall's gorge and the male aspect of the force of the waterfall that gushes down through the gorge and spills over in the form of glass beads scattered on the floor.[163] With this interpretation of Yun's installation, we come full circle from Chŏng Sŏn's *Complete View of Mount Kŭmgang* of 1734 (see fig. 76) in which the yin-yang dualism is featured so prominently in the form of the highest peak, Piro-bong, at the apex and the arch-shaped rainbow bridge (Pihong-gyo) at the lowest point, and the contrast between the earthen and rocky peaks.

The practice of traveling to discover and sketch scenery of exceptional beauty or uncommon character continues to be a living tradition among Korean artists, and along with it the tradition of true-view landscape painting, the pride of the Korean people. The mode of expression or the media of execution might not be the same, but the underlying spirit that goes through all the true-view representations may be the same through the centuries—and even in the centuries to come.

NOTES

Introduction

1 Yi Sŏng-mi, *Chosŏn sidae kŭrimsok ŭi sŏyang hwapŏp* (2000).

2 Yi Sŏng-mi, *Chosŏn sidae kŭrimsok ŭi sŏyang hwapŏp* (2008).

3 Yi Sŏng-mi, *Korean Landscape Painting.*

4 Yi Sŏng-mi, "Artistic Tradition and the Depiction of Reality," 360–65.

5 Yi T'ae-ho, *Yet hwagadŭl ŭn uri ttang ŭl ŏttŏke kŭryŏtna.*

6 The books in the Korean Culture Series (Seoul: Hollym) already in print are: Kim Youngna, *Modern and Contemporary Art in Korea* (2005); Lee Sang-hae, *The Architecture of Korea's Private Academies* (2005); Kim Dong-uk, *Palaces of Korea* (2006); Yi Sŏng-mi, *Korean Landscape Painting*; Chung Hyung-min, *Modern Korean Ink Painting*; Kim Hee-Jin, *Maedeup: The Art of Traditional Korean Knots* (2006); David Shaffer, *Seasonal Customs of Korea* (2007); Kim Lena, *Buddhist Sculpture of Korea* (2007); Kim Sung-woo, *Buddhist Architecture of Korea* (2007); Jeon Kyung-wook, *Traditional Performing Arts of Korea* (2008); Song Hye-jin, *Confucian Ritual Music of Korea* (2008); Kang Kyung-sook, *Korean Ceramics* (2008); and Lee Byoung-ok, *Korean Folk Dance* (2008). See the website of the Korean Foundation, at http://en.kf.or.kr/?menuno=591, for future publications in the series.

1

Historical and Intellectual Background
of the Late Chosŏn Period

1 Ahn's periodization is as follows: the early Chosŏn period is from 1392 to about
 1550, or the last years of King Chungjong's reign (r. 1506–1544); the mid-Chosŏn
 period is from about 1550 to 1700, or the first half of King Sukchong's reign; the late
 Chosŏn period is from about 1700 to 1910, which is further divided into two phas-
 es. The first of these is from 1700 to 1850, or the last years of the famous scholar-
 official cum calligrapher Kim Chŏng-hŭi (1786–1856), and the second is from 1850
 to the end of the dynasty. See Ahn, *Hanguk hoehwa-sa,* 91–92, and 154n4, where he
 offers other scholars' periodizations.

2 See Lee Ki-baik, *New History of Korea,* 209–17, for a concise history of the Japanese
 and Manchu invasions.

3 The split of scholars into various factions beginning from the mid-Chosŏn period
 (King Sŏnjo's reign, 1567–1607), which lasted until the late Chosŏn period, is too
 complex a subject to introduce here. Suffice it to say that the factions engaged in
 power struggles and played important roles, both positive and negative, in the po-
 litical and cultural spheres of late Chosŏn society. For a discussion of these factions,
 see Lee Ki-baik, *New History of Korea,* 208–9; and Yi Sŏng-mu, *Chosŏn yangban
 sahoe yŏngu,* 366–488.

4 See Haboush, "Constructing the Center," 46–90, especially 74–78: "The Ritual
 Controversy and the Search for a New Identity in Seventeenth-Century Korea," in
 Haboush and Deuchler eds., *Culture and State in Late Chosŏn Korea* (Cambridge:
 Harvard University Press, 1999), 46–90, esp., 74-78.

5 Publications consulted for Korea's intellectual background in the seventeenth and
 eighteenth centuries include Ch'oe Yŏng-sŏng, *Hanguk yuhak sasang-sa;* Ch'oe
 Wan-su, "Kyŏmjae Chŏng Sŏn chin'gyŏng sansuhwa-go"; and Kang Kwan-sik,
 "Chosŏn hugi misul ŭi sasangjŏk kiban."

6 This four-character imperial handwriting was given to Min Chŏng-jung when
 he visited Yanjing. See the entry on "Taebodan sayŏnsŏl" (Detailed record on the
 building of the Taebodan), in *Hanguk minjok munhwa daebaekkwa sajŏn* (Encyclo-
 pedia of Korean people and culture), vol. 6, 390–91.

7 The name of the shrine consists of the first and the last characters taken from King
 Sŏnjo's writing, *man-chŏl-p'il-dong.* The meaning of this phrase, in short, is: "It is
 impossible to bend the loyal minister's integrity. See the entry on "Mandong-myo"
 in *Encyclopedia of Korean People and Culture,* vol. 7, 612–13.

8 See the entry on "Taebodan sayŏnsŏl" in *Encyclopedia of Korean People and Cul-
 ture,* vol. 6, 390–91.

9 The earliest incident of the use of the term "so-Chunghwa" in official record is
 found in the *Veritable Records of King Sŏngjong* (Book 20, the third year of King
 Sŏngjong, 1472 *imjin,* the tenth day, *ŭlsa,* of the seventh month). There it is stated
 that the Eastern Nation—i.e., Korea—had been referred to as so-Chunghwa since

Kija promoted civilized teachings. My translation of the term as "minor China" is not yet a standard translation among historians, who mostly avoid using it.

10 For Kija Chosŏn, see Lee Ki-baik, *New History of Korea,* 14–16.

11 *Veritable Records of King Sŏngjong* (Book 208, the eighteenth year of King Sŏngjong, 1487, the *chŏngmi* year, the twenty-first day of the tenth month).

12 According to the *Veritable Records of King Injo* (Book 32, the fourteenth year of King Injo, 1636, *pyŏngja,* the twenty-first day of the second month), the king's refusal to receive the emissary became one of the causes of the second (and worst) Manchu invasion of Korea.

13 *Veritable Records of King Sukchong,* Biography of King Sukchong.

14 See, for example, Hong Sŏn-p'yo, "Chin'gyŏng Sansu nŭn Chosŏn Chunghwa juŭi ŭi sosaninga?" In the essay title, "Chosŏn Chunghwa" instead of "so-Chunghwa" was used, as Ch'oe Wan-su had used in his 1981 essay cited in note 5.

15 Numerous appearance of the term "so-Chunghwa" can be found in the *Veritable Records of Kings Chŏngjo, Sunjo, and Hŏnjong.*

16 A series of entries concerning this matter can be found in Yi Sŏng-mi, ed., *Chosŏn wangjo sillok misul kisa charyojip,* vol. 7. They are the *Veritable Records of King Sukchong,* Book 31, 1697, the twenty-third year (*chŏngch'uk*) of King Sukchong, the fourth day (*chŏngch'uk*) of the seventh month; and the *Veritable Records of King Yŏngjo,* Book 101, 1763, the thirty-ninth year (*kyemi*) of King Yŏngjo, the twenty-second day (*kiyu*) of the fourth month.

17 *Veritable Records of King Yŏngjo,* 1769, the forty-sixth year (*kich'uk*) of King Yŏngjo, the eighteenth day (*chŏngmyo*) of the eighth month.

18 See Lee Ki-baik, *New History of Korea,* 232–33.

19 Ibid., 236. For more information on Yi Su-gwang's *Chibong yusŏl,* see Ch'oe Yŏng-sŏng, *Han'guk yuhaksa,* vol. 3, 370–79.

20 For Wang Yangming's philosophy and its influence in Korea, see Ch'oe Yŏng-sŏng, *Han'guk yuhaksa,* vol. 3, 283–388. See also Wang Yangming, *Instructions for Practical Living and Other Neo-Confucian Writings.*

21 Ch'oe Yŏng-sŏng, *Han'guk yuhaksa,* vol. 3, 388–401; and Lee Ki-baik, *New History of Korea,* 233–34.

22 See the biography of Yi Ik and the contents of *Sŏngho sasŏl* by Han U-gŭn in the Korean translation of *Sŏngho sasŏl (Kuggyŏk Sŏngho sasŏl),* vol. 1, 1–41 (Seoul: Minjok munhwa ch'ujin-hoe, 1976). Yi Ik decided not to serve in the government after witnessing his father's death during exile in Unsan, P'yŏng'an-do, and his brother Cham's execution in 1706 amid factional strife.

23 See Yi Won-sun, "Sŏhak ŭi toip kwa chŏn'gae." Alphonsus Vagnoni, a Jesuit priest from Italy, came to China in 1596 and later used the Chinese name Gao Yizhi.

24 Sullivan, *Meeting of Eastern and Western Art,* 42.

25 The Korean phonetic writing system was invented in 1443 by a group of scholars under the order of King Sejong the Great (r. 1418–1450), and in 1446 it was promulgated with the formal name *Hunmin chŏngŭm* ("correct sounds to teach the people"). The term *han'gŭl* has been used since 1927, when during the Japanese occupation Korean scholars were prohibited from using the term *kuggŏ* ("national language").

26 See Ch'oe So-ja, *Chŏng gwa Chosŏn,* chapter 4, "Chosŏn ŭi tae-chŏng kwan'gye"

(Chosŏn's policy toward Qing), particularly the section on "Chosŏn Crown Prince in Shenyang," 142–50, for the arrangement of the meeting of Crown Prince Sohyŏn and Adam Schall by Duoergon, the fourteenth son of Nurhachi.

27 Yi Wŏn-sun, "Sŏhak ŭi toip kwa chŏn'gae," 193. The Chinese name for the calendar is *Xiyang xinfa lishu*, the Korean is *Sŏyang sinbŏp yŏksŏ*.

28 In Korean history this incident is known as the Sinyu saok or Sinyu pakhae (*sinyu* being the cyclical year), 1801.

29 See Yi Wŏn-sun, "Sŏhak ŭi toip kwa chŏn'gae," 198, for a list of the Chinese books on Western learning that were recorded to have been read by such Chosŏn scholars as Yi Su-gwang (1563–1628), the scholar of the *sirhak* school, and Yi Pyŏk (1754–1786), author of the *Essentials of the Holy Teaching (Sŏnggyo yoji)*.

30 Yi Wŏn-sun, "Sŏhak ŭi toip kwa chŏn'gae," 19.

31 Yi Sŭng-hun was martyred in the 1801 persecution of Christians along with Chŏng's baptized brother, Yak-jŏn. Since then, three more generations of Yi family produced martyrs.

32 According to recent findings, Chŏng became deeply religious later in life to the extent of being baptized and receiving the extreme unction rite at his death. See Kim Hyŏng-hyo, *Wŏnhyo esŏ Tasan kkaji*, 520.

33 No Tae-hwan, "Chŏngjo sidae sŏgi suyong nonŭi wa sŏhak chŏngch'aek." The titles of the twenty-seven books destroyed are listed in ibid., 240n99.

34 Sullivan, "Some Possible Sources of European Influence on Late Ming and Early Ch'ing Painting"; and Sullivan, *Meeting of Eastern and Western Art,* 46–49.

2

Western Influence on Korean Painting

1 See Kim Yong-dŏk, *Chosŏn hugi sasangsa yŏn'gu*, 422.

2 In the latter part of this letter, the Crown Prince tells Schall that he is returning the Bible as he was afraid of its being maltreated in Chosŏn, where Christianity is unknown. Schall, in his return letter, recommended the Crown Prince be baptized before returning home, but the prince did not pursue it. Instead, he had several Qing persons who had been baptized accompany him. Schall's letter was originally in Latin, which was translated into French in 1928 by Father Gustave-Charles Mu-tel. This letter, in turn, was translated into Korean by Professor Kim Ŭi-jŏng. See ibid., 422.

3 Crown Prince Sohyŏn died on April 26, 1645 only three days after he became ill. An article in the *Veritable Records of King Injo* (vol. 48, *ŭlyu*, 1645, June 27) states that when he died, he bled from the seven openings of his head, and his whole body turned pitch black. This suggests that the Crown Prince was poisoned to death.

4 Because of the traditional attitude toward China during the Ming period, emissaries to the Ming court were called *chochŏn-sa*—literally, emissaries to the court of the Son of Heaven (i.e., the Chinese emperor)—and their travel records, *chochŏn-rok*. However, after the establishment of the conquering foreign Qing dynasty, emissaries were called either *yŏnhaeng-sa* or *puyŏn-sa*, both simply meaning "emissar-

ies going to Yanjing," and their travel records wcre collectively called *yŏnhaeng-rok*. There are exceptions to this, such as the famous *Yehol Diary* (Yorha ilgi) by Pak Chi-won; Hwang Won-gu, "Yŏnhaeng-rok sŏnjip haeje," in *Kukyŏk yŏnhaeng-rok sŏnjip* (Korean translation of Selected Yŏnhaeng-rok) (Seoul: Minjok munhwa ch'ujin-hoe, 1976), 2–3. This alone reflects the contempt for the Manchus on the part of the Chosŏn ruling class.

5 Yi Ik, "Hwasang yodol," in Yi Ik, *Sŏngho sasŏl*, vol. 2, 64–65.

6 Yi Ŭi-hyŏn, *Kyŏngja yŏnhaeng chapchi*.

7 Other Chinese paintings in the list included those by famous masters of the Song, Yuan, and Ming dynasties, such as Mi Fu (1051–1107), Zhao Mengfu (1254–1322), and Dong Qichang (1555–1636).

8 Yi Ŭi-hyŏn, *Imja Yŏnhaeng chapchi*.

9 See Michael Sullivan, "China and European Art, 1600–1800," in Sullivan, *Meeting of Eastern and Western Art*, 41–87, for a number of European engravings or books with engraved illustrations that were in China since the late sixteenth century. Also, some Chinese artists made their own versions of the stories of Christ based on the European engravings.

10 Hong Tae-yong, "Liu-Bao mundap," in *Tamhŏnsŏ Oejip*, vol. 4, 56.

11 See Sullivan, *Meeting of Eastern and Western Art*, 46-47. Figure 5 here is taken from figure 30 in ibid.

12 *Sŭngjŏng'won Ilgi* (Diary of royal secretariat), Book 1492, August 28, 1781 (*sinch'uk*, the fifth year of King Chŏngjo).

13 See figures 8–21 in *Chosŏn sidae ch'osanghwa* (Joseon Portraits), III (Seoul: National Museum of Korea, 2008).

14 From 1601 to 1693, three Jesuit churches were constructed in Yanjing: the South Church (Nandang) in 1601, the East Church (Dongdang) in 1650, and finally the North Church (Beidang) in 1693. See Yi Won-sun, "Sŏhak ŭi doip kwa chŏn'gae," 190. According to art historian Michael Sullivan, Giovanni Gherardini, a native of Bologna, came to Yanjing in 1700 and decorated the new Jesuit church with illusionistic frescoes and a "dome" on the ceiling. In Sullivan, *Meeting of Eastern and Western Art*, 54.

15 This piece appears in Yi Ki-ji's *Iram-jip*, vol. 2, 25–26. Yi died in prison in 1722, only two years after his visit to Yanjing. He and his father as well as a number of prominent *Noron* (Old faction) officials were purged because of their attempt to install Prince Yŏn'ing (later, King Yŏngjo) as the Crown Prince to succeed King Kyŏngjong, his elder brother. Yi's *Collected Writings* were published posthumously with a preface by Kim Won-haeng (1702–1772) dated 1768.

16 See Xie Chungjeng, "Ji gukong Zhuanjin-zhai tiandinghua, chuanjingtu."

17 Yi Ki-ji, *Iram-jip*, vol. 2, 26.

18 See Osborne, *Oxford Companion to Art*, 1,161 on the historical application of the term from the Greek through the post-Renaissance period and its somewhat pejorative implication as it was much used in decorative arts.

19 Yi Tŏk-mu, "Ibyŏn-gi," 166–67.

20 Yi Ki-ji, *Iram-jip*, 25–26.

21 Hong Tae-yong, "Liu-Bao mundap," vol. 4, 42.

22 Ibid., vol. 3, 167–68.

23 This quotation comes from his "Hwasang yodol," vol. 2, 64–65.

24 Pak Chi-won spent six days in Rehe, and recorded his conversations with Qing scholars at the Taixue (university). It took him five days to get to Rehe from Yanjing, where he stayed for six days. His journey back to Yanjing took another six days. He also recorded the transportation and travel conditions on the road back and forth.

25 Pak Chi-won, "Yanghwa" (Western painting), in his *Yŏrha ilgi* (Yehol diary), Book 3 (*ha*), Korean translation by Yi Ka-won, *Han'guk myŏngjŏ taejŏn-jip*, vol. 22, 339–40.

26 The best reference on this topic is Kim Tong-uk, "Hwasŏng ch'uksŏng e sayongdwen jajae unban kigu e taehaesŏ."

27 Chŏng Yak-yong, "Ch'ilsil kwanhwa–sŏl," 202. The Korean translation appears in Chŏng Yak-yong, *Tasan simun-jip*, vol. 5, 19–20.

28 Benjamin Hobson was born in London, where he studied medicine, but moved to China in 1839 as a missionary physician and, beginning in 1843, established three hospitals (in Hong Kong, Guangzhou, and Shanghai, respectively) before returning to London in 1859. The book *Bowu xinpien* was published in 1885 by Momei shugwan, in Shanghai. The copy I consulted is housed in the library of Seoul National University.

29 Hesin, *Bowu xinbian,* section 1, 43.

30 Chŏng Yak-yong, "Ch'ilsil kwanhwa–sŏl."

31 Yi Kyu-gyŏng, "Ŏmhwa yaksu pyŏnjŭng-sŏl," 145.

32 For different kinds of varnish used in the West, see Osborne, *Oxford Companion to Art*, 1,176–77.

33 For a detailed analysis of the contents of "Hwajŏn" (Painting basket), see Yi Sŏngmi, "*Imwon kyŏngje-ji* e natanan Sŏ Yu-gu ŭi chungguk hoehwa mit hwaron e taehan kwansim."

34 The Chinese authors Sŏ Yu-gu consulted for the "Boundary Painting" section were Wi Hui (1624–1680), Peng Shiwang (1610–1683), and Zhang Chao (active until around 1676). See Sŏ Yu-gu, *Imwon kyŏngje-ji*, vol. 5, 151.

35 See note 25 regarding Pak Chi-won's "Yanghwa."

36 At present, three portraits of Kim Yuk remain. See Cho Sŏn-mi, *Ch'osanghwa yŏn'gu: Ch'osanghwa wa ch'osanghwa-ron*, 413–14, fig. 132.

37 Kim Ch'ang-ŏp, *Kajae yŏnhaeng-rok.*

38 Yi Tŏk-mu, "Ibyŏn-gi," 261.

39 Hu Bing was from Simen, Zhejiang, and was famous for spider painting. See Yu Jianhwa, *Zhongguo meishujia Renimg cidian*, 624.

40 Zhu's birds-and-flowers paintings were also reputed to be fresh and beautiful. See ibid., 211.

41 See Cho Sŏn-mi, *Ch'osanghwa yŏn'gu: Ch'osanghwa wa ch'osanghwa-ron*, figure 139, p. 40.

42 See Ahn Hwi-joon, "Naejo chungguk'in hwaga Maeng Yŏng-gwang."

43 Called *tongjŏng*, this white part of the collar can be removed and replaced with a clean one when necessary.

44 See the entry on Sin Im in the *Encyclopedia of Korean People and Culture*, vol. 13, 908.

45 See *Encyclopedia of Korean People and Culture*, vol. 20, 131–32, for more details on Chŏng's life.

46 "Yŏ Yŏn'gyŏng hwasa Jiao Bingzhen sŏ" (Letter to the Yanjing painter Jiao Bingzhen), in *Sigam sŏnsaeng munjip* (Collected writings of Kim Sŏk-ju), vol. 8 (letters), in *Han'guk yŏktae munjip ch'ongsŏ* (Collection of collected writings of successive dynasties), vol. 603, 456–57. My English translation is based on the Korean translation by Kang Kwan-sik in his "Chin'gyŏng sidae ch'osanghwa ŭi inyŏmjŏk kiban," 281–84.

47 See Pyŏn Yŏng-sŏp, *P'yoam Kang Se-hwang yŏn'gu*, 118–20.

48 It appears that in paintings of supernatural beings, such as this one, it was easier to apply Western painting techniques that the Chosŏn emissaries to Yanjing saw and wrote about.

49 See Kang Kwan-sik, "Chin'gyŏng sidae ch'osanghwa ŭi inyŏmjŏk kiban," 306, *Portrait of Im Mae* by Han Chŏng-rae, dated 1777, in the National Museum of Korea.

50 The death of Crown Prince Sado in 1762 was one of the saddest stories in Chosŏn history. He was put to death by his father, King Yŏngjo, who considered his son deranged. The Crown Princess, Lady Hyegyŏng, left a memoir—the celebrated literary piece *Hanjungrok* (Records of sorrowful days)—in which she recorded the whole story of her husband's death as well as her life thereafter. See Haboush, *Memoirs of Lady Hyegyŏng,* for an annotated English translation and analysis of the text.

51 See Kim Kyŏng-sŏp, "Yongju-sa taeungbojŏn Sambulhoedo yŏn'gu," 1997.

52 See Kang Kwan-sik, "Yongju-sa hubult'aeng gwa Chosŏn hugi kungjung hoehwa," 2008.

53 Saehyang P. Chung has pointed out that some of the genre paintings by Kim Hong-do, such as his *Peddlers, Village School,* and *The Fortune Telling,* contained in his *Album of Genre Paintings*, show certain features of Western figure composition in their arrangement or in presenting an important figure larger than the rest. Chung's argument was based on the similar features seen in the illustrations of the Bible that had been translated into Chinese. See Chung, "Kim Hong-do's 'Peddlers' and Its Possible Artistic Antecedents." 1998.

54 Yi Kyu-sang, "Hwaju-rok."

55 Kang Sin's dates are based on the Kang Se-hwang family's genealogy chart in Pyŏn Yŏng-sŏp, *P'yoam Kang Sehwang hoehwa yŏn'gu*, 216.

56 Kang Se-hwang, "Che Sin'ahwa ch'ihu," 296–97. Kang Se-hwang's eldest son, Yŏn, was appointed to the governor of Hoeyang in 1788.

57 Kang Se-hwang, "Sŏyang'in sohwa wolyŏngdo mobonhu," 297.

58 Ch'oe Kang-hyŏn, *Yŏkju O'udang yŏnhaeng-rok,* 141.

59 O Chu-sŏk doubted the authenticity of the inscription of Kang Se-hwang, and offered Yi In-mun (1745–1821) as the probable painter of the pine tree. See O Chu-sŏk's "Huasŏn Kim Hong-do, kŭ ingan kwa yesul," in *Tanwon Kim Hongdo,* 283.

60 According to the late Ch'oe Sun-u, the longtime director of the National Museum of Korea in Seoul, the spurious seal was impressed on the painting by Ko Hŭi-dong (1886–1965), a well-known painter, around 1910. Ch'oe Sun-u, *Han'guk hoehwa,* 46.

61 For a *ch'aekka-do* without the bookshelves, see figures 83 and 84 in *Kkum kwa sarang: Maehok ŭi uri minhwa.*

62 Yi Kyu-sang, "Hwaju-rok," 249; and Yu Hong-jun, "Yi Kyu-sang *Ilmonggo* ŭi hwaronsa-jŏk ŭi'i," 39.

63 See the passage in Nam Kong-chŏl's *Kŭmrŭng-jip*, quoted in O Chu-sŏk, "Huasŏn Kim Hong-do, gŭ ingan gwa yesul," 283.

64 See Kang Kwan-sik, *Chosŏn hugi kungjung hwawon yŏngu.*

65 Korean scholars have not yet agreed upon an English translation of the term *ŭigwe*. The first character means "rites" and the second means "tracks" (as in railroad tracks). I offer my own translation: "the book of state rites." See Yi Sŏng-mi, "*Euigwe* and the Documentation of Joseon Court Ritual Life."

66 See Yi Sŏng-mi, "Chosŏn hugi chinjak, chinch'an ŭigwe rŭl t'onghae bon kungjung ŭi misul munhwa."

67 For Lang Shining's life and art, see Beurdeley and Beurdeley, *Giuseppe Castiglione*; and Yang Boda, "Castiglione at the Ch'ing court."

68 See Raggio and Wilmering, "Liberal Arts Studiolo from the Ducal Palace Gubbio."

69 Black and Wagner, "Court Style *Ch'aekkŏri*," 1998.

70 Cho Hŭi-ryong and Yu Chae-gŏn, *Hosan oesa*, 197.

71 The subject of this painting was explained by Pak Che-ga's inscription on the upper left. See Yi Sŏng-mi, *Chosŏn sideae kŭrimsok ŭi sŏyang hwapŏp* (2008), 162, for the transcription and translation of the inscription.

72 His birth date and his courtesy name, Kŭmyu, and style names, Saengwon and Chŏggam, can be found in Chang Chi-yŏn, *Haedong sisŏn*, 77, quoted in the *Encyclopedia of Korean People and Culture*, vol. 13, 681.

73 For a comprehensive treatment of court documentary paintings of the Chosŏn period, see Pak Chŏng-hye, *Chosŏn sidae kungjung kirokhwa yŏngu.*

74 *Jieziyuan huachuan*, vol. 1, 286.

75 For the history of the draining and cleaning of the stream during the Chosŏn period and the existing versions of the *Chunchŏn kyech'ŏp* album, see Pak Chŏng-hye, *Chosŏn sidae kungjung kirokhwa yŏngu*, 280–295.

76 See Yi Sŏng-mi, "Screen of the Five Peaks of the Chosŏn Dynasty"; for a revised and expanded version of the article, see Yi Sŏng-mi et al., *Chosŏn wangsil ŭi misul munhwa.*

77 Kang Kwan-sik has pointed out that the original title of this screen is *Kwanhwado chŏngriso kyebyŏng*. This title is difficult to translate. The term *kwanhwa* refers to a piece of music performed at the banquet at Pongsudang hall, in the Hwasŏng Detached Palace, and *chŏngriso* refers to the office established in 1794 in the newly built citadel of Hwasŏng to oversee a series of celebratory events, such as the building of the Hwasŏng citadel, the refurbishing of Hyŏnryung-won, the tomb of the Crown Prince Sado, father of King Chŏngjo, and others. Finally, *kyebyŏng* refers to screens produced in multiple copies to be owned by a group of officials who participated in a certain event, in this case, for the officials of *chŏngriso*. See Kang Kwan-sik, "Chin'gyŏng sidae hwawonhwa ŭi sigakjŏk sasilsŏng" (Visual reality in paintings by court painters of the "true-view period"), *Kansong munhwa* no. 49 (Autumn 1995): 58–60.

78 This *ŭigwe* is called *Wonhaeng ŭlmyo chŏngri ŭigwe* (*ŭigwe* of the royal visit to Crown Prince Sado's tomb in the *ŭlmyo* year, i.e., 1795, printed in *chŏngri* metal type). Although the events recorded in this book took place in 1795, the actual

date of the book's publication is 1798. Also see Yi Sŏng-mi, "Chosŏn hugi chinjak, chinch'an ŭigwe rŭl t'onghae bon kungjung ŭi misul munhwa."

79 See Pak Chŏng-hye, *Chosŏn sidae kungjung kirokhwa yŏngu*, 318–20.

80 *Wonhaeng ŭlmyo chŏngri ŭigwe*, ch. 2, kyesa (letter to the king), the twenty-eighth day of the intercalary second month, 1795.

81 Built in 1791, Yongyang-bongjŏ-chŏng is a small detached palace built for a day-rest for royal retinue on its way to Hwasŏng. This place also housed an office to manage the pontoon bridge, by then a permanent structure to be used for royal trip to Hwasŏng. See Pak Chŏng-hye, *Chosŏn sidae kungjung kirokhwa yŏngu*, 386n124.

82 The international situation at the turn of the century involving Russia, China, and Chosŏn made it possible for King Kojong to declare himself emperor of Korea and change the name of the dynasty from Chosŏn to Taehan Cheguk (the Great Han Empire). See *Chosŏn sidae chinch'an chinyŏn chinha tobyŏng yŏngu* for a comprehensive study of the royal banquet–related screens from 1795 to 1902 with three essays, by Sŏ In-hwa, Pak Chŏng-hye, and Judy Van Zile respectively.

83 Each of these officials would have owned a copy of the screen.

84 There are exceptions to this composition. The eight-panels banquet screen of 1868 (the royal banquet to celebrate the sixtieth birthday of Queen Mother Cho), now in the Los Angeles County Museum of Art, shows two pairs of two panels each that accommodates one building, while panels 5, 6, and 7 accommodate another larger building compound, leaving the last panel for inscription. See Yi Sŏng-mi, "Chosŏn hugi chinjak, chinch'an ŭigwe rŭl t'onghaebon kungjung ŭi misul munhwa," 116–97, figure 9-1. For a monographic treatment of this screen, see Jungmann, "Documentary Record versus Decorative Representation."

85 The banquet was held in celebration of the two events: the first is the sixtieth birthday of Dowager Queen Sunwon (1789–1857), the grandmother of the reigning king, and the second is the forty-first birthday (*mango*, literally "in sight of fifty") of Dowager Queen Cho (1808–1890), the mother of the reigning king.

86 In *Chosŏn sidae chinch'an chinyŏn chinha tobyŏng yŏngu*, see figure 4-1, 28–29, for the entire view of the eight-fold screen that followed the conservative traditional rendering of the buildings, the sides of which go parallel to each other.

87 This 1887 royal banquet was held in celebration of the Dowager Queen Cho's eightieth birthday.

88 The Outer Kyujang-gak Royal Library (Oegyujang-gak) on the island that housed the valuable royal documents known as *ŭigwe* was sacked during this incident, and many of these documents were taken to France and had been kept in the Bibliothèque Nationale de France for 145 years. In May 2011 they were returned to Korea on the condition of renewable loan every five years. They are now kept in the National Museum of Korea, Seoul.

89 See *Kojong Hwangje ch'osanghwa t'ŭkpyŏljŏn*; also see Yi Ku-yŏl, *Kŭndae Han'guk misulsa ŭi yŏngu*, 136–39.

90 See Yun Pŏm-mo, "1910 nyŏndae ŭi sŏyang hoehwa suyong gwa chakka ŭisik." For paintings of Landor and Taylor, see Chung Hyung-min, *Modern Korean Ink Painting*, figures 1-12 and 1-13, respectively.

91 See Kwon Haeng-ga, "Kojong hwangje ŭi ch'osang: Kŭndae sigak maeche ŭi toip gwa ŏjin ŭi pyŏnyong," 31–35.

92 See the entry on Hwang Chŏl, in *Encyclopedia of Korean People and Culture*, vol. 25, 513.

93 See the *New Encyclopedia Britannica*, 15th ed. (1988), vol. 15, s.v., "Chemical Compound," especially the section on "The Development of Synthetic Dyestuffs." Because of their inexpensive production cost compared to traditional natural pigments, these new synthetic pigments ushered in a revolution in pigment-making in 1856; their invention therefore had a great impact on handicrafts, the fabric industry, and painting.

94 *Kojong sillok* (The veritable records of King Kojong), vol. 11, the cyclical year *kapsul* (1874), May 5.

95 *Yŏngjŏng mosa togam ŭigwe*, handwritten and hand-illustrated (dated to 1900), 73–74.

96 See Pak Chŏng-hye, *Chosŏn sidae kungjung kirokhwa yŏngu*, 430, for the titles and the contents of those events.

97 The term *kiroso* refers to the Office of the Elders as well as to the exclusive Club of the Elders, the members of which consist of retired high officials over the age of seventy. Traditionally, Chosŏn kings also joined the club when they reached the age of fifty-one.

98 The Kiroso building was built in 1394 in Chingchŏng-bang area in central Seoul. Over the years it had been repaired many times, and the Yŏngsu-gak was newly added to the compound in 1719, when King Sukchong joined the Club of Elders.

99 After the Chosŏn kingdom changed its statehood into the Taehan empire, all the imperial paraphernalia were made in gold or gilt in accordance with imperial protocol.

100 See Yi Sŏng-mi, "Chosŏn wangjo ŏjin kwangye togam ŭigwe," 88–89, chart 11.

101 In the Natural History Museum of the Smithsonian Institution, there is another oil portrait of Emperor Kojong painted by Antonio Zeno Schindler, a portrait painter of the Smithsonian Institution, based on the photograph of the emperor taken in the 1880s. See figures 17 and 5 in Kwon Haeng-ga, "Kojong hwangje ŭi chʼosang: Kŭndae sigak maechʼe ŭi toip gwa ŏjin ŭi pyŏnyong," for the oil painting and the photo image of Emperor Kojong, respectively. Also see ibid., 36–38, for the circumstances of the production of the oil portrait and how these two items have been kept at the Smithsonian.

102 The date of this portrait is unknown, but judging from its painting style, it must date from the early twentieth century. Between September 28, 1901, and May 18, 1902, Emperor Kojong had four portraits painted. They are (1) the portrait of most regal attire (*myŏnbok-pon*); (2) the portrait in daily office hat (*iksŏngwan-bon*); (3) the large-size portrait in military attire (*kunbok taebon*); and (4) the small-size portrait in military attire (*kunbok sobon*). See Yi Sŏng-mi, "Chosŏn wangjo ŏjin kwangye togam ŭigwe," 61. But this particular portrait is not one of them as the crown Kojong is wearing is called *tʼongchʼŏn-gwan*, an imperial crown.

103 See the schedule of events in *Ŏjin tosa togam ŭigwe* (Book of state rites on the painting of the royal portraits), 1902, handwritten manuscript, Changsŏgak library, Academy of Korean Studies; and Yi Sŏng-mi, "Chosŏn wangjo ŏjin kwangye togam ŭigwe," 65.

104 Yi Sŏng-mi, "Chosŏn wangjo ŏjin kwangye togam ŭigwe," 74–75.

105 See Cho Sŏn-mi, *Ch'osanghwa yŏn'gu: Ch'osanghwa wa ch'osanghwa ron*, 269–365, for the life and art of Ch'ae Yong-sin.

106 See ibid., 210n1, for research works published before Cho Sŏn-mi's *Ch'osanghwa yŏn'gu*.

107 Ibid., 313–15.

108 In Korean the treaty is called Ŭlsa boho choyak, or simply Ŭlsa choyak. It was a prelude to the annexation of Korea by Japan in 1910. All the diplomatic functions of the Taehan empire were taken over by the Japanese. See the Ŭlsa choyak entry in *Encyclopedia of Korean People and Culture*, vol. 17, 417–19.

109 See Ch'oe Ik Hyŏn in ibid., vol. 22, 471–72.

3

True-View Landscape Painting

..

1 This English translation was based on Ch'oe Wan-su's *Kyŏmjae Chŏng Sŏn chin'gyŏng sansuhwa* (1993).

2 Ch'oe Wan-su, *Kyŏmjae Chŏng Sŏn* (2009).

3 O Se-ch'ang, *Kŭnyŏk sŏhwajing*, 166. Also see the Korean translation of the same work, O Se-ch'ang, *Kuggyŏk Kŭnyŏk sŏhwajing*, vol. 1, 651.

4 For the most comprehensive annotated English translation of Jing Hao's *Bifaji*, see Munakata, *Ching Hao's Pi-fa chi*, 12–13.

5 For translations of the key parts of the *Linchuan gaozhi*, see Bush and Hsio-yen Shih, *Early Chinese Texts on Painting*, 150–54.

6 See Yi T'ae-ho, "Chosŏn hugi chin'gyŏng sansu ŭi paltal-gwa t'oejo." Pages in this exhibition catalog are not numbered.

7 Pak Ŭn-sun, *Kŭmgangsan-do yŏn'gu*, 83. For the definition of the term *tianji*, see Bush, *Chinese Literati on Painting*, 56–58.

8 For my English translation of the term *ŭigwe* into "book of state rites," see Yi Sŏng-mi, "*Euigwe* and the Documentation of the Joseon Court Ritual Life," 131n2.

9 These terms are found in several *Books of State Rites for the Painting and Copying of Royal Portraits* from 1688 to 1902. See Yi Sŏng-mi, "Chosŏn wangjo ŏjin kwangye togam ŭigwe," 25–26, 64.

10 *Han'guk hanchaŏ sajŏn*, vol. 3, 555.

11 For the transcription of the inscription and an interpretation of the term *chin'gyŏng* as simply "real scenery," see Pyŏn Yŏng-sŏp (1988), 190nn75, 76.

12 The earliest recorded map of the Korean peninsula is *P'alto-do* (Map of the eight provinces), made by Yi Hoe in 1402. Although the original version is no longer extant, the map is incorporated in a mid-fifteenth-century map of the world produced by Yi Hoe and other scholars drawing on material from Chinese sources. For an illustration of this later map, see *Chosŏn chŏn'gi kukpo chŏn*, 102–3, plate 65.

13 For the sources of these recorded works, see Ahn Hwi-joon, "Chosŏn wangjo hugi hoehwa-ŭi sin tonghyang," 19.

14 Mun Myŏng-dae has identified the subject of this small screen as King T'aejo of

Koryŏ praying on Mount Kŭmgang. See Mun Myŏng-dae, "Noyŏng ŭi Amita Chijang Posal e taehan koch'al." (1979), 47–57.

15 *Veritable Records of King T'aejo,* vol. 13, 1,398, April, *imin* day. It is recorded that the king assigned to the painters Cho Chun and Kim Sa-hyŏng one scene each, whereupon Chŏng To-jŏn (1337–1398) composed a poem for all eight scenes. See Ahn Hwi-joon, *Chosŏn wangjo sillok-ŭi sŏhwa saryo,* 16–17. Also see Yi Sŏng-mi et al., eds. *Chosŏn wangjo sillok misul kisa charyojip,* vol. 1, 16–19. In the latter, the original text is followed by its Korean translation for easier reading and comprehension.

16 The Kijŏn originally referred to the area within the radius of 500 *ri* (about 200 kilometers) from the capital. But here, it refers to the suburbs of the capital.

17 *Veritable Records of King Sejong,* vol. 53, 1,431, August, *muo* day. See also *Veritable Records of King Tanjong,* vol. 14, 1,455, intercalary June, *chŏngmi* day. Besides these entries, many more recorded instances of requests by Chinese emissaries for paintings of Mount Kŭmgang can be found throughout the Chosŏn period.

18 *Veritable Records of King Munjong,* vol. 3, 1,450, August, *kyŏngja* day.

19 *Veritable Records of King Myŏngjong,* vol. 26, 1,560, June, *chŏng'yu* day.

20 See figure 7 in Pang Tong-in, *Han'guk ŭi chido* (Map of Korea) (1976; reprint, Seoul: Sejong taewang kinyŏm saŏphoe, 2000).

21 For a pioneering study of the origins and development of *kyehoe-do* in the Chosŏn period, see Ahn Hwi-joon, "Literary Gatherings and Their Paintings in Korea." For a more recent and comprehensive study of the subject, see Yun Chin-yŏng, "Chosŏn sidae Kyehoe-do yŏn'gu."

22 The names of some of the participants at this gathering included Yun Kŭn-su (1537–1616), who spent his reading recess in 1567; Chŏng Yu-il (1533–1576), who was granted a recess in 1570; and Chŏng Ch'ŏl (1536–1593), who spent the reading recess with Yi I (1536–1584). Other notable participants were Ku Pong-ryŏng (1526–1586) and Yu Sŏng-ryong (1542–1607).

23 However, sadly, in place of the Reading Hall, today there is an apartment complex of high-rise buildings that almost obliterates the view of the whole mountain behind it. Only a stone marker that tells the history of the hall stands at the entrance to the complex.

24 *Veritable Records of King Chungjong,* vol. 84, 1,537, March, *pyŏngsin* day.

25 For an in-depth study of Yi Ching, see Kim Chi-hye, "Hŏju Yi Ching Hoehwa Yŏn'gu"; and Kim Chi-hye, "Hŏju Yi Ching ŭi Saeng'ae wa Sansu Yŏn'gu."

26 See Chin Chun-hyŏn, *Ŭri ttang chin'gyŏng sansu,* 39.

27 For a detailed study of this painting, see Yi T'ae-ho, "Han Si-gak ŭi *Puksae Sŏnŭndo* wa *Pukkwan Silgyŏng-do*"; and Yi Kyŏng-hwa, "*Puksae Sŏnŭn-do* yŏn'gu," especially 45–48.

28 See Yi T'ae-ho, "Han Si-gak ŭi *Puksae Sŏnŭn-do* wa *Pukkwan Silgyŏng-do*"; and Yi Kŏn-sang, "*Puksae Sŏnŭn-do* wa *Pukkwan Such'angrok*," for all the transcription of the poems and their translation into Korean. This album consists of thirty-two leaves in all; twenty-four leaves of poems, six leaves of paintings, and the front and back covers. All the leaves are illustrated in this article.

29 Yu Chun-yŏng, "Kugok-to ŭi palsaeng gwa kinŭng e taehayŏ."

30 See Yun Chin-yŏng, "Chosŏn sidae kugok-to yŏn'gu," 10, for a list of Chinese paint-

ings on the theme retrieved from Ferguson, *Lidai zhulu huamu*. Also see Kang Sin-ae, "Chosŏn sidae *Mui kugok-to* ŭi yŏnwon kwa t'ŭkching," chart no. 1 for an additional list.

31 For a possible route of transmission of Chinese paintings from Mount Wuyi to Korea, see Yu Chun-yŏng, "Kugok-to ŭi palsaeng gwa kinŭng e taehayŏ," 4–7.

32 For the Chinese philosopher Zhu Xi and his followers, "principle" (Korean *i*; Chinese *li*) and "matter-energy" (Korean *ki*; Chinese *qi*) were two distinct entities. Yi I's phrase "subtlety of *li* and *qi* [*igi chi myo*]" suggests that they were not two distinct entities, but two entities in one inseparable state. For a discussion of Yi I's theories, see Ch'oe Yŏng-sŏng, *Han'guk yuhak sasang-sa*, vol. 2. For Zhu Xi's teachings, see Zhu, *Reflections on Things at Hand*.

33 See figure 24 in Chin Chun-hyŏn, *Tanwon Kim Hong-do yŏn'gu*, 165.

34 In the nineteenth century, scenes of the Nine-Bend Stream at Kosan were painted with Yi I's poetry inscribed at the top of each scene.

35 See Yu Chun-yŏng, "*Kogun kugok-to* rŭl chungsim ŭro pon sipch'il segi silgyŏng sansu ŭi illye."

36 See Yun Chin-yŏng, "Chosŏn sidae kugok-to yŏn'gu," for photographs of the nine sites.

37 The most comprehensive research on Chŏng Sŏn's life appears in Ch'oe Wan-su, *Kyŏmjae Chŏng Sŏn* (2009), vol. 3, 492–514. In this chronology of Chŏng Sŏn, Ch'oe recorded Chŏng's career activities and also included those of his contemporaries who were close to the artist.

38 Kang Kwan-sik, "Kyŏmjae Chŏng Sŏn ŭi sahwan kyŏngryŏk kwa aehwan."

39 Kang Kwan-sik, "Kyŏmjae Chŏng Sŏn ŭi chŏnmun-hak kyŏmkyosu ch'ulsa wa *Kŭmgang chŏndo* ŭi chŏnmun yŏkhak chŏk haesŏk." The position was supposed to be the ninth rank, but he was given the sixth rank under the condition that his salary for two and a half years be equal to that of the ninth rank.

40 See Kang Kwan-sik, ibid., 141–47, for the changing system of the position of the astronomy instructor during the Chosŏn period, and reasons for Chong Sŏn's appointment for the position despite his *yangban* background.

41 See Kang Kwan-sik, "Kyŏmjae Chŏng Sŏn ŭi sahwan kyŏngryŏk kwa aehwan,"148, for paintings produced in Hayang; 157–58 for those produced in Chŏngha; and 162-63 for those produced in Yangch'ŏn.

42 Ibid., 179–81.

43 See *Veritable Records of King Yŏngjo*, vol. 18, 1,754, March, *kapsin* day.

44 Cho Yŏng-sŏk, "Kyŏmjae Chŏng Tongch'u aesa." The Korean translation of the entire eulogy can be found in Ch'oe Wan-su, "Kyŏmjae Chŏng Sŏn kwa chin'gyŏng sansu hwap'ung" (Kyŏmjae Chŏng Sŏn and the true-view landscape painting style), in Ch'oe Wan-su, *Chin'gyŏng sidae*, 103–6.

45 Ch'oe's description of the Paegak sadan as an advocate of the so-Chunghwa concept can be disputed in light of the fact that Kim Ch'ang-ŏp (*ho* Nogajae or Kajae; 1658–1721), another of the Kim brothers and a member of the group, was favorably impressed by the new Qing dynasty during his visit to Yanjing. Kim describes his encounter with Chinese books and paintings in his travelogue, *Kajae Yŏnhaeng-gi*.

46 Ahn Hwi-joon, "Chosŏn hugi mit malgi ŭi sansuhwa," 206; and Ch'oe Wan-su, *Kyŏmjae Chŏng Sŏn* (2009), vol. 1, 98–111.

47 See Yi Sŏng-mi, "Southern School Literati Painting."

48 Ibid, 180–81, for documentary evidence of the earliest instances of these painting manuals' appearances in Korea.

49 Ibid, 183–84.

50 Cho Yŏng-sŏk, "Kyŏmjae Chŏng Tongch'u aesa," quoted in Ch'oe Wan-su, *Chin'gyŏng sidae*, 104.

51 Yi Sŏng-mi, "*Hŏju pugun sansu yuch'ŏp*," 218.

52 Ko Yŏn-hŭi, *Chosŏn hugi sansu kihaeng yesul yŏn'gu*, 65–68.

53 For a detailed discussion of the history of the different names of Mount Kŭmgang, see Pak Ŭn-sun, *Kŭmgangsan-do yŏn'gu*, 14–34.

54 See Map 5 in Yi Sŏng-mi, *Korean Landscape Painting*, 176.

55 See Ch'oe Wan-su, *Kyŏmjae Chŏng Sŏn* (2009), vol. 1, plate 1-13, for the best illustrations of all thirteen leaves.

56 See Yi T'ae-ho, "Chosŏn hugi chin'gyŏng sansu ŭi paltal gwa t'wejo." Unfortunately, the poetry section has been separated from the painting. Ch'oe Wan-su, however, has identified a poem by Yi Pyŏng-yŏn as having been written for Chŏng Sŏn's painting. This assumes that Chŏng Sŏn was traveling to that area at the invitation of Yi, who was then serving as magistrate of the Kŭmhwa district, the entrance to the vast Diamond Mountain area. See Ch'oe Wan-su, *Kyŏmjae Chŏng Sŏn chin'gyŏng sansuhwa*, 16.

57 For example, see Book 2 of *Sunam-jip*, the collected writings of Yi Pyŏng-sŏng (*ho* Sunam; 1675–1735), the younger brother of Yi Pyŏng-yŏn, quoted in Ch'oe Wan-su, *Kyŏmjae Chŏng Sŏn chin'gyŏng sansuhwa*, 20.

58 Pak Ŭn-sun, *Kŭmgangsan-do yŏn'gu*, 156–58.

59 See Kang Kwan-sik, "Kyŏmjae Chŏng Sŏn ŭi chŏnmun-hak kyŏmkyosu ch'ulsa wa *Kŭmgang chŏndo* ŭi chŏnmun yŏkhak chŏk haesŏk," 164–67, for the comparative chart of calligraphy and his discussion of the possible date of the painting as sometime after the early 1740s.

60 "Kwandong" refers to the area including Mount Kŭmgang and others along the eastern coastal region. This album is also in the collection of the Kansong Art Museum.

61 See Ch'oe Wan-su, *Kyŏmjae Chŏng Sŏn* (2009), vol. 1, 341–97, for illustrations of all eleven leaves of the album and many poems related to individual scenes composed by contemporary literati.

62 Kang Kwan-sik, "Kyŏmjae Chŏng Sŏn ŭi chŏnmun-hak kyŏmkyosu ch'ulsa wa *Kŭmgang chŏndo* ŭi chŏnmun yŏkhak chŏk haesŏk," 166. Ch'oe Wan-su dates this painting circa 1752 on the grounds that it shows a very advanced stage of abstraction, which he considered to be a late feature in Chŏng's paintings. See Ch'oe Wan-su, *Kyŏmjae Chŏng Sŏn* (2009), vol. 3, 279.

63 See Kang Kwan-sik, "Kyŏmjae Chŏng Sŏn ŭi chŏnmun-hak kyŏmkyosu ch'ulsa wa *Kŭmgang chŏndo* ŭi chŏnmun yŏkhak chŏk haesŏk," 162–72. For other scholars' earlier essays from which Kang further pursued the matter, see footnotes 64 and 65 in ibid.

64 This is in contrast to the traditional Chinese view of the universe consisting of the circular heaven and the square earth within the circle. See Kang Kwan-sik, "Kyŏmjae Chŏng Sŏn ŭi chŏnmun-hak kyŏmkyosu ch'ulsa wa *Kŭmgang chŏndo* ŭi

chŏnmun yŏkhak chŏk haesŏk," for a complicated chain of discussion on Chŏng's understanding of contemporary Western astronomy and the influence on Chŏng of Kim Sŏk-mun's *Illustrations for the Study of the Book of Changes* (Yŏkhak tosŏl), published in 1726, in which the traditional Neo-Confucian concept of the universe was modified by Western astronomy.

65 "Layers of fragrance" is a translation of Chunghyang, another name for Mount Kŭmgang.

66 In Chinese myth *pusang* (Chinese *fusang*) is an imaginary tree in the eastern sea, from whence the sun rises.

67 My English translation is based on O Chu-sŏk's Korean translation in his "Yet kŭrim iyagi," 3.

68 This story is recounted in the biography of Zong Bing in Shen Yue (441–513), comp., *Songshi*, Book 53, "Liezhuan."

69 The undated *General View of Inner Mount Kŭmgang* shows much crisper brush lines and stronger contrasts of light and dark. It also uses fewer of the "Kyŏmjae vertical strokes" to render the sharp, rocky peaks. Instead, they are outlined with lines of even thickness and painted with opaque white pigment. These features point to the artist's earlier style, less confident and less personal, mentioned earlier in connection with the 1711 album.

70 See chapter 1, the discussion of making maps of the Korean peninsula.

71 Yi Man-bu, *Chihaeng-rok*, 259. The English translation is taken from Yi Sŏng-mi, "Koreans and Their Mountain Paintings," 23.

72 See Pak Ŭn-sun, *Kŭmgangsan-do yŏn'gu*, 131–35, for a list of Chŏng Sŏn's Mount Kŭmgang paintings in album or screen format.

73 See Ch'oe Wan-su, *Kyŏmjae Chŏng Sŏn* (2009), vol. 3, 248–76, for the eight paintings that form a screen titled *The Eight Scenes of the Kwandong Area*, in the collection of the Kansong Art Museum.

74 My English translation of the inscription is a slightly modified version of a Korean translation in Ch'oe Wan-su, *Kyŏmjae Chŏng Sŏn chin'gyŏng sansuhwa*, 42.

75 This album in the Kansong Art Museum consists of two volumes and contains thirty-two leaves in all: volume 1 has nineteen leaves, while volume 2 has thirteen leaves.

76 Today this area, still called Apkujŏng-dong, is densely packed with high-rise apartment buildings, the unmistakable sign of Korea's modernization.

77 See Kang Kwan-sik, "Kwangju Chŏngmun gwa Changdong Kimmun ŭi segyo wa Kyŏmjae Chŏng Sŏn ŭi *Chŏngp'ung-gye*." By this time the branch of the Andong Kim family was known as the Changdong Kim clan, Changdong being the area near the Chŏngp'ung Valley, and the name of the district where their homes were located.

78 Kang Kwan-sik, "Kwangju Chŏngmun kwa Changdong Kimmun ŭi segyo wa Kyŏmjae Chŏng Sŏn ŭi *Chŏngp'ung-gye*," 142, figure 4. The copy was made in 1720 and is currently in the collection of the Sŏngho Memorial Hall in Ansan, in the province of Kyŏnggi.

79 See ibid., figures 4–10, for all the Chŏngp'ung Valley paintings.

80 See Ch'oe Wan-su, *Kyŏmjae ŭi Hanyang Chin'gyŏng*, 124–29.

81 There is a painting called *Samun t'alsa* (Taking off the straw rain-cape at the temple

gate) dated to 1755 (cyclical year *kihae*), but it is not a landscape painting. See Ch'oe Wan-su, *Kyŏmjae Chŏng Sŏn* (2009), vol. 3, figure 190.

82 See Kwŏn Yŏng-pil, Pyŏn Yŏng-sŏp, and Yi Sŏng-mi, *Fragrance of Ink,* figure 9 (all three images). They are now mounted as small hanging scrolls.

83 For the life and art of Yi In-sang, see Yu Hong-jun, "Yi In-sang hoehwa ŭi hyŏngsŏng gwa pyŏnchyŏn." See also his *Hwain yŏlchŏn,* vol. 2, 58–126.

84 See Yi Sŏng-mi, *Korean Landscape Painting,* figure 70, "Terrace of Immortals' Retreat," for an example of Yi In-sang's true-view landscape of Mount Kŭmgang in which he employed mostly wet brushstrokes.

85 See Ch'oe Wan-su, *Kyŏmjae Chŏng Sŏn* (2009), vol. 3, figure 121.

86 All East Asian paintings can be called "images of mind" (Chinese *sinyin*; Korean *simin*) because the brushstrokes, like the writer's autograph, represent the character, ideas, thoughts, and the personality of the artist. See Fong et al., *Images of the Mind,* 3.

87 In the original acquisition record of the National Museum, the painting was labeled as "finger painting landscape" because of its unusual brushstrokes. If the inscription by the artist was not there, we would have taken it as a finger painting.

88 The term Kyŏmjae ilp'a was introduced by Yi Tong-ju in his "Kyŏmjae ilp'a ŭi chin'gyŏng sansu." This article was originally published in *Asea,* no. 4 (1969), 160–86.

89 See Yi Ye-sŏng, *Hyŏnjae Sim Sa-jŏng yŏn'gu,* 12–42. Although he produced some true-view landscapes, his works generally reflect a strong influence of Chinese painting manuals.

90 These two paintings form parts of a four-fold screen now kept in Seikenji, Shizuoka prefecture, Japan. See Jungmann, *Painters as Envoys,* figure 59. Of the two panels, the Mount Kŭmgang panel does show much influence of Chŏng Sŏn.

91 See ibid., 147–54.

92 The pioneering study on Kim Yun-gyŏm is Yi T'ae-ho's article, "Chinjae Kim Yun-gyŏm ŭi chin'gyŏng sansu." For a more comprehensive study of the artist, see Yi Ta-hong, "Chinjae Kim Yun-gyŏm ŭi hoehwa yŏn'gu."

93 Only eight of the twelve leaves mentioned in the inscription survive. They are now in the National Museum of Korea.

94 For a brief history of the Myogilsang-am temple, see the *Encyclopedia of Korean People and Culture,* vol. 8, 109.

95 See *Chin'gyŏng sansu-hwa,* plate 132, for Ŏm Ch'i-uk's painting. It is in the National Museum of Korea.

96 A special issue on Ch'oe Puk with contributions by Yi Chu-sŏng (on documentary sources), Hong Sŏn-p'yo (on Ch'oe's life and art), Pak Ŭn-sun (on his landscape painting), and Song T'ae-won (on his figure painting) was published in *Misulsa yŏn'gu,* no. 5 (1991). Because of Ch'oe's unruly lifestyle, he was very poor in his old age; he was found dead on a street, drunken and frozen on a cold winter's night. There is a novel on Ch'oe's life, *Hosaeng-gwan Ch'oe Puk* by Yim Yŏng-t'ae.

97 The birth date of Kang Hŭi-ŏn was traditionally known to be 1710. But in new research of Yi Sun-mi, she introduced an official document—namely, the list of persons who were successful in the "cloud category" (*unkwa*) state examination

with their dates of birth. According to this document, Kang was born in 1738. See Yi Sun-mi, "Tamjŏl Kang Hŭi-ŏn ŭi hoehwa yŏn'gu," especially 144–45.

98 See figure 17 (bottom) in Lee Tae-ho (Yi T'ae-ho), "Painting from Actual Scenery and Painting from Memory," 134, for a photograph of the mountain seen from a similar spot taken by Kang Hŭi-ŏn.

99 See Yi Sŏng-mi, "Ideals in Conflict," 288–314, especially 296.

100 Kim Sŏk-sin was a nephew of Kim Ŭng-hwan but was formally adopted by him. See O Se-chang, *Kuggyŏk Kŭnyŏk sŏhwajing*, vol. 2, 795–96. As a result, he became a cousin to his brother Kim Tŭk-sin.

101 This is one of the leaves of the album *Tobong-ch'ŏp*, which, according to the cartouche, was painted for two contemporary figures, Yi Chae-hak (1745–1806) and Sŏ Yong-bo (1757–1824), who had roamed about the mountain.

102 Yi Sŏng-mi, "Ideals in Conflict."

103 He served as the vice-minister of the Ministry of Military Affairs in 1783 and as the mayor of Hansŏng in 1785, if we list two of his important official posts. See Pyŏn Yŏng-sŏp, *P'yoam Kang Sehwang hoehwa yŏn'gu*, 216–18.

104 Kang Se-hwang's travel record is preserved in *P'yoam yugo* (Collected writings of P'yoam) (Sŏngnam: Academy of Korean Studies, 1979), 254–62.

105 My English translation is based on the Korean translation by Pyŏn Yŏng-sŏp in Pyŏn Yŏng-sŏp, *P'yoam Kang Sehwang hoehwa yŏn'gu*, 117.

106 *P'yoam yugo*, 261–62.

107 See the discussion in chapter 2 of Kang's interest in Western painting techniques.

108 This album consists of sixteen leaves: two leaves of calligraphy—one inscription by Kang Se-hwang and another by a certain Susa—twelve leaves of painting depicting scenic spots in and around Songdo (present-day Kaesŏng), and two leaves of colophons by a certain Namch'ŏnmin. The title of the album was given as *P'yoam sŏnsaeng yujŏk* (Master P'yoam's remaining paintings) by someone who put the leaves together in an album form. But in modern scholarship the album was renamed *Songdo kihaeng-ch'ŏp*, based on the internal evidence—i.e., contents of the inscriptions and the painted images. See Pyŏn Yŏng-sŏp, *P'yoam Kang Sehwang hoehwa yŏn'gu*, 96n26.

109 See ibid., 102–5, for evidence that the album was painted in 1757. The confirmation of this date comes from Hŏ P'il's colophon to *Myogilsang-do*, in which Kang's trip to Songdo was mentioned.

110 See figure 78 in Yi Song-mi, *Korean Landscape Painting*, 121.

111 It can be identified as the main building because the character *tae*, the first character of Taeung-jŏn (Hall of the great hero), is visible on the black signboard under the roof, and it is the only colored building in the compound.

112 See Chin Chun-hyŏn, *Tanwon Kim Hong-do yŏn'gu*, for the most comprehensive treatment of Kim Hong-do's life and his painting.

113 Kang Se-hwang started his official career in 1773, rather late in life, while there is evidence that Kim Hong-do began his career at the court bureau of painting in 1765 at age twenty-one. In this court bureau called *sap'o-sŏ*, both men were ranked as *pyŏlche* (6B grade). Chin Chun-hyŏn, *Tanwon Kim Hong-do yŏn'gu*, 656–57.

114 "Song Kim Ch'albang Hong-do Kim Ch'albang Ŭng-hwan sŏ" (Preface to sending off Kim Hong-do and Kim Ŭng-hwan), in *P'yoam yugo*, 237–38.

115 The set includes (1) *Myŏngyŏng-dae* (Clear-mirror terrace), (2) *Pibong-p'ok* (Flying-Phoenix waterfall), (3) *Myŏng'yŏn-dam* (Resounding deep pond), (4) *Ongch'ŏn* (Jar-shaped cliff), (5) *Hwansŏn-jŏng* (Immortal-calling pavilion), (6) *Kŭmran-gul* (Golden kasaya cave), (7) *Kuryong-yŏn* (Nine-dragon waterfall pond), and (8) *Yŏngrang-ho* (Yŏngrang lake). See the catalog entries by Ch'oe Wan-su in *Tanwon Kim Hongdo* (exhibition catalog, 1995), 243–45, for the locations and the origin of names of each of the sites. The order of these eight scrolls can be different in other publications.

116 In *Tanwon Kim Hongdo* (exhibition catalog, 1995), 244, this scroll was called *Ch'ŏngsŏk-chŏng* (Bundle-stone pavilion), but Chin Chun-hyŏn changed its name to *Hwansŏn-jŏng* by comparing this image with that in the sixty-leaf album attributed to Kim Hongdo. See Chin Chun-hyŏn, *Tanwon Kim Hong-do yŏn'gu*, 237; and *Tanwon Kim Hongdo* (exhibition catalog, 1995), figure 36. Chin also renamed *Kŭmran-gul* (Golden kasaya cave) as *Hyŏnjong-am* (Suspended-bell rock), and *Yŏngrang-ho* (Yŏngrang lake) as *Sijung-dae* (Prime minister terrace) for the same reason.

117 See *Tanwon Kim Hongdo* (exhibition catalog, 1995), figures 75–85, for the reproductions of all the leaves of these two albums.

118 Kyŏng-rim is the style name of Kim Han-t'ae (1762–?), a younger contemporary of Kim Hong-do, whose main job was a court translator, but thanks to his family business of salt dealing, he possessed great wealth and patronized artists. See the catalog entry by O Chu-sŏk in *Tanwon Kim Hongdo* (essays, 1995), 245.

119 See the essays by Kwon Yŏng-p'il ("The Ideals of Scholar Painting of the Chosŏn Period"), Yi Sŏng-mi ("Southern School Literati Painting of the Late Chosŏn Period"), and Byun Young-sup (Pyŏn Yŏng-sŏp) ("On Kang Se-hwang: The Lofty Ideals of a Literati Artist"), in Kwŏn Yŏng-pil, Pyŏn Yŏng-sŏp, and Yi Sŏng-mi, *Fragrance of Ink*, 141–218. Also see Yi Sŏng-mi, "Ideals in Conflict."

120 Yi Man-bu, *Chihaeng-rok,* 259–30. This English translation is by Yi Sŏng-mi, "Koreans and Their Mountain Paintings," 24.

121 The album was first introduced by Ch'oe Sun-wu (1916–1984) in his "Chiujae ŭi Haesan-chŏp."

122 Also see Pak Ŭn-sun, *Kŭmgangsan-do yŏn'gu*, 409.

123 See *Tanwon Kim Hongdo* (exhibition catalog, 1995), figures 1–60, for the reproduction of all sixty leaves of the album.

124 The title *Kŭmgang sagun-ch'ŏp* was attached to this set of albums for some time before its full release in 1995.

125 These documents are (1) Hong Sŏk-chu's (1774–1842) preface, dated 1812, to the painting, *Sea and Mountain (Haesan-kwon)*, owned by Hong Hyŏn-ju (1793–1865); (2) Hong Sŏk-chu's "Selection of Twenty-Three Poems out of Seventy Written for Tanwon's *Album of Sea and Mountains* (Haesan-chŏp), dated 1821; and (3) Hong Kil-chu's (1766–1841) colophon to the *Album of Sea and Mountains*, dated 1929. The first two are found in Hong Sŏk-chu's collected writings, *Yŏnch'ŏn-jip*, Books 20 and 4, respectively; the third is in Hong Kil-chu's collected poems and writings, *P'yorong ŭlch'am*, Book 5. Also see Chin Chun-hyŏn, *Tanwon Kim Hong-do yŏn'gu*, 219–31, for additional documents that might be related to Kim Hong-do's *Album of the Four Districts of Kŭmgang*.

126 Ch'oe Wan-su, while partly admitting the difficulties in reconciling the discrepancies between the existing albums and the documentary evidence, concluded on the basis of the "characteristic traits of Kim Hong-do's style" that the five-album set is the original form of the *Haesan-ch'ŏp*. See Ch'oe Wan-su's essay in *Tanwon Kim Hongdo* (essays, 1995), 242.

127 See Chin Chun-hyŏn, *Tanwon Kim Hong-do yŏn'gu*, 275–80. Chin goes as far as to differentiate two different hands in the albums.

128 This album is in an undisclosed private collection.

129 See Chin Chun-hyŏn, *Tanwon Kim Hong-do yŏn'gu*, 289, for the contents of the album and the reason for the earlier attribution to Kim Hong-do.

130 The albums have been published in a monograph, *Tongyu-ch'ŏp* (Album of travel to the East) (Seoul: Sŏnggyun-gwan University Press, 1994). The monograph contains an essay by Cho Sŏn-mi, "Tongyu-ch'ŏp ko," as well as transcriptions and translations of all the diaries and poems into Korean.

131 These prints were either included in local gazetteers and encyclopedic compilations or published independently. Most of these prints and painting manuals reached Korea soon after their appearance in China and greatly influenced Chosŏn-period landscape compositions. The most representative of Chinese printed books with landscape illustrations include *Sihu youranji* (1547), *Hainei qiguan* (1606), and *Mingshan shengkaiji* (1616). Also see *Zhongguo banhuashi tulu*, vol. 1, plates 162–96. Under the category of "topography" are listed various woodblock-printed landscapes published during the late Ming and early Qing periods.

132 Published in *Richono kaiga*, cat. no. 50.

133 In fact, there is a large-scale (105.7 × 64.5 centimeters) maplike woodblock print of Mount Kŭmgang titled *Complete View of the Four Great Temples of Mount Kŭmgang*, dated 1899, in the collection of Yŏngnam University Museum in Taegu, North Kyŏngsang. See figure 68 in *Mong'yu Kŭmgang*.

134 The title of the same scene in the *Four-District Album* is the "Front View of Coastal Kŭmgang."

135 Kim's services at the court bureau of painting were rather well documented mostly in the numerous books of state rites (*ŭigwe*) ranging in dates from 1805 through 1875. See Pak Chŏng-hye, "Ŭigwe rŭl t'onghae pon Chosŏn sidae ŭi hwawon," 273–90, especially 273. However, aside from the two albums of Mount Kŭmgang paintings, only a couple of landscapes with figures have survived.

136 For a detailed introduction of the contents of this album, along with the transcription of the two pieces of writings by Yi Kwang-mun, who commissioned the album, see Pak Ŭn-sun, "Kim Ha-jong ŭi *Haesando-ch'ŏp*."

137 The suffix "*kwon*" means handscroll, but the leaves in the album seem to have been in the album form from the beginning. The albums, now in a private collection, first came to be known at a Sotheby's auction in 1991. See *Korean Works of Art*, no. 38, for illustrations of three leaves. For the entire contents of the album, see Pak Ŭn-sun, *Kŭmgangsan-do yŏn'gu*, 355–59.

138 See *Tanwon Kim Hongdo* (exhibition catalog, 1995), figure 45, for the "Clear-Mirror Terrace" from the *Four Districts Album, and Four-District Album*; and Yi Sŏng-mi, *Korean Landscape Painting*, figure 107, 154, for Kim's "Clear-Mirror Terrace" from his 1815 album.

139 In the nineteenth century, Mount Kŭmgang paintings produced by anonymous painters for ordinary people, now termed "folk painting," appeared. See Yi Sŏng-mi, *Korean Landscape Painting*, figures 110 and 111, 158–62, for two such screen paintings.

140 See Pak Chun-yŏng (Park Junyoung), "Imdang Paek Ŭn-bae ŭi hoehwa yŏn'gu," 9–12, for the newly discovered death date of Paek Ŭn-bae. Previously, his death date was given as end of the nineteenth century.

141 See Yi Sŏng-mi, *Korean Landscape Painting*, figure 109, 156, for Cho's *Nine-Dragons [Waterfall] Pond* in the Kansong Art Museum, Seoul.

142 See Pak Ŭn-sun, *Kŭmgangsan-do yŏn'gu*, figure 116, 383.

143 See Hong Sŏn-p'yo, "Nam Ku-man che *Hamhŭng sipkyŏng-do*," for the brief introduction to the ten scenes of Hamhŭng and the two hanging scroll paintings that remain today of the original ten paintings.

144 See ibid., figures 3 and 4, for the illustration of the seventeenth-century painting, *Kugyŏng-dae* (Tortoise-scene terrace). The two paintings are now in a private collection, and their current condition seems to be poor.

145 One *chang* equals approximately three meters.

146 My English translation is based on the Korean translation of the inscription that appears on pages 62–63 of Pak Chun-yŏng's thesis, "Imdang Paek Ŭn-bae ŭi hoehwa yŏn'gu."

147 See Yi Sŏng-mi, "Screen of the Five Peaks of the Chosŏn Dynasty," and the revised version of the article with the same title in Yi Sŏng-mi et al., *Chosŏn wangsil ŭi misul munhwa*, 466–519, for the symbolism, iconography, and stylistic analyses of the *Screen of the Five Peaks*.

148 Despite his unique position in nineteenth-century Korean painting, the only monographic treatment in print on Yun Che-hong is by Kwon Yun-gyŏng, "Hoam misulgwan sojang Yun Che-hong ŭi *Haksan Mukhŭi-ch'ŏp*." For master's theses on Yun, see Kwon Yun-gyŏng, "Yun Che-hong ŭi hoehwa"; and Kim Ŭn-ji, "Haksan Yun Che-hong ŭi hoehwa yŏn'gu."

149 On Korean finger painting, see Kim Chi-ŭn, "Chosŏn sidae chidu-hwa e taehan insik kwa chejak yangsang."

150 See Yi Yun-hŭi, "Tong'asia samguk ŭi chidu-hwa pigyo yŏn'gu."

151 See Ahn Hwi-joon, *Han'guk Hoehwasa*, 296–316.

152 See Pyŏn Yŏng-sŏp, "18 segi hwaga Yi Pang-un kwa kŭ'ŭi hwap'ung," especially 97, chart 2, for a list of Yi's extant paintings that had been known up to early 1980s, which includes only a few true-view landscapes.

153 Pak Ŭn-sun, "19 segi ch'o myŏngsŭng yuyŏn kwa Yi Pang-un ŭi *Sagun kangsan samsŏn susŏk sŏhwa-ch'ŏp*," especially 297 for the evidence of Yi's activities up to 1815.

154 See the facsimile reproduction of the album *Sagun kangsan samsŏn susŏk sŏhwa-ch'ŏp* (Album of calligraphy and painting of the scenic spots of the four districts and the three immortals' waters and rocks) (Seoul: Kungmin University Museum, 2007).

155 For the transcription and translation into Korean of the colophon, see ibid., 295.

156 See *Uri ttang, uri ŭi chin'gyŏng*, 192–99, for illustrations of all eight leaves in color.

157 At first sight they don't look like rocks, but if we compare the thin linear con-

tour lines of the rocks with the same in another leaf of the same album called *P'yŏngdŭng-sŏk* (Flat climb rocks), we can be convinced that they are rocks. See ibid., 193, for the illustration of the leaf.

158 See Pak Ŭn-sun's catalog entry in *Uri ttang, uri ŭi chin'gyŏng,* 308, in which she attributes Yi Pang-un's straight, dark brushstrokes as being influenced by Chŏng Sŏn.

159 See Yi Sŏng-mi, *Korean Landscape Painting,* figure 112, 162–63, for another example of An Chung-sik's true-view painting, titled *Ch'ehwa-jŏng,* dated to 1915, a ten-panel screen painting.

160 See the exhibition catalog *Sansuhwa sadaega chŏn* for their paintings as well as essays on the lives and art of these four masters. Also see Yi Sŏng-mi, "Han'guk-in ŭi chŏngsŏ," 16–29, with an English abstract.

161 Almost all albums of paintings of Mount Kŭmgang include the Pearl Pond. See Yi Sŏng-mi, *Korean Landscape Painting,* figures 101 and 102, 148, 149.

162 See the exhibition catalog, *Mong'yu Kŭmgang.*

163 This interpretation is given by Chang Tong-gwang in *Mong'yu Kŭmgang,* 194.

SELECTED BIBLIOGRAPHY

Books and Articles in Korean

Ahn Hwi-joon 安輝濬. "Chosŏn hugi mit malgi ŭi Sansuhwa" 朝鮮 後期 及 末期의 山
水畵 (Landscape painting of the late and end of the Chosŏn period). In *Sansuhwa*
山水畵 (Landscape painting), vol. 12 of *Han'guk ŭi mi* 韓國의 美 (Beauty of Korea),
202–11. Seoul: Chung'ang Ilbo, 1982.

———. "Chosŏn wangjo hugi hoehwa ŭi sin tonghyang" 朝鮮王朝後期 繪畵의 新 動
向 (New trends in late Chosŏn painting). *Kogo misul* 考古美術 no. 134 (June 1977):
8–20.

———. "Naejo chungguk'in hwaga Maeng Yŏng-gwang" 來朝 中國人畵家 孟永光 (The
Chinese painter Meng Yongguang who came to Korea). In *Han'guk hoehwa-sa yŏn'gu*
韓國繪畵史 研究 (A study of history of Korean painting), 620–40. Seoul: Sigong-sa,
2000.

———, ed. *Chosŏn wangjo sillok ŭi sŏhwa saryo* 朝鮮王朝實錄의 書畵史料 (Articles on
painting and calligraphy in the *Veritable Records of the Chosŏn Dynasty*). Sŏngnam:
Academy of Korean Studies, 1983.

———. *Han'guk hoehwasa* 韓國繪畵史 (History of Korean painting). Seoul: Ilchi-sa,
1980.

Ch'oe Kang-hyŏn 崔康賢. *Yŏkju O'udang yŏnhaeong-rok* 譯註 五友堂燕行錄
(Annotated translation into Korean of the travel diary of Kim Sun-hyŏp). Seoul:
Kukhak charyowon, 1993.

Ch'oe So-ja 崔韶子. *Ch'ŏng gwa Chosŏn* 淸과 朝鮮 (Qing and Chosŏn). Seoul: Hye'an, 2005.

Ch'oe Sun-wu 崔淳雨. "Chiujae ŭi Haesan-ch'ŏp" 之又齋의 海山帖 (Chiujae's *Album of Sea and Mountains*). *Kogo misul* 考古美術 no. 56–57 (1965): 47–49.

———, ed. *Han'guk hoehwasa* 韓國繪畵史 (Korean painting). Seoul: Tosan munhwa-sa, 1981.

Ch'oe Wan-su, ed. 崔完秀 *Chin'gyŏng sidae: Uri munhwa ŭi hwanggŭm-gi* (The Chin'gyŏng period: The golden age of our culture) 진경시대: 우리문화의 황금기. Seoul: Dolbege, 1998.

———. *Kyŏmjae Chŏng Sŏn* 謙齋鄭敾 (Kyŏmjae Chŏng Sŏn). Seoul: Hyŏnam-sa, 2009.

———. *Kyŏmjae Chŏng Sŏn chin'gyŏng sansuhwa* 鄭敾 眞景山水畵 (The true-view landscape paintings of Kyŏmjae Chŏng Sŏn). Seoul: Pŏmmun-sa, 1993.

———. "Kyŏmjae Chŏng Sŏn chingyŏng sansuhwa-go" 謙齋鄭敾 眞景山水畵考 (A study of the true-view landscape paintings of Chŏng Sŏn). *Kansong munhwa* 澗松文華 no. 21 (1981): 39–60.

———. *Kyŏmjae ŭi Hanyang chin'gyŏng* 겸재의 한양진경 (Chŏng Sŏn's true-view landscapes of Hanyang). Seoul: Tong-a Ilbo-sa, 2004.

Ch'oe Yŏng-sŏng 崔英成. *Han'guk yuhak sasang-sa* 韓國儒學思想史 (History of Korean Neo-Confucian thought). Vols. 2–4. Seoul: Asea Munhwa-sa, 1995.

———. *Han'guk yuhak t'ongsa* 韓國儒學通史 (Korean Confucianism through the ages). Seoul: Simsan, 2006.

Chŏngjŏn Yi Sang-bŏm 靑田 李象範 (Chŏngjŏn Yi Sang-bŏm). Seoul: Hoam Art Museum, 1997.

Chang Chi-yŏn 張志淵. *Haedong sisŏn* 海東詩選 (Selection of poems of the Eastern Nation). Seoul: Kyŏngsŏng sinmun-gwan, 1918.

Chin Chun-hyŏn 陳準鉉. *Tanwon Kim Hong-do yŏn'gu* 단원 김홍도연구 (A study on Tanwon Kim Hong-do). Seoul: Ilchi-sa, 1999.

———. *Ŭri ttang chingyŏng sansu* 우리 땅 진경산수 (True-view landscape of our land). Paju: Borim, 2005.

Chin'gyŏng sansu-hwa 眞景山水畵 (True-view landscape painting). Kwangju: Kwangju National Museum, 1987.

Cho Hŭi-ryong 趙熙龍 and Yu Chae-gŏn 劉在建. *Hosan oesa* 壺山外史 (Chronicles of forgotten men) and *Yihyang kyŏnmunrok* 里郷見聞錄 (Experiences in villages). Translated by Nam Man-sŏng. Seoul: Samsung Foundation for Culture, 1980.

Cho Sŏn-mi 趙善美. *Ch'osanghwa yŏn'gu: Ch'osanghwa wa ch'osanghwa-ron* 초상화연구 (肖像畵研究): 초상화와 초상화론 (肖像畵와 肖像畵論) (A study on portraiture: Its theory and practice). Seoul: Munye ch'ulpan-sa, 2007.

———. "Tongyu-ch'ŏp ko" 東遊帖考 (A study on the *Tongyu-ch'ŏp*). In *Tongyu-ch'ŏp* 東遊帖 (Album of journey to the East), 272–98. Seoul: Sŏnggyun-gwan University Press, 1994.

Cho Yŏng-sŏk 趙榮祏. "Kyŏmjae Chŏng Tongch'u aesa" 謙齋 鄭同樞 哀辭 (Eulogy for [Minister] Chŏng Kyŏmjae). In *Kwanajae-go* 觀我齋稿 (Collected writings of Cho Yŏng-sŏk), 249–53. Sŏngnam: Academy of Korean Studies, 1984.

Chŏng Yak-yong 丁若鏞. "Chilsil kwanhwa–sŏl" 漆室觀畵說 (A theory on the looking into the painting created in a pitch-dark room). In *Chŏng Tasan chŏnjip* 鄭茶山全

集 (Complete writings of Chŏng Yak-yong), vol. 1 (Poetry and essays), 138. Seoul: Munhŏn p'yŏnch'an wiwonhoe, 1960.

———. *Tasan simun-jip* 茶山詩文集 (Collection of Tasan's poetry and essays). Korean translation. Seoul: Minjok Munhwa Ch'ujin-hoe, 1983.

Chosŏn chŏn'gi kukpo chŏn 朝鮮前期國寶展 (Treasures of the early Chosŏn dynasty). Exhibition catalog. Seoul: Ho-am Art Museum, 1997.

Chosŏn sidae chinch'an chinyŏn chinha tobyŏng yŏn'gu 조선시대 진찬 진연 진하 도병연구 (朝鮮時代 進饌 進宴 進賀 圖屏研究) (A study on the Chosŏn period royal banquet screen paintings). Seoul: Kugnip kuggakwon, 2000.

Han'guk hanchaŏ sajŏn 韓國漢字辭典 (Dictionary of Korean terms composed of Chinese characters). Seoul: Center for Oriental Studies, Tan'guk University, 1995.

Han'guk minjok munhwa tae paekkwa sajŏn 한국민족문화대백과사전 (韓國民族文化大百科事典) (Encyclopedia of Korean people and culture). Sŏngnam: Academy of Korean Studies, 1988–91.

Han'guk Sasangsa Taegye 韓國思想史大系 (An outline of history of Korean thoughts). Vol. 5. Sŏngnam: Academy of Korean Studies, 1992.

Han'guk yŏktae munjip ch'ongsŏ 韓國歷代文集叢書 (Collectanea of Korean collected writings). Seoul: Kyŏng'in Munhwa-sa, 1992.

Hong Sŏn-pyo 洪善杓. "Chin'gyŏng sansu nŭn Chosŏn chunghwa chuŭi ŭi sosaninga?" 眞景山水는 朝鮮中華主義 所産인가 (Is true-view landscape painting a product of Chosŏn Chunghwa-ism?). *Kana Art* 가나아트 (July and August 1994): 52–55.

———. "Nam Ku-man che Hamhŭng Sipkyŏng-do" 南九萬題 咸興十景圖 (Ten scenes of Hamhŭng with Nam Ku-man's inscriptions). *Misulsa yŏn'gu* no. 2 (1988): 140–48.

Hong Tae-yong 洪大容. "Liu-Bao mundap" 劉鮑問答 (Conversation with Liu and Bao). In *Tamhŏnsŏ Oejip* 湛軒書 外輯 (Outer essays of the collected writings of Hong Tae-yong), 56. Korean translation. Seoul: Minjok munhwa ch'ujin-hoe, 1975–86.

Hwang Won-gu 黃元九. "Yŏnhaeng-rok sŏnjip haeje" 燕行錄選集 解題 (Introduction to the selected travel records to Yanjing). In *Kuggyŏk yŏnhaeng-rok sŏnjip* 國譯 燕行錄選集 (Korean translation of selected Yŏnhaeng-rok), 2–3. Seoul: Minjok munhwa ch'ujin-hoe, 1976.

Kang Kwan-sik 姜寬植. "Chin'gyŏng sidae ch'osanghwa ŭi i'nyŏmjŏk kiban" 眞景時代 山水畫의 理念的 基盤 (Ideological foundations of the portraiture of the Chin'gyŏng period). In Ch'oe Wan-su, ed., *Chin'gyŏng sidae* 진경시대 (眞景時代) (The Chin'gyŏng period), vol. 2, 281–84. Seoul: Dolbege, 1998.

———. *Chosŏn hugi kungjung hwawon yŏn'gu* 조선후기 궁중화원 연구 (A study on the late Chosŏn period court painters). 2 vols. Seoul: Tolbege, 2001.

———. "Chosŏn hugi misul ŭi sasangjŏk kiban" 朝鮮後期 美術의 思想的 基盤 (Intellectual foundations of the arts of the late Chosŏn period). In *Han'guk sasangsa taegye* 韓國思想史 大系 (An outline of history of Korean thoughts), 535–92. Sŏngnam: Academy of Korean Studies, 1992.

———. "Kwangju Chŏngmun kwa Changdong Kimmun ŭi segyo wa Kyŏmjae Chŏng Sŏn ŭi *Chŏngp'ung-gye*" 光州鄭門과 壯洞 金門의 世交와 謙齋 鄭敾의 淸風溪 (The friendship over generations between the Chŏng clan of Kwangju and the Kim clan of Changdong and Kyŏmjae Chŏng Sŏn's *Chŏngp'ung-gye*). *Misul sahakpo* 美術史學報 no. 26 (June 2006): 119–46.

———. "Kyŏmjae Chŏng Sŏn ŭi chŏnmun-hak kyŏmkyosu ch'ulsa wa *Kŭmgang chŏndo*

ŭi chŏnmun yŏkhak chŏk haesŏk" 謙齋 鄭敾의 天文學 兼敎授 出仕와 金剛全
圖의 天文 易學的 解析 (Kyŏmjae Chŏng Sŏn's appointment as astronomy instructor
at the Office of Meteorology and his *Complete View of Mount Kŭmgang* interpreted
in light of astronomy and *Book of Changes*). *Misulsahakpo* 美術史學報 no. 27
(December 2006): 137–94.

———. "Kyŏmjae Chŏng Sŏn ŭi sahwan kyŏngryŏk kwa aehwan" 謙齋 鄭敾의 仕宦經
歷과 哀歡 (Kymjae Chŏng Sŏn's official career, and joys and sorrows while in office).
Misulsahakpo 美術史學報 no. 29 (December 2007): 137–94.

———. "Yongju-sa hubult'aeng gwa Chosŏn hugi kungjung hoehwa—tae'ungbojŏn
Samse Yŏraech'et'aeng ŭi chakka wa sigi, yangsik ŭi chae kŏmto" 龍珠寺 後佛
幀과 朝鮮後期 宮中繪畫—大雄寶殿 三世如來幀의 作家와 時期, 樣式의 再檢
討 (Yongju-sa's Behind-the-Buddha tanka and the late Chosŏn court painting: A
reexamination of the artist, date, and the painting style of the *Three Generations of
Buddha Tanka*). A paper presented at the quarterly meeting of the Association of Art
History Studies. Seoul, September 6, 2008.

Kang Se-hwang 姜世晃. "Che Sin'ahwa ch'ihu" 題信兒雉後 (Colophon to my son
Sin's pheasant painting). In *P'yoam yugo* 豹菴遺稿 (Collected writings of Kang Se-
hwang), 279. Sŏngnam: Academy of Korean Studies, 1979.

———. *P'yoam yugo* 豹菴遺稿 (Collected writings of Kang Se-hwang). Sŏngnam:
Academy of Korean Studies, 1979.

———. "Sŏyang'in sŏhwa wolyŏngdo mobonhu" 西洋人 書畫 月影圖 模本後
(Colophon to the copy of Westerner's painting of moon shadow). In *P'yoam yugo* 豹
菴遺稿 (Collected writings of Kang Se-hwang), vol. 5, 297. Sŏngnam: Academy of
Korean Studies, 1979.

Kang Sin-ae 姜信愛. "Chosŏn sidae *Mui kugok-to* ŭi yŏnwon kwa t'ŭkching" 朝鮮時代
武夷九曲圖의 淵源과 特徵 (Origin and characteristics of the *Mui kugok-to* of the
Chosŏn period). *Misulsahak yŏn'gu* 美術史學研究 no. 254 (June 2007): 5–40.

Kim Ch'ang-ŏp 金昌業. *Kajae yŏnhaeng-rok* 稼齋燕行錄 (Kajae's travel diary to
Yanjing). In *Kuggyŏk yŏnhaeng-rok sŏnjip* 國譯 燕行錄選集 (Korean translation of
selected travel diary to Yanjing), 273–78. Seoul: Minjok munhwa ch'ujin-hoe, 1976.

Kim Chi-hye 金智惠. "Hŏju Yi Ching Hoehwa Yŏn'gu" 虛舟 李澄 繪畫研究 (A study of
Hŏju Yi Ching's paintings). MA thesis, Hong'ik University, 1992.

———. "Hŏju Yi Ching ŭi saeng'ae wa sansu yŏn'gu" 虛舟 李澄의 生涯와 山水研究
(The life and landscape paintings of Hŏju Yi Ching). *Misulsahak yŏn'gu* 美術史學研
究 no. 207 (1995): 5–48.

Kim Chi-ŭn 김지은. "Chosŏn sidae chidu-hwa e taehan insik kwa chejak yangsang: 18-
19 segi rŭl chungsim ŭro" 朝鮮時代 指頭畫에 對한 認識과 製作樣相: 18, 19 世紀를
中心으로 (The understanding and production of the eighteenth- and nineteenth-
century Korean finger painting). *Misulsahak yŏngu* 美術史學研究 no. 265 (March
2010): 105–36.

Kim Hyŏng-hyo 金亨曉. *Wonhyo esŏ Tasan kkaji* 원효에서 다산까지 (From Wonhyo
to Tasan). Sŏngnam: Ch'ŏnggye ch'ulpan-sa, 2000.

Kim Kyŏng-sŏp 金京燮. "Yongju-sa taeungbojŏn Sambulhoedo yŏn'gu" 龍珠寺 大雄寶
殿 三佛會圖 研究 (A study on the three generations of Buddha painting in Yongju-
sa Temple). MA thesis, Dongguk University, 1997.

Kim Mun-sik 金文植 and Chŏng Ok-ja 鄭玉子, eds. *Chŏng jo sidae ŭi sasang kwa*

munhwa 朝鮮時代의 思想과 文化 (Thoughts and culture of King Chŏngjo's reign). Seoul: Tolbege, 1999.

Kim Tong-uk 金東旭. "Hwasŏng ch'uksŏng e sayongdwen chajae unban kigu e taehaesŏ" 華城 築城에 使用된 資材運搬 機具에 대해서 (On the mechanical devices employed in moving construction materials for the construction of Hwasŏng). In *Kŭndae rŭl hyanghan kkum* 근대를 향한 꿈 (A dream for modernity), 112–23. Yong'in: Kyŏnggi-do Provincial Museum, 1998.

Kim Ŭn-ji 김은지. "Haksan Yun Che-hong ŭi hoehwa yŏn'gu 鶴山 尹濟弘의 繪畵研究 (A study on Haksan Yun Che-hong's painting). MA thesis, Hongik University, 2008.

Kim Yong-dŏk 金龍德. *Chosŏn hugi sasangsa yŏn'gu* 朝鮮後期 思想史 研究 (A study on the history of late Chosŏn period thoughts). Seoul: Ŭlyu munhwa-sa, 1977.

Kkum kwa sarang: Maehok ŭi uri minhwa 꿈과 사랑: 매혹의 우리민화 (Dream and love: Enchanting Korean folk paintings). Seoul: Hoam Art Museum, 1998.

Ko Yŏn-hŭi 高蓮姬. *Chosŏn hugi sansu kihaeng yesul yŏn'gu* 조선후기 산수기행예술 연구 (A study on the late Chosŏn poetry and paintings created on the journey through scenic landscapes). Seoul: Ilchi-sa, 2001.

Kojong Hwangje ch'osanghwa tŭkbyŏljŏn 高宗皇帝 肖像畵 特別展 (A special exhibition of the portrait of Emperor Kojong). Kwachŏn: Museum of Contemporary Art, 1982.

Kwon Haeng-ga 權幸佳. "Kojong Hwangje ŭi ch'osang: Kŭndae sigak maeche ŭi toip kwa ŏjin ŭi pyŏnyong" 高宗皇帝의 肖像: 近代 視覺媒體의 導入과 御眞의 變容 (The portraits of Emperor Kojong: The introduction of the modern visual media and the change in imperial portraiture). PhD dissertation, Hong'ik University, 2005.

Kwon Yun-gyŏng 權倫慶. "Hoam misulgwan sojang Yun Che-hong ŭi *Haksan Mukhŭi-chŏp*" 湖巖美術館 所藏 鶴山 尹濟弘의 墨戲帖 (Yun Che-hong's *Album of Ink Play* in the collection of Hoam Art Museum). *Hoam Misulgwan yŏn'gu nonmun-jip* 湖巖 美術館 研究論文集 no. 2 (1997): 186–217.

———. "Yun Che-hong ŭi hoehwa" 尹濟弘의 繪畵 (Yun Che-hong's painting). MA thesis, Seoul National University, 1996.

Mong'yu Kŭmgang: Kŭrim ŭro ponŭn Kŭmgangsan sambaek-nyŏn 夢遊金剛: 그림으로 본 금강산 300년 (Dream journey to Kŭmgang: Three hundred years of Mount Kŭmgang paintings). Seoul: Ilmin Museum of Art, 1999.

Mun Myŏng-dae 文明大. "Noyŏng ŭi Amita Chijang Posal e taehan koch'al" 魯英의 阿彌陀 地藏菩薩에 대한 考察 (On Noyŏng's Amitabha and the Bodhisattva Kshitigarbha). *Misul charyo* 美術資料 no. 25 (December 1979): 47–57.

Nam Kong-ch'ŏl 南公轍. *Kŭmrŭng-jip* 金陵集 (Nam's collected writings). 1815. In Kyujang-gak Library, Seoul National University.

No Tae-hwan 盧大煥. "Chŏngjo sidae sŏgi suyong nonŭi wa sŏhak chŏngch'aek" 正祖 時代 西器受容 論議와 書學政策 (Discussions on the reception of Western culture and the policies toward the Western learning during King Chŏngjo's reign). In Chŏng Ok-ja, ed., *Chŏngjo sidae ŭi sasang gwa munhwa* (Thoughts and culture of King Chŏngjo's reign), 201–45. Seoul: Dolbege, 1999.

O Chu-sŏk 吳柱錫. "Huasŏn Kim Hong-do, kŭ ingan kwa yesul" 畵員 金弘道: 그 人間과 藝術 (Kim Hong-do: His art and personality). In *Tanwon Kim Hongdo* 檀園 金弘道. 1–110. Seoul: Samsung munhwa chaedan, 1995.

———. "Yet kŭrim iyagi" 옛 그림 이야기 (Story of old paintings). *Pangmulgwan sinmun*

박물관신문 (Monthly news of the National Museum of Korea) no. 306 (February 1, 1997): 4.

O Se-chang 吳世昌. *Kŭnyŏk sŏhwajing* 槿域書畫徵 (Biographical dictionary of Korean calligraphers and painters). Reprint. Seoul: Pomun sŏjŏm, 1975.

———. *Kuggyŏk Kŭnyŏk sŏhwajing* 국역 근역서화징 (Korean translation of Biographical dictionary of painters and calligraphers of Korea). Seoul: Sigong-sa, 1998.

Ŏjin tosa dogam ŭigwe 御眞圖寫都監儀軌 (Book of state rites for the painting of royal portraits). 1902 (handwritten manuscript). Changsŏgak library, Academy of Korean Studies, Sŏngnam.

Pak Chi-won 朴趾源. *Yŏrha ilgi* 熱河日記 (Yehol diary). In *Han'guk myŏngjŏ taejŏn-jip* 韓國名著大全集 (Collection of famous Korean writings), vols. 21–23. Korean translation by Yi Ka-won. Seoul: Taeyang sŏjŏk, 1975.

Pak Chŏng-hye 박정혜. *Chosŏn sidae kungjung kirokhwa yŏngu* 조선시대 궁중기록화 연구(A study on the court documentary paintings of the Chosŏn period). Seoul: Ilchi-sa, 2000.

Pak Chun-yŏng 박준영 (Park Junyoung). "Imdang Paek Ŭn-bae ŭi hoehwa yŏn'gu" 淋塘 白殷培의 繪畫研究 (A study of Imdang Paek Ŭn-bae's painting). MA thesis, Hongik University, 2007.

Pak Ŭn-sun 朴銀順. "Kim Ha-jong ŭi Haesando-chŏp" 金夏鍾의 海山圖帖 (Kim Ha-jong's *Album of Sea and Mountains*). *Misulsa nondan* 美術史論壇 no. 4 (1996): 309–31.

———. *Kŭmgangsan-do yŏn'gu* 金剛山圖 연구 (A study of the paintings of Mount Kŭmgang). Seoul: Ilchi-sa, 1997.

———. "19 segi ch'o myŏngsŭng yuyŏn kwa Yi Pang-un ŭi *Sagun kangsan samsŏn susŏk sŏhwa-chŏp*" 19世紀 初 名勝유연과 이방운의 四郡江山 三仙 水石 書畫帖 (The early nineteenth-century practice of traveling to scenic spots and the *Album of Calligraphy and Painting of the Scenic Spots of the Four Districts and the Three Immortals' Waters and Rocks*). *Onji nonch'ong* 溫知論叢 5, no. 1 (1999): 289–329.

Pyŏn Yŏng-sŏp 邊英燮. "18 segi hwaga Yi Pang-un kwa kŭ'ŭi hwap'ung" 18世紀 畫家 李昉運과 그의 畫風 (The eighteenth-century painter Yi Pang-un and his painting style). *Ewha sahak yŏn'gu* 梨花史學研究 no. 13–14 (1983): 95–115.

———. *P'yoam Kang Sehwang hoehwa yŏn'gu* 豹菴姜世晃 繪畫研究 (A study of P'yoam Kang Sehwang's paintings). Seoul: Ilchi-sa, 1988.

Sansuhwa sadaega chŏn 山水畫 四大家展 (An exhibition of the Four Great Masters of landscape painting) Seoul: Hoam Art Museum, 1989.

Sŏ Yu-gu 徐有榘. *Imwon kyŏngje-ji* 林園經濟志 (Essays on rural life and economy). Manuscript completed ca. 1840, photocopy of the original by Seoul National University, 1966) . Vol. 5. 1983. Reprint, Seoul: Pogyŏng munhwa-sa.

Sŭngjŏng-won ilgi 承政院日記 (Diary of royal secretariat). Seoul: Kuksa p'yŏnchan wiwonhoe, 1961.

Tanwon Kim Hongdo 檀園 金弘道 (Essays for the special exhibition catalog commemorating Kim Hong-do's 250th anniversary of his birth). Seoul: Samsung munhwa chaedan, 1995.

Tanwon Kim Hongdo 檀園 金弘道 (Special exhibition catalog commemorating Kim Hong-do's 250th anniversary of his birth). Seoul: Samsung munhwa chaedan, 1995.

Tongyu-chŏp 東遊帖 (Album of travel to the East). Seoul: Sŏnggyun-gwan University Press, 1994.

Uri ttang, uri ŭi chin'gyŏng 우리 땅, 우리의 진경 (Our land, our true-view landscape). Ch'unch'ŏn: National Museum of Ch'unch'ŏn, 2002.

Veritable Records of King Chŏngjo 正祖實錄. Reduced format facsimile reproduction of these documents, published by the National History Council 國史編纂委員會, 1955–1958, *Chosŏn wangjo sillok* 朝鮮王朝實錄 (Veritable records of the Chosŏn dynasty).

Veritable Records of King Chungjong 中宗實錄.

Veritable Records of King Hŏnjong 憲宗實錄.

Veritable Records of King Injo 仁祖實錄

Veritable Records of King Munjong 文宗實錄.

Veritable Records of King Myŏngjong 明宗實錄.

Veritable Records of King Sejong 世宗實錄.

Veritable Records of King Sŏngjong 成宗實錄.

Veritable Records of King Sukchong 肅宗實錄.

Veritable Records of King Tanjong 端宗實錄.

Veritable Records of King Yŏngjo 英祖實錄.

Veritable Records of King Sunjo 純祖實錄

Wonhaeng ŭlmyo chŏngri ŭigwe 園幸乙卯整理儀軌 (Book of state rites for King Chŏngjo's visit to the tomb of his father in *ŭlmyo* year printed with chŏngri metal type). 1795. Changsŏ-gak Library, Academy of Korean Studies, Sŏngnam.

Yi Ik 李瀷. "Hwasang yodol" 畫像凹突 (Concavity and convexity in painted images). In *Sŏngho sasŏl* 星湖僿說 (Miscellaneous writings of Yi Ik), vol. 4, 64–65. Korean translation. Seoul: Minjok munhwa ch'ujin-hoe, 1978.

Yi Ki-ji 李器之. *Iram-jip* 一庵集 (Collected writings of Yi Ki-ji). Korean translation. Seoul: Minjok munhwa ch'ujin-hoe, 1996.

Yi Kŏn-sang 李建上. "*Puksae Sŏnŭn-do* wa *Pukkwan Such'angrok*: Sŏlt'an Han Si-gak (1621–?) ŭi silgyŏng sansu-hwa" 北塞宣恩圖와 北關酬唱錄: 雪灘 韓時覺의 實景山水畵 (*Puksae Sŏnŭn-do* and *Pukkwan Such'angrok*: Sŏlt'an Han Si-gak (1621–?)'s real scenery landscapes). *Misul charyo* 美術資料 no. 52 (December 1993): 129–67.

Yi Ku-yŏl 李龜烈. *Kŭndae Han'guk misulsa ŭi yŏn'gu* 近代 韓國美術史의 研究 (A study on modern Korean art history). Seoul: Mijin-sa, 1992.

Yi Kyŏng-hwa 이경화. "*Puksae Sŏnŭn-do* yŏn'gu" 北塞宣恩圖 研究 (A study of Puksae Sŏnun-do). *Misulsahak yŏn'gu* 美術史學研究 no. 254 (June 2007): 41–66.

Yi Kyu-gyŏng 李圭景. "Ŏmhwa yaksu byŏnjŭng-sŏl" 罨畫藥水辨證說 (Essay on the medicinal liquid and color). In *Oju yŏnmun changjŏn san'go* 五洲衍文長箋散稿 (Collection of miscellaneous notes and writings of Yi Kyu-gyŏng), vol. 2, chapter 38, 145. Seoul: Myŏngmun-dang, 1977.

Yi Kyu-sang 李奎象. "Hwaju-rok" 畫廚錄 (Records on painters). In *Ilmonggo* 一夢稿 (Collected writings of Yi), (Yi Kyu-sang's preface, written in 1776). In *Hansan sego* 韓山世稿 (Writings of generations of Yi family from Hansan), vol. 30, 249.

Yi Man-bu 李滿敷. *Chihaeng-rok* 地行錄 (Records of traveling the land). Korean translation by Yi Ch'ang-sŏp. Seoul: Mongnam munhwa-sa, 1990.

Yi Sŏng-mi 李成美. "Chosŏn hugi chinjak, chinch'an ŭigwe rŭl t'onghae pon kungjung ŭi misul munhwa" 朝鮮後期 進爵, 進饌儀軌를 通해본 宮中의 美術文化 (Art

and culture of the late Chŏson period as seen through palace banquets). In *Chosŏn hugi kungjung yŏnhyang munhwa* 朝鮮後期 宮中宴饗文化 (Palace banquets and the late Chosŏn culture), vol. 2, 116–97. Seoul: Minsokwon, 2005.

———. *Chosŏn sidae kŭrimsok ŭi sŏyang hwapŏp* 조선시대 그림 속의 서양화법 (Western painting methods in the Chosŏn period painting). Seoul: Daewon-sa, 2000.

———. *Chosŏn sidae kŭrimsok ŭi sŏyang hwapŏp* 조선시대 그림 속의 서양화법 (Western painting methods in the Chosŏn period painting). Enlarged and revised edition. Seoul: Sowadang, 2008.

———. "Chosŏn wangjo ŏjin kwan'gye togam ŭigwe" 朝鮮王朝 御眞關係 都監儀軌 (Books of state rites for the painting and copying of royal portraits of the Chosŏn dynasty). In Yi Sŏng-mi 李成美, Kang Sin-hang 姜信沆, and Yu Song-ok 劉頌玉, *Chosŏn sidae ŏjin kwangye togam ŭigwe yŏn'gu* 朝鮮時代 御眞關係 都監儀軌 研究 (A study on the books of state rites for the painting and copying of royal portraits of the Chosŏn period), 1–137. Sŏngnam: Academy of Korean Studies, 1997.

———. "Han'guk-in ŭi chŏngsŏ: Chŏngjŏn Yi Sang-bŏm" 韓國人의 情緒 (The ethos of the Koreans: Chŏngjŏn Yi Sang-bŏm's Painting). In *Chŏngjŏn Yi Sang-bŏm* 青田 李 象範 (Chŏngjŏn Yi Sang-bŏm), 16–29. Seoul: Hoam Art Museum, 1997.

———. "*Hŏju pugun sansu yuchŏp*: Chŏn Yi Chong-ak ŭi chin'gyŏng sansu hwachŏp kan'gae" 虛舟府君山水遺帖: 傳 李宗岳의 眞景山水畫帖 簡介 (Album of landscape paintings bequeathed by my late father: A brief introduction to the album of true-view landscape paintings by Yi Chong-ak). *Changsŏ-gak* 藏書閣 no. 3 (July 2000): 215–28.

———. "*Imwon kyŏngje-ji* e natanan Sŏ Yu-gu ŭi chungguk hoehwa mit hwaron e taehan kwansim—Chosŏn sidae hugi hoehwasa e michin chungguk ui yŏnghyang" 林園經 濟志에 나타난 徐有榘의 中國繪畫 및 畫論에 대한 關心—朝鮮時代 後期 繪畫 史에 미친 中國의 影響 (Sŏ Yu-gu's interest in Chinese painting and painting theory as expressed in *Imwon kyŏngje-ji*: Chinese influence on late Chosŏn painting). *Misul sahak yŏn'gu* 美術史學研究 193 (March 1992): 33–61.

Yi Sŏng-mi et al., *Chosŏn wangsil ŭi misul munhwa* 조선왕실의 미술문화 (Art and culture of the Chosŏn royal court). Seoul: Daewon-sa, 2005.

———. *Chosŏn wangjo sillok misul kisa charyojip* 朝鮮王朝實錄美術記事資料集 (Art-related articles from the *Veritable Records of the Chosŏn Dynasty*). 7 vols. Sŏngnam: Academy of Korean Studies, 2001–4.

Yi Sŏng-mu 李成茂. *Chosŏn yangban sahoe yŏn'gu* 朝鮮兩班社會研究 (A study on the Yangban Society of Chosŏn). Seoul: Ilchogak, 1995.

Yi Sun-mi 李順未. "Tamjol Kang Hŭi-ŏn ŭi hoehwa yŏn'gu" 澹拙 姜熙彥의 繪畫研 究 (A study on Tamjol Kang Hŭi-ŏn's painting). *Misulsa yŏn'gu*. 미술사연구 no. 12 (1998): 141–68.

Yi T'ae-ho 李泰浩. "Chinjae Kim Yun-gyŏm ŭi chin'gyŏng sansu 眞宰 金允謙의 眞 景山水 (True-view landscapes of Kim Yun-gyŏm)." *Kogo misul* 考古美術 no. 52 (December 1981): 1–23.

———. "Chosŏn hugi chin'gyŏng sansu ŭi paltal kwa t'oejo" 朝鮮後期 眞景山水의 發 達과 退潮 (The development and decline of true-view landscape painting of the late Chosŏn period). *Chin'gyŏng sansu-hwa* 眞景山水畫 (True-view landscape painting). Exhibition catalog. Kwangju: Kwangju National Museum, 1987.

———. "Han Si-gak ŭi *Puksae Sŏnŭn-do* wa *Pukkwan Silgyŏngdo*" 韓時覺의 北塞宣

恩圖와 北關 實景圖 (Han Sigak's *Puksae Sŏnŭn-do* and *Pukkwan Silgyŏng-do*). *Chŏngsin munhwa yŏn'gu* 精神文化研究 no. 34 (1988): 207–35.

———. *Yet hwagadŭl ŭn uri ttang ŭl ŏttŏke kŭryŏtna* 옛 화가들은 우리 땅을 어떻게 그렸나 (The way past Korean artists painted their land). Seoul: Saenggak ŭi namu, 2010.

Yi Ta-hong 이다홍. "Chinjae Kim Yun-gyŏm ŭi hoehwa yŏn'gu" 眞宰 金允謙의 繪畫 研究 (A study on Chinjae Kim Yun-gyŏm's painting). MA thesis, Hong'ik University, 2009.

Yi Tŏk-mu 李德懋. "Ibyŏn-gi" 入燕記 (Record of entry into Yanjing). In *Ch'ŏngjanggwan chŏnsŏ* 青莊館全書 (Complete works of Yi Tŏk-mu), vol. 11, 66–67. Korean translation. Seoul: Minjok munhwa ch'ujin-hoe, 1978.

Yi Tong-ju 李東洲. "Kyŏmjae ilp'a ŭi chin'gyŏng sansu" 謙齋一派의 眞景山水 (True-view landscape paintings by a group of followers of Kyŏmjae). In *Urinara ŭi yet kŭrim* 우리나라의 옛 그림 (Old paintings of our country), 151–92. Seoul: Paggyŏng-sa, 1975.

Yi Ŭi-hyŏn 李宜顯. *Imja yŏnhaeng chapchi* 壬子燕行雜識 (Miscellaneous records of travel to Yanjing in the cyclical year *imja*, i.e., 1732). In *Kuggyŏk yŏnhaeng-rok sŏnjip* 국역연행록선집 (Selection of travel diaries to Yanjing), vol. 5, 90–112. Korean translation. Seoul: Minjok Munhwa Chujin-hoe, 1976.

———. *Kyŏngja yŏnhaeng chapchi* 庚子燕行雜識 (Miscellaneous records of travel to Yanjing in the cyclical year *kyŏngja*). In *Kuggyŏk yŏnhaeng-rok sŏnjip* 국역연행록선집 (Selection of travel diaries to Yanjing, Korean translation), vol. 5, 9–64. Seoul: Minjok Munhwa Chujin-hoe, 1976.

Yi Won-sun 李元淳. "Sŏhak ŭi doip kwa chŏn'gae" 西學의 導入과 展開 (Introduction and development of Western learning). In *Han'guk sasangsa taegye* 韓國思想史大系 (An outline of history of Korean thoughts), vol. 5, 185–235. Sŏngnam: Academy of Korean Studies, 1992.

Yi Ye-sŏng 李禮成. *Hyŏnjae Sim Sa-jŏng yŏn'gu* 玄齋沈師正研究 (A study on Sim Sa-jŏng's painting). Seoul: Ilchi-sa, 2000.

Yi Yun-hŭi 이윤희. "Tong'asea samguk ŭi chidu-hwa pigyo yŏn'gu" 東亞細亞 三國의 指頭畫 比較研究. (A comparative study of finger paintings of three East Asian nations). MA thesis, Academy of Korean Studies, 2008.

Yim Yŏng-t'ae 임영태. *Hosaeng-gwan Ch'oe Puk* 호생관 최북 (novel on the artist). Seoul: Muni-dang, 2007.

Yŏngjŏng mosa togam ŭigwe 影幀模寫都監儀軌 (Book of state rites for the copying of royal portraits). 1900. Changsŏ-gak Library, Academy of Korean Studies, Sŏngnam.

Yu Hong-jun 兪弘濬. *Hwa'in yŏlchŏn* 화인열전 (Biographies of painters). Seoul: Yŏksa pip'yŏng-sa, 2001.

———. "Yi In-sang hoehwa ŭi hyŏngsŏng gwa pyŏnchŏn" 李麟祥 繪畫의 形成과 變遷 (The formation and transformation of Yi In-sang's painting). *Kogo misul* 考古美術 no. 161 (March 1984): 32–48.

———. "Yi Kyu-sang *Ilmonggo* ŭi hwaronsa-jŏk ŭi'i" 李奎象 一夢稿의 畫論史的 意義 (The significance of Yi Kyu-sang's *Ilmonggo* in art theory). *Misulsahak* 美術史學 4 (1992): 31–76.

Yu Chun-yŏng 兪俊英. "*Kogun Kugok-to* rŭl chungsim ŭro pon sipch'il segi silgyŏng sansu ŭi illye" 谷雲九曲圖를 中心으로 본 十七世紀 實景山水의 一例 (One

seventeenth-century example of real-scenery painting: *Kogun Kugok-to*). *Chŏngsin munhwa yŏn'gu* 精神文化研究 8 (1982): 38–46.

———. "Kugok-to ŭi palsaeng-gwa kinŭng e taehayŏ" 九曲圖의 發生과 技能에 대하여 (On the origin and function of paintings of the Nine-Bend Stream). *Kogo misul* 考古 美術 no. 151 (1981): 1–22.

Yun Chin-yŏng 尹軫暎. "Chosŏn sidae kugok-to yŏn'gu" 朝鮮時代 九曲圖 研究 (A study on paintings of the Nine-Bend Stream of the Chosŏn period). MA thesis, Academy of Korean Studies, 1997.

———. "Chosŏn sidae kyehoe-do yŏn'gu" 朝鮮時代 契會圖 研究 (A study on Kyehoe-do of the Chosŏn period). PhD dissertation, Academy of Korean Studies, 2003.

Yun Pŏm-mo 尹凡牟. "1910 nyŏndae ŭi sŏyang hoehwa suyong kwa chakka ŭisik" 1910 年代의 西洋繪畫 受容과 作家意識 (The acceptance of Western painting and the self-awareness of painters in 1910s). *Misul sahak yŏn'gu* 美術史學研究 no. 203 (September 1994): 111–56.

Books and Articles in English and Other Languages

Ahn Hwi-joon. "Literary Gatherings and Their Paintings in Korea." *Seoul Journal of Korean Studies* 8 (1995): 85–106.

Beurdeley, Cécil, and Michael Beurdeley. *Giuseppe Castiglione: A Jesuit Painter at the Court of the Chinese Emperors*. Translated by Michael Bullock. Rutland, Vermont: Charles E. Tuttle Company, 1971.

Black, Kay E., and Edward Wagner. "Court Style *Ch'aekkŏri*." In Kumja Paek Kim, ed., *Hopes and Aspirations: Decorative Paintings of Korea*, 23–35. San Francisco: Asian Art Museum of San Francisco, 1998.

Bush, Susan. *The Chinese Literati on Painting: Su Shih (1037–1101) to Tung Ch'i-ch'ang (1555–1636)*. Cambridge: Harvard University Press, 1971.

Bush, Susan, and Hsiao-yen Shih. *Early Chinese Texts on Painting*. Cambridge: Harvard University Press, 1985.

Ch'oe Wansu. *True-view Landscape: Paintings by Chong Son (1676–1759)*. Translated and edited by Youngsook Pak and Roderick Whitfield. London: Saffron Korea Library, 2005.

Chung Hyung-min. *Modern Korean Ink Painting*. Elizabeth, N.J.: Hollym, 2006.

Chung, Saehyang P. "Kim Hong-do's 'Peddlers' and Its Possible Artistic Antecedents." *Oriental Art* 44, no. 3 (Autumn 1998): 40–49.

Ferguson, John C. *Lidai zhulu huamu* 歷代著錄畫目 (Painting titles recorded in books through the ages). Taipei: Zhonghua shuju, 1968.

Fong, Wen C., et al. *Images of the Mind*. Princeton, N.J.: Princeton University Press, 1984.

Haboush, Jahyun Kim, and Martina Deuchler, eds. "Constructing the Center: The Ritual Controversy and the Search for a New Identity in Seventeenth-Century Korea." In Haboush and Deuchler, eds., *Culture and State in Late Chosŏn Korea*, 46–90. Cambridge: Harvard University Press, 1999.

———. *Culture and State in Late Chosŏn Korea*. Cambridge: Harvard University Press, 1999.

———. *The Memoirs of Lady Hyegyŏng: The Autobiographical Writings of a Crown Princess of Eighteenth Century Korea.* Berkeley: University of California Press, 1996.

Hesin 合信 [Benjamin Hobson]. *Bowu xinbian*博物新編 (The new edition of extensive knowledge). Shanghai: Momei shugwan, 1855.

Jieziyuan huachuan 芥子園畫傳 (Mustard seed garden manual of paintings). Originally published in 1697. Beijing: Renmin meisu chubanshe, 1960.

Jungmann, Burglind. "Documentary Record versus Decorative Representation: A Queen's Birthday Celebration at the Korean Court" *Arts Asiatiques* 62 (2007): 95–111.

———. *Painters as Envoys: Korean Inspiration in Eighteenth-Century Japanese Nanga.* Princeton, N.J.: Princeton University Press, 2004.

Kim, Kumja Paek, ed. *Hopes and Aspirations: Decorative Paintings of Korea.* San Francisco: Asian Art Museum of San Francisco, 1998.

Korean Works of Art. Exhibition catalog. New York: Sotheby's, October 22, 1991.

Kwon Yŏng-p'il. "The Ideals of Scholar Painting of the Chosŏn period." In *The Fragrance of Ink: Korean Literati Paintings of the Chosŏn Dynasty (1392–1910) from Korea University Museum,* 141–63. Seoul: Korean Studies Institute, 1996.

Kwŏn Yŏng-pil, Pyŏn Yŏng-sŏp, and Yi Sŏng-mi, eds. *The Fragrance of Ink: Korean Literati Paintings of the Chosŏn Dynasty (1392–1910) from Korea University Museum.* Seoul: Korean Studies Institute, Korea University, 1996.

Lee Ki-baik. *A New History of Korea,* translated by Edward W. Wagner and Edward J. Shultz. Seoul: Ilchogak, 1984.

Lee Tae-ho. "Painting from Actual Scenery and Painting from Memory: Viewpoint and Angle of View in Landscape Paintings of the Late Joseon Dynasty." *International Journal of Korean Art and Archaeology* 3 (2009): 106–49.

Munakata, Kiyohiko. *Ching Hao's Pi-fa chi: A Note on the Art of the Brush.* Ascona, Switzerland: Artibus Asiae, 1974.

New Encyclopedia Britannica. 15th ed. Chicago: Encyclopedia Britannica, Inc., 1994.

Osborne, H., ed. *The Oxford Companion to Art.* Oxford: Oxford University Press, 1970.

Proceedings of the International Symposium on Chinese Painting. Taipei: National Palace Museum, 1972.

Raggio, Olga, and Antoine M. Wilmering. "The Liberal Arts Studiolo from the Ducal Palace Gubbio." *Metropolitan Museum of Art Bulletin* (Spring 1996): 5–56.

Richono kaiga – Kongetsuken korekusiyon – 李朝の繪畫 – 坤月軒 コレクショ ン - (Korean Paintings of Yi dynasty [1392–1910] from the Kongetsuken collection). Exhibition catalog. Toyama: Toyama Museum of Fine Art, 1985.

Smith, Judith G., ed. *Arts of Korea.* New York: Metropolitan Museum of Art, 1998.

Sŏ In-hwa, Chŏng-hye Pak, and Judy van Zile. *Folding Screens of Court Banquets and Congratulatory Ceremonies in the Joseon Dynasty.* Seoul: National Center for Korean Traditional Performing Arts, 2000.

Sullivan, Michael. *The Meeting of Eastern and Western Art.* Revised and expanded edition. Berkeley: University of California Press, 1989.

———. "Some Possible Sources of European Influence on Late Ming and Early Ch'ing Painting." In *Proceedings of the International Symposium on Chinese Painting,* 595–615. Taipei: National Palace Museum, 1972.

Wang Yangming. *Instructions for Practical Living and Other Neo-Confucian Writings.* Translated by Wing-tsit Chan. New York: Columbia University Press, 1963.

Xie Chungjeng 聶崇正. "Ji gukong Zhuanjin-zhai tiandinghua, chuanjingtu" 記故
宮倦勤齋天頂畫, 全景畫 (On the complete view and the ceiling painting of the
Zhuanjin-zhai in the Forbbiden Palace). *Gugong bowuyuan yuangan,* 故宮博物院
院刊 no. 3 (1995): 19–22.

Yang Boda. "Castiglione at the Ch'ing court." *Orientations* 19 (November 1988): 44–51.

Yi Sŏng-mi. "Artistic Tradition and the Depiction of Reality: True-View Landscape of
the Chosŏn Dynasty." In *Arts of Korea,* 330–65. New York: Metropolitan Museum of
Art, 1998.

———. "*Euigwe* and the Documentation of Joseon Court Ritual Life." *Archives of Asian
Art* 58 (2008): 113–33.

———. "Ideals in Conflict: Changing Concepts of Literati Painting in Korea." In *The
History of Painting in East Asia: Essays on Scholarly Method,* 288–314. Taipei: Rock
Publishing International and National Taiwan University, 2008.

———. *Korean Landscape Painting: Continuity and Innovation Through the Ages.*
Elizabeth, N.J.: Hollym, 2006.

———. "Koreans and Their Mountain Paintings." *Koreana* 8, no. 4 (Winter 1994): 18–25.

———. "Screen of the Five Peaks of the Chosŏn Dynasty." *Oriental Art* 42, no. 4 (1996–
97): 13–24.

———. "Southern School Literati Painting of the Late Chosŏn Period." In *The Fragrance
of Ink: Korean Literati Paintings of the Chosŏn Dynasty (1392–1910) from Korea
University Museum,* edited by Kwŏn Yŏng-pil, Pyŏn Yŏng-sŏp, and Yi Sŏng-mi, 177–
91. Seoul: Korean Studies Institute, Korea University, 1996.

Yu Jianhwa 俞劍華. *Zhongguo meishujia Renimg cidian* 中國美術家人名辭典
(Biographical dictionary of Chinese artists). Shanghai: Renmin meishu chubanshe,
1982.

Zhongguo banhuashi tulu 中國版畫史圖錄 (Illustrated catalog of the history of
Chinese woodblock prints). Vol. 1. Shanghai: Renmin meisu chupanshe, 1983.

Zhu, Xi. *Reflections on Things at Hand: The Neo-Confucian Anthology.* Translated by
Wing-tsit Chan. New York: Columbia University Press, 1967.

GLOSSARY OF NAMES, TERMS, AND TITLES OF PAINTINGS

..

Abahai (1592–1643, later Qing Taizong 太宗) 阿巴亥

Academy of Korean Studies 韓國精神文化研究院/ 韓國學中央研究院

Agyŏng 亞卿

Album of a Journey to Songdo 松都紀行帖

Album of a Kŭmgang Journey While at Rest 金剛臥遊帖

Album of Autumn Foliage Mountain 楓嶽圖卷

Album of Calligraphy and Painting of the Scenic Spots of the Four Districts and Three Immortals' Waters and Rocks 四郡江山參僊水石書畫帖

Album of Famous Scenes of Kwandong (*Kwandong myŏngsŭng-ch'ŏp*) 關東名勝帖

Album of Finger-Painting Landscapes 指頭畫帖

Album of Mount Kŭmgang and Its Old Temples 金剛山中古刹帖

Album of Paintings of Mount Kŭmgang 蓬萊圖卷

Album of Realistic Images of the Sea and Mountain (*Hae'ak chŏnsin-ch'ŏp*) 海岳傳神帖

Album of Sea and Mountains (*Haesan-ch'ŏp*) 海山帖

Album of Subjects Presenting Poem 諸臣製進帖

Album of the Four Districts of Kŭmgang 金剛四郡帖

Album of the Pyŏngjin Year, 1796 (*Pyŏngjin-nyŏn hwach'ŏp*) 丙辰年畫帖

Album of the Ŭlmyo Year, 1795 (*Ŭlmyo-nyŏn hwach'ŏp*) 乙卯年畫帖

Aleni, Julius (1582–1630) 艾儒略

An Chŏng-bok (1712–1791) 安鼎福

An Chung-sik (1861–1919) 安中植

Apku-jŏng 鴨鷗亭

Bamboo-Shoot Pinnacles (Oksun-bong) 玉荀峯

199

Beidang 北堂

Bifaji 筆法記

Boating [along the Stream] at Mount Wuyi
 (*Wuyi fangzhao-tu*) 武夷放棹圖

Bodhisattva Dharmodgata 曇無竭菩薩

Bodhisattva Ksitigarbha 地藏菩薩

Bust Portrait of Sin Im 申銋半身像

Calling the Dog 招狗圖

Cats and Sparrows 猫鵲圖

Ch'ae Che-gong (1720–1799) 蔡濟恭

Ch'ae Yong-sin (1850–1941) 蔡龍臣

ch'aekka-do or *ch'aekkeri* 冊架圖, or
 冊巨里

Ch'angdŏk Palace 昌德宮

Ch'ilbo-san chŏndo 七寶山全圖

Ch'oe Ik-hyŏn (1833–1906) 崔益鉉

Ch'oe Puk (1712–ca. 1786) 崔北

Ch'ŏnbul-am 千佛菴

Ch'ŏng'un-dong 清雲洞

Ch'ŏngha 清霞

Ch'ŏngjanggwan 青莊館

Ch'ŏngp'ung-gye 清風溪

Ch'ŏngsŏk-chŏng (Bundle-Stones
 Pavilion) 叢石亭

ch'ŏnju-sang 天主像

Ch'ŏnju kangsaeng ŏnhang kiryak 天主降
 生言行紀略

Chaehwa 載化

Chang Chi-yŏn (1864–1920) 張志淵

Chang'am 丈巖

Chang'an-sa 長安寺

Cheju Island 濟州島

Chi Un-yŏng (1851–1935) 池運英

Chibong 芝峰

Chibong yusŏl 芝峰類說

Chin chŏng-bang 鎮定坊

chin'gyŏng 眞景

chin'gyŏng sansu-hwa 眞景山水畫

chinbun 眞粉

chinha 進賀

Chinjŏng sŏsang 進呈書像

chinmuk 眞墨

Cho Chŏng-gyu (1791–?) 趙廷奎

Cho Hŭi-ryong (1797–1859) 趙熙龍

Cho Se-gŏl (1636–1705) 曹世傑

Cho Sŏk-chin (1853–1950) 趙錫晉

Cho Yŏng-sŏk (1686–1761) 趙榮祏

choch'ŏn-rok 朝天錄

choch'ŏn-sa 朝天使

Chŏggam 適庵

chok 簇

Chŏng Ch'ŏl (1536–1593) 鄭澈

Chŏng Ho (1648–1736) 鄭澔

Chŏng Hwang (1735–?) 鄭晃

Chŏng Sang-gi (1678–1752) 鄭尙驥

Chŏng Sŏn (1676–1759) 鄭敾

Chŏng Sŏn p'a 鄭敾派

Chŏng Su-yŏng (1743–1831) 鄭遂榮

Chŏng To-jŏn (1337–1398) 鄭道傳

Chŏng Yak-chŏn (1758–1816) 丁若銓

Chŏng Yak-jong (1760–1801) 丁若鍾

Chŏng Yak-yong (1762–1836) 丁若鏞

Chŏng Yŏ-chang (1450–1504) 鄭汝昌

Chŏng Yŏn (1541–?) 鄭演

Chŏng Yu-il (1533–1576) 鄭惟一

Chŏng'yu chaeran 丁酉再亂

Chŏnghae chinch'an tobyŏng 丁亥進饌
 圖屏

Chŏngmyo horan 丁卯胡亂

chŏngri-cha 整理字

chŏngsa; Ch. *jingshe* 精舍

Chŏngyang-sa 正陽寺

Chongzhen 崇禎 (Qing Yizong 毅宗,
 r. 1628–1744)

Chosŏn dynasty 朝鮮王朝

Chunch'ŏn kyech'ŏp 濬川契帖

chung'in 中人

Chunghwa; Ch. Zhonghwa 中華

Chunghyang 衆香

Clear-Mirror Terrace (Myŏnggyŏng-dae)
 明鏡臺

Clearing after Rain on Mount Inwang
 (Inwang chesaek-to) 仁王霽色圖

Complete View of Mount Ch'ilbo 七寶山
 全圖

*Complete View of Mount Chiri Seen
 from Kŭmdae* (Kŭmdae tae Chiri
 Chŏnmyŏn-do) 金臺對智異全面圖

Complete View of Mount Kŭmgang 金剛
 全圖

Crown Prince Sado (1735–1762) 思悼世子

Crown Prince Sohyŏn (1612–1645) 昭顯
世子

Dong Qichang (1555–1636) 董其昌
Dongdang 東堂
Dowager Queen Cho (1808–1890) 趙大
妃
Dowager Queen Sunwon (1789–1857)
純元王后
Duobaogejing–tu 多寶格景圖

Evangelicae Historiae Imagines 福音史
事圖解

Fang Cong-I (ca. 1302–1393) 方從義
fei-li-bu-dong 非禮不動
Ferocious Dog 猛犬圖
Ferocious Tiger under Pine Tree 松下猛
虎圖
Flying-Phoenix Waterfall (Pibong-p'ok)
飛鳳瀑

Gao Kegong (1248–1310) 高克恭
Gate Rocks at T'ongch'ŏn (T'ongch'ŏn
munam) 通川門岩
*Gathering of Scholars at the Toksŏ-dang
Reading Hall* (Toksŏ-dang kyehoe-do)
讀書堂契會圖
General View of Inner Mount Kŭmgang
(Kŭmgang naesan ch'ŏngdo) 金剛內
山總圖
Gu Bing 顧炳
Guo Xi (ca. 1000–ca. 1090) 郭熙
Gushi huapu 顧氏畫譜
Gushi lidai minggong hwapu 顧氏歷代名
公畫譜
Gwangxue 光學

Haedong sisŏn 海東詩選
Haedong yŏksa 海東繹史
Haegŭmgang 海金剛
Haegŭmgang humyŏn 海金剛後面
Haehŭmgang chŏnmyŏn 海金剛前面
Hainei qiguan 海內奇觀
Hamgyŏng province 咸鏡道
Han Ch'i-yun (1765–1814) 韓致奫

Han Hŭng-il (1587–1651) 韓興一
Han Myŏng-hoe (1415–1487) 韓明澮
Han Paek-gyŏm (1552–1615) 韓百謙
Han Si-gak (1621–?) 韓時覺
Hanjuktang 寒竹堂
Hanjung-rok 閑中錄
Hansan sego 漢山世稿
Hansŏng p'anyun 漢城判尹
Hayang 漢陽
Hesin (Benjamin Hobson, 1816–1873)
合信
Hŏ P'il (1709–1761) 許佖
Hŏ Paek-ryŏn (1891–1977) 許百鍊
Hŏju 虛舟
Hong Hyŏn-ju (1793–1865) 洪顯周
Hong Ik-han (1586–1637) 洪翼漢
Hong Kil-chu (1766–1841) 洪吉周
Hong Se-sŏp (1832–1884) 洪世燮
Hong Sŏk-chu (1774–1842) 洪奭周
Hong Tae-yong (1731–1783) 洪大容
Hosaeng-gwan 毫生館
Hu Bing (dates unknown) 胡炳
Huajŏn 畫筌
Hŭngsŏn Taewongun 興宣大院君
Hwaju-rok 畫廚錄
Hwang Ch'ŏl (1864–1930) 黃鐵
Hwasang yodol 畫像拗突
Hwasŏng Detached Palace 華城行宮
Hwasŏng nŭnghaeng tobyŏng 華城陵幸
圖屛
Hwayangdong 華陽洞
Hyesan 惠山
Hyŏlmang-bong 穴望峰
Hyŏngsan; Ch. Hengshan 衡山

Ibyŏn-gi 入燕記
igi chi myo 理氣之妙
iksŏn'gwan-bon 翼善冠本
Ilmonggo 一夢稿
Imdang 淋塘
Imin chinyŏn tobyŏng 壬寅進宴圖屛
Imjin waeran 壬辰倭亂
Immortal-Calling Pavilion (Hwansŏn-
jŏng) 喚仙亭
Imo kullan 壬午軍亂
inhwa 印畫

Injŏng-mun 仁政門
Insu-bong 仁壽峯
Iram 一庵

Jiao Bingzhen (active in the seventeenth century) 焦秉貞
jiehua 界畵
Jieziyuan huachuan 芥子園畵傳
Jin dynasty 金
Jing Hao (active ca. 870–ca. 930) 荊浩
Jurchen 女眞

Kabo kyŏngjang 甲午更張
Kaegol-san 皆骨山
Kajae Yŏnhaeng-gi 稼齋燕行記
Kang Hŭi-ŏn (1738–before 1784) 姜熙彦
Kang Se-hwang (1713–1791) 姜世晃
Kang Sin (1767–1821) 姜信
Kanghwa-do 江華島
Kangwon province 江原道
Kich'uk chinch'an tobyŏng, 1829 己丑進
饌圖屛
Kija (active around 1100 BCE) 箕子
Kijŏn 畿甸
Kim Ch'ang-hŭp (1653–1722) 金昌翕
Kim Ch'ang-hyŏp (1651–1708) 金昌協
Kim Ch'ang-jip (1648–1722) 金昌集
Kim Ch'ang-ŏp (1658–1721) 金昌業
Kim Ch'ang-su (active in the mid-nine-teenth century) 金昌秀
Kim Ha-jong (1793–after 1875) 金夏鍾
Kim Han-t'ae (1762–?) 金漢泰
Kim Hong-do (1745–1806) 金弘道
King Hŏnjong (r. 1834–1849) 憲宗
Kim Kŭk-hyo (1542–1618) 金克孝
Kim Kyŏng-rim (1762–?) 金景林
Kim Kyu-hŭi (1857–?) 金奎熙
Kim Sang-ch'ŏl (1712–1791) 金尙喆
Kim Sŏk-ju (1634–1684) 金錫冑
Kim Sŏk-mun (1658–1745) 金錫文
Kim Sŏk-sin (1758–?) 金碩臣
Kim Su-ch'ŏl (active in the mid-nineteenth century) 金秀哲
Kim Su-hang (1629–1689) 金壽恒
Kim Su-jŭng (1624–1701) 金壽增
Kim Sun-hyŏp (1693–1732) 金舜協

Kim Tŏk-sŏng (1729–1797) 金德成
Kim Tŭk-sin (1754–1852) 金得臣
Kim U-jin (1754–?) 金宇鎭
Kim Ŭng-hwan (1742–1789) 金應煥
Kim Won-haeng (1702–1772) 金元行
Kim Yang-gŭn (1734–1799) 金養根
Kim Yong-won (1842–1935) 金鏞元
Kim Yu-sŏng (1725–?) 金有聲
Kim Yuk (1580–1658) 金堉
Kim Yun-gyŏm (1711–1775) 金允謙
Kim Yun-sik (1835–1920) 金允植
King Ch'ŏlchong (r. 1849–1863) 哲宗
King Chŏngjo (r. 1776–1800) 正祖
King Chungjong (r. 1506–1544) 中宗
King Hŏnjong (r. 1834–1849) 憲宗
King Hyojong (r. 1649–1659) 孝宗
King Injo (r. 1623–1649) 仁祖
King Kojong (r. 1863–1907) 高宗
King Munjong (r. 1450–1452) 文宗
King Myŏngjong (r. 1545–1567) 明宗
King Sejo (r. 1455–1468) 世祖
King Sejong (r. 1418–1450) 世宗
King Sŏngjong (r. 1469–1494) 成宗
King Sŏnjo (r. 1567–1607) 宣祖
King Sukchong (r. 1674–1720) 肅宗
King T'aejo (r. 918–943) 太祖
King Tan'gun (2333 BCE–?) 檀君
King Yejong (r. 1468–1469) 睿宗
King Yŏngjo (r. 1724–1776) 英祖
kiroso 耆老所
Kisa 耆社
Kiya 箕野
Ko Hŭi-dong (1886–1965) 高羲東
Ko Yong-hu (1577–?) 高用厚
Kogun Chŏngsa 谷雲精舍
Kogun kugokto 谷雲九谷圖
Koguryŏ 高句麗
Koran-sa 皐蘭寺
Koryŏ 高麗
Kosan 高山
Ku Pong-ryŏng (1526–1586) 具鳳齡
Kudam 龜潭
Kugok-kye; Ch. Jiuquxi 九曲溪
Kugyŏng-dae 龜景臺
Kŭmdae tae Chiri Chŏnmyŏn-do 金臺對
智異全面圖

Kŭmgang-bong 金剛峰
Kŭmgang-san 金剛山
Kŭmgang sagun-ch'ŏp 金剛四郡帖
Kŭmgangsanjung koch'alch'ŏp 金剛山中 古刹帖
Kŭmhwa district 金華縣
Kŭmrŭng-jip 金陵集
kunbok sobon 軍服小本
kunbok taebon 軍服大本
Kungjung sungbul-to 宮中崇佛圖
Kŭnyŏk sŏhwajing 槿域書畫徵
Kuro-hoe 九老會
Kuryŏng p'okp'o 九龍瀑布
Kwanajae-go 觀我齋稿
Kwanajae 觀我齋
Kwandong myŏngsŭng-ch'ŏp 關東名勝帖
Kwandong p'algyŏng 關東八景
Kwanghae-gun (r. 1608–1623) 光海君
kuanglun 光論
Kwanhwado chŏngriso kyebyŏng 觀華圖 整理所禊屏
Kwesan 槐山
Kwon Hyŏk (1694–1759) 權爀
Kwon Sang-ha (1641–1721) 權尙夏
Kyebyŏng 契屏
kyehoe-do 契會圖
Kyesa 啓辭
Kyŏmjae 謙齋
Kyŏmjae ilp'a 謙齋一派
Kyŏmjae sujik chun 謙齋 垂直皴
Kyŏnggyo myŏngsŭng-chŏp 京郊名勝帖
Kyujang-gak 奎章閣
Kyujang-gak chabi taeryŏng hwawon 奎章 閣 差備待令畫員

Lady Hyegyŏng (1735–1815) 惠慶宮洪氏
Lang Shining (Giuseppe Castiglione, 1688–1766) 郎世寧
li 里
Li Madu (Matteo Ricci, 1552–1610) 利瑪竇
liezhuan 列傳
Linchuan gaozhi 林泉高致

Mandong-myo 萬東廟
mang'o 望五

Mang'yang-jŏng 望洋亭
Meng Yongguang (active in the first half of seventeenth century) 孟永光
Mi Fu (1051–1107) 米芾
Mi ink-dots 米點
Min Sang-ho (1870–1933) 閔商鎬
Ming dynasty 明
Mingshan-ji 名山記
Mingshan shenggai-ji 名山勝概記
Mingshi 明史
minhwa 民畫
Mong'wa 夢窩
Mount Inwang Seen from Tohwa-dong 桃花洞望仁王山
Mount Kŭmgang Viewed from Ch'ŏnil Terrace (Ch'ŏnil-tae mang Kŭmgang) 天一臺望金剛
Mui-san 武夷山
munbang-do 文房圖
Musin chinch'an tobyŏng 戊申進饌圖屏
Myogilsang-am 妙吉祥庵
myŏnbok-pon 冕服本
myŏngbun ŭiri-ron 名分義理論

Naegak illyŏk 內閣日曆
Naegŭmgang 內金剛
Nakhwa-am 落花巖
Naknam-hŏn 落南軒
Naknamhŏn yangnoyŏn-do 落南軒養老 宴圖
Nam Kong-ch'ŏl (1760–1840) 南公轍
Nam Ku-man (1629–1711) 南九萬
Namhan sansŏng 南漢山城
namjong-hwa 南宗畫
Nan Huiren (Ferdinand Verbiest, 1623– 1688) 南懷仁
Nandang 南堂
Ni Zan (1301–1374) 倪瓚
Nine-Dragon Pond (Kuryong-yŏn) 九 龍淵
Nine Bend Stream of Mount Wuyi 武夷 九曲圖
No Su-hyŏn (1891–1978) 盧壽鉉
No Yŏng (active in the fourteenth century) 魯英
Nogajae or Kajae 老稼齋, 稼齋

Non t'aesŏ-pŏp 論泰西法
Nong'am 農巖
North Kyŏngsang province 慶尙北道
Nurhachi (1555–1627, Qing Taizu 太祖)
　奴爾哈赤

Obongbyŏng 五峯屏
Oegŭmgang 外金剛
Oekyjanggak 外奎章閣
Old Villa in the Hwagae District 花開縣
　舊莊圖
Ŏm Ch'i-uk (active in the nineteenth
　century) 嚴致郁
Outside Scenery Projected through a Con-
　cave Lens 外景透凹鏡圖

P'alto-do 八道圖
P'igŭm-jŏng 披襟亭
p'ok 幅
P'ung'ak-kwon 楓嶽卷
P'ung'ak-san 楓嶽山
P'unggye-chipsŭng-gi 風溪集勝記
P'yohun-sa 表訓寺
P'yŏng'yang chŏndo 平壤全圖
P'yorong ŭlch'am 縹礱乙懺
Paegak sadan 白岳社團
Paek Ŭn-bae (1820–1901) 白殷培
Paekche 百濟
Paekha 白下
Paengma-gang 白馬江
Pak Che-ga (1750–1805) 朴齊家
Pak Chi-won (1737–1805) 朴趾源
Pak Hoe-su (1786–1861) 朴晦壽
Pak Myŏng-won (1725–1790) 朴明源
Pak T'ae-yu (1648–1746) 朴泰維
Pan'gye 磻溪
Pan'gye surok 磻溪隨錄
Pearl Pond in Inner Kŭmgang 內金剛眞
　珠潭
Peng Shiwang (1610–1683) 彭士望
Pibong-p'ok (Flying-Phoenix Waterfall)
　飛鳳瀑
Pihong-gyo 飛虹橋
Piro-bong 毘盧峯
Piwon 秘苑
Pongsu-dang 奉壽堂

Pontoon Bridge at Noryang-jin Ford 露梁
　舟橋圖
Prince Pongrim (1619–1659) 鳳林大君
Prince Yŏn'ing (1694–1776) 延礽君
Pukgwan Such'ang-rok 北關酬唱錄
Pukhan Sansŏng 北漢山城
Pusang 扶桑
puyŏn-sa 赴燕使
pyŏlche 別提
Pyŏn Kwan-sik (1899–1976) 卞寬植
Pyŏn Sang-byŏk (active in the eighteenth
　century) 卞相璧
Pyŏngja horan 丙子胡亂

Qiqi Tushuo 『奇器圖說』
Qishun 祁順

Ricci, Matteo (Li Madu, 1552–1610)
　利馬竇
Royal Retinue in Sihŭng Returning to
　Seoul 還御行列圖

sa'aek 賜額
Sa'in-am (Official's Rock) 舍人巖
Sach'ŏn 槎川
sago 史庫
Sambulhoe-do 三佛會圖
samjŏl 三絶
Samjŏndo 三田渡
Samse yŏrae ch'et'aeng 三世如來體幀
Samun t'alsa 寺門脫蓑
Samyŏn 三淵
sangbon 像本
Sansu-go 山水考
sanrŭng 山陵
sap'o-sŏ 司圃署
sappyŏng 挿屏
Schall, Adam (1591–1666) 湯若望
Screen of the Five Peaks (obong-byŏng)
　五峯屏
Segŏm-jŏng 洗劍亭
Seikenji 淸見寺
Shen Yue (441–513) 沈約
Shenyang 瀋陽
Shenzong (r. 1572–1619) 神宗
Shijujai shuhuapu 十竹齋書畫譜

Shizuoka prefecture 静岡県

Sigam 息庵

sihŏllyŏk; Ch. *shixianli* 時憲曆

silgyong 實景

Silla 新羅

Sim Sa-jŏng (1707–1769) 沈師正

Sim Yŏm-jo (1734–1783) 沈念祖

Sim'in; Ch. *sinyin* 心印

Simyang ilgi 瀋陽日記

Sin Im (1642–1725) 申銋

Sin Kwang-hyŏn (1813–?) 申光絢

Sin Kyŏng-jun (1712–1782) 申景濬

Sinmi yang'yo 辛未洋擾

Sinmyo-nyŏn P'ung'ak toch'ŏp (1711) 辛卯年楓嶽圖帖

Sinnyŏ-hyŏp 神女峽

Sinyu sa'ok or Sinyu pakhae 辛酉邪獄 辛酉迫害

sirhak; Ch. *shixue* 實學

Small Insect Projected through a Convex Lens 蟲像透凸鏡圖

So-Chunghwa 小中華

Sŏ Chae-p'il (1864–1951) 徐載弼

Sŏ Chik-su (1735–?) 徐直修

Sŏ Ho-su (1736–1799) 徐浩修

Sŏ Yong-bo (1757–1824) 徐龍輔

Sŏ Yu-gu (1764–1845) 徐有榘

sŏ'in 西人

sŏhak 西學

Sŏhak ch'ip'yŏng 西學治平

Sŏhak pŏm 西學凡

Sohyŏn Seja (1612–1645) 昭顯世子

Sŏkchi 石芝

sokhwach'e 俗畫體

Sŏktam Chŏngsa 石潭精舍

Sŏlguk No'in 雪國老人

sŏn'gyŏng 仙境

Song Chun-gil (1606–1672) 宋浚吉

Song Si-yŏl (1607–1689) 宋時烈

Songdo 松都

Songdo kihaeong-ch'ŏp 松都紀行帖

Sŏnggyo yoji 聖敎要旨

Sŏngho 星湖

Sŏngho Memorial Hall 星湖紀念館

Sŏngho sasŏl 星湖僿說

Songp'a district 松坡區

Songshi 宋史

Sŏnwon-sa 禪源寺

South Kyŏngsang province 慶尚南道

Sŏyanghwa-gi 西洋畫記

Sŏyang sinbŏp yŏksŏ; Ch. *Xiyang xinfa lishu* 西洋新法易書

Special State Examination for Applicants from the Northern Frontier (Puksae Sŏnŭn-do) 北塞宣恩圖

Spring Morning over Mount Paegak (Paegak ch'unhyo-do) 白岳春曉圖

Sŭngjŏng'won ilgi 承政院日記

Sunjong (r. 1907–1910)

Suryŏm (Bamboo-Curtain Waterfall) 水簾

Susin sŏhak 修身西學

t'ongch'ŏn-gwan 通天冠

Tae Chin-hyŏn (Dai Jinxian, Ignatius Kogler; 1680–1736) 戴進賢

Taebo-dan 大報壇

taech'ŏng 大廳

Taehan cheguk 大韓帝國

Taehŭng-sa 大興寺

Taewon-gun 大院君→Hŭngsŏn Taewon-gun

T'aebaek Mountain 太白山

T'aego-jŏng 太古宗

T'aengni-ji 擇里志

t'aegŭk; Ch. *taiji* 太極

Tamhŏn 湛軒

Tamhŏnsŏ Oejip 湛軒書 外集

Tanbal-ryŏng mang Kŭmgang 斷髮嶺望金剛

tangbun 唐粉

tangmuk 唐墨

Tangshi huapu 唐詩畫譜

Tanwon 檀園

Tanwon-do 檀園圖

Tasan 茶山

Terrenz, Joannes (Deng Yuhan, 1576–1630) 鄧玉函

Tianqi 天啓

Tobong-do 道峰圖

Togam 都監

Togok 陶谷

Tong'yu-ch'ŏp 東遊帖
Tongguk chido 東國地圖
tongguk chin'gyŏng 東國眞景
Tongguk chiriji 東國地理志
Tongguk munhŏn pigo 東國文獻備考
Tongho mundap 東湖問答
Tongjak –chin 銅雀津
Tongnip hyŏphoe 獨立協會
Tongsa kangmok 東史綱目
Toro-go 道路考
Toyotomi Hideyoshi (1536–1598) 豊臣
 秀吉
Tut'a 頭陀
Tut'a-ch'o 頭陀草

ŭibyŏng 義兵
ŭigwe 儀軌
Ŭlsa poho choyak or Ŭlsa choyak 乙巳保
 護條約, 乙巳條約
Ŭmjuk 陰竹

Vagnoni, Alphonsus (Gao Yizhi, 1536–
 1606) 高一志
Verbiest, Ferdinand (Nan Huiren, 1623–
 1688) 南懷仁
Vos, Hubert (1855–1935)

Wang Shouren (ho Yangming; 1472–1529)
 王守仁
Wang Xun (eighteenth century) 王勛
Wang Yangming→Wang Shouren
Wang Zheng (1571–1644) 王徵
Wanli 萬曆
Wei Xi (1624–1680) 魏禧
White-Cloud Pond (Paegun-dam) 白雲潭
Wind and Rain God 風雨神圖
Winding Covered Veranda of a Palace
 回廊曲檻宮式
Wonhaeng ŭlmyo chŏngri ŭigwe 園幸乙
 卯整理儀軌
Worship of the Buddha in Palace 宮中崇
 佛圖

Xie He 謝赫
Xiushen xixue 修身西學
xixue 西學

Xixue fan 西學凡
Xixue zhiping 西學治平
Xizong (r. 1621–1627) 熹宗

Yang 陽
Yang Erzeng (seventeenth century)
 楊爾曾
yangban 兩班
Yangch'ŏn 陽川
Yangch'ŏng 洋青
Yanghwa-jin 楊花津
Yangju 洋朱
Yangnok 洋綠
Yi Chae (1680–1746) 李縡
Yi Chae-hak (1745–1806) 李在學
Yi Cham (1660–1706) 李潛
Yi Ching (1581–after 1645) 李澄
Yi Chong-ak (1726–1773) 李宗岳
Yi Chong-hyŏn (1718–1777) 李宗賢
Yi Chung-hwan (1690–1752) 李重煥
Yi Ha-gon (1677–1724) 李夏坤
Yi Ha-ŭng (1820–1898) 李昰應
Yi Han-jin (1628–1682) 李漢鎭
Yi Hui-ji (1715–1785) 李徽之
Yi Hwang (1501–1570) 李滉
Yi Hyŏng-rok (1808–?) 李亨祿
Yi I-myŏng (1658–1722) 李頤命
Yi I (1536–1584) 李珥
Yi Ik (1681–1763) 李瀷
Yi In-mun (1745–1821) 李寅文
Yi In-sang (1710–1760) 李麟祥
Yi Ki-ji (1690–1722) 李器之
Yi Kwang-mun (1778–1838) 李光文
Yi Kyu-gyŏng (1788–1856) 李圭景
Yi Kyu-sang (1727–1796) 李圭象
Yi Man-bu (1664–1732) 李萬敷
Yi Myŏng-gi (dates unknown) 李命基
Yi Nyŏng (active ca. 1122–1146) 李寧
Yi P'ung-ik (1804–1887) 李豊瀷
Yi Pang-un (1761–after 1815) 李昉運
Yi Pyŏk (1754–1786) 李檗
Yi Pyŏng-yŏn (1671–1751) 李秉淵
Yi Rulue (Giulio Aleni, 1582–1649)
 艾儒略
Yi Saek (1328–1396) 李穡
Yi Sang-bŏm (1897–1972) 李象範

Yi Sang-ŭi (1560–1624) 李尙毅
Yi Sŏ (1662–1723) 李漵
Yi Sŏng-gil (1562–?) 李成吉
Yi Sŏng-gye (1335–1408) 李成桂
Yi Su-gwang (1563–1628) 李睟光
Yi Sun-sin (1545–1598) 李舜臣
Yi Sŭng-hun (1756–1801) 李承薰
Yi Tŏk-mu (1741–1793) 李德懋
Yi Ŭi-hyŏn (1669–1745) 李宜顯
Yi Ŭi-sŏng (1775–1833) 李義聲
Yi Yu-won (1814–1888) 李裕元
Yi Yun-min (1774–1841) 李潤民
Yi Yun-yŏng (1714–1759) 李胤永
Yihyang kyŏnmun-rok 里鄕見聞錄
Yijing 易經
Yimwon kyŏngje-ji 林園經濟誌
yin 陰
Yŏ Yŏn'gyŏng hwasa Jiao Bingzhen sŏ 與燕京畫師焦秉貞書
Yŏkhak tosŏl 易學圖說
Yŏn'gaek 煙客
Yŏnch'ŏn-jip 淵泉集
Yŏnghwa-dang 映花堂
Yongju-sa 龍珠寺
Yŏngsŏn-sa 領選使
Yŏngsu-gak 靈壽閣
Yŏngt'ongdong-gu 靈通洞口
Yongyang-bongjŏ-jŏng 龍驤鳳翥亭
yŏnhaeng-rok 燕行錄
yŏnhaeng-sa 燕行使

Yŏnp'yŏng Relying on His Mother in His Childhood 延平髫齡依母圖
Yorha ilgi 熱河日記
Yu Chae-gŏn (1793–1880) 劉在建
Yu Hyŏng-won (1622–1673) 柳馨遠
Yu Sŏng-ryong (1542–1607) 柳成龍
Yu Suk (1827–1873) 劉淑
Yuanjing-ji 遠鏡記
Yuansi chichi tushuo lutsui 遠西奇器圖說錄最
Yun Che-hong (1760–after 1840) 尹濟弘
Yun Feng (sixteenth century) 尹鳳
Yun Kŭn-su (1537–1616) 尹根壽
Yun Sŏk-nam (1939–) 尹錫男
Yun Sun (1680–1741) 尹淳
Yun Tu-sŏ (1668–1715) 尹斗緖
Yunlin 雲林
Yutiandian 玉田店

Zhang Chao (active until ca. 1676) 張潮
Zhao Mengfu (1254–1322) 趙孟頫
zhen shanshui 眞山水
zhenjing 眞景
Zhongguo mingshan-ji 中國名山記
Zhongyong 中庸
Zhu Shuzeng (dates unknown) 朱述曾
Zhu Xi (1130–1200) 朱熹
Zhuanjin-zhai 倦勤齋
Zong Bing (375–443) 宗炳
Zuo Shaoren (active second half of the nineteenth century) 左紹仁

ILLUSTRATIONS

INDEX